Rembrandt

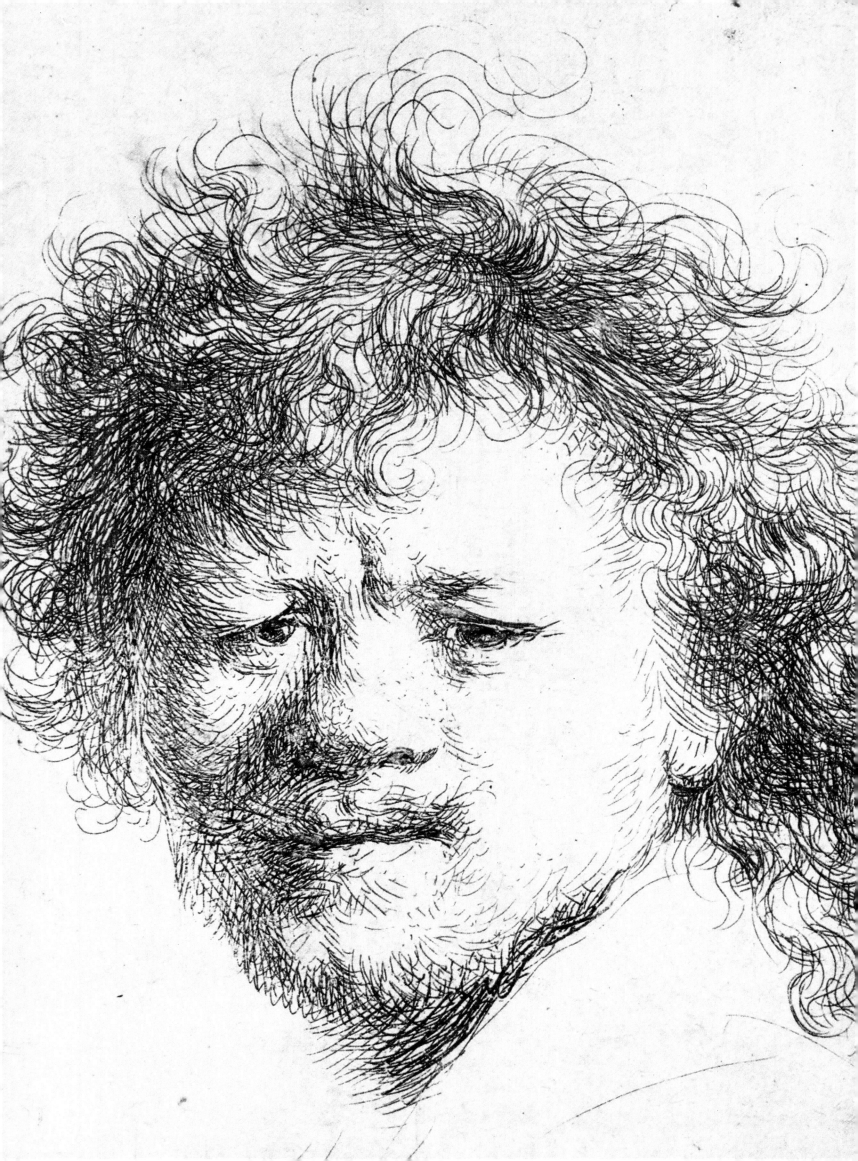

Rembrandt

Pierre Cabanne

KONECKY&KONECKY

FRONTISPIECE:
Self-Portrait with Long Curly Hair, 1631.
Etching, first state. 6.3 x 6.6 cm.
Rembrandthuis, Amsterdam.

Konecky & Konecky
156 Fifth Ave.
New York, NY 10010

First published in French in 1991
Copyright © 1991, Editions du Chêne, Hachette Livre

First Published in English in 1997
Translated by Sean Konecky
Translation © 1997, Sean Konecky

ISBN: 1-56852-180-4

Layout of English language edition by STUDIO 31, INC.

Printed in Italy

Rembrandt

At what point does Rembrandt show us his true self? No doubt, as with Van Gogh, Cézanne or Picasso in his hallucinatory self-portrait of 1972, when he looks at his own face, draws his features and scrutinizes the passage of time. Or perhaps when overcome with grief he looks at the world differently and abandons himself to dreams. His technique, which no longer has to be dazzling since he has lost his joy in living, is entirely at the service of his sole remaining passion, painting; and he transforms it into a scalpel cutting into the human world that no longer admires and fawns upon him.

No artist has ever understood so deeply, with such anguish and uncertainty, the problem of the relationship between man — that is, himself — and the world, between the painter and God, between the language of the moment and the expression of eternity. His life and his art were a continual questioning: no one before him had discovered that painting possessed this kind of force, that it could make colors surge with the glorious power of light and shadow, the effects of chiaroscuro, "that night that leans upon the shore of light," in the words of Henri Focillon.

The trembling gleams of a candle, reflections in a mirror, the pale clarity of night, or daylight piercing the darkness of a room, the resplendent solar rays falling on the ground, all declare the primacy of light.

Rembrandt painted himself many, many times. (It is impossible to establish with certainty the total number of portraits painted, engraved and drawn by the artist. Many have disappeared; some were copied by his students and reworked by the artist himself. Many Rembrandts have been deattributed in recent years. In all perhaps one half of his total output as portraitist has survived.) He presents himself in front of the mirror in different lights. Time seems suspended as one meets him first as a young man, proud and self-confident, a bit of a show-off — even somewhat bizarre with his long hair and floppy hats sometimes adorned with a feather — arrogant, sometimes severe. Then as time passes and misfortunes pile up, his features become grosser, almost bloated, tinged with the blood that suffuses his cheeks and heavy eyelids and the circles under his eyes.

His brushstrokes become denser; the nervous brutality of his hand erases transparencies and dilutes nuances. His once brilliant glance has become lifeless, anxious. His forehead is deeply wrinkled. His cheeks sag. The corners of his mouth droop. His old vanity has given way to resignation. Reds and browns that seem to have been kneaded or pulverized predominate. He was once the most celebrated painter in Holland, admired, loved, rich, the toast of the town. Now alone, defeated, he can hardly believe his fate, and breaks out into a senile nervous laughter that won't stop (Wallraf-Richartz Museum, Cologne).

He was not that old when he painted this self-portrait. Only 59, but he seems at least twenty years older. Painting had aged him, not in his own eyes (nor in ours), nor in his hands, but in the implacable gaze of his contemporaries who labeled him mad, immoral and disgraced. This is what shakes the pathetic and grotesque laughter out of him. Later on he regains a measure of balance, and his last self-portraits are much more dignified. But this image remains, of one, who looks into nothingness and paints himself as a clown.

He does not ask for our pity. He defies it and offers himself at the same time to history and the world as the most sublime testimony of the meeting of destiny, painting and genius. And without a doubt the truest. After Rembrandt it would no longer be possible to feign or deceive. Painting for Delacroix, Manet, Van Gogh, Cézanne would reside in the act of baring one's soul.

Modern painting begins with the decrepit face of this "toothless old lion" that overwhelmed Van Gogh. This painting is only itself, and with an astonishing alchemy brings together a mysterious

The Jewish Bride

marriage of emotion and grandeur. Self-portraiture it is, but by one who stands on the edge of the abyss.

Look at his face from up close: his rounded cheeks, bulbous nose and wrinkled brow. What an admirable piece of work. The flesh is of pale gold, of rust and blood. Its luminosity is dispelled in the shadows around his lips. Copper tones suggesting the bottom of a kettle are here and there shot through with bronze and are echoed in the yellows of his bonnet and the shawl he wears over his clothes.

The harmony of colors, the opposition of light and dark, everything breathes. Consider the tender intimacy of *The Jewish Bride*, the rippling body touched by the failing light of day in *The Descent from the Cross*, the disjointed and bloodied carcass of *The Slaughtered Ox*, the visionary intensity of *Christ at Emmaus*, or the heavy golden flesh of *Bathsheba*. All bear witness to a captivating intimacy between life and painting.

The self-portrait in the Dahlem Museum in Berlin, which Rembrandt painted in 1634, shows him self confident in his large velvet beret, with a slightly mocking, lively look. His mustache is curled up with a kind of impertinence, and he has a foulard carelessly knotted under his fur collar. Rembrandt executed several self-portraits that year, in which he does something that no other Dutch artist had dared to do before him: sign his paintings with his first name only, in the style of the great Italian masters. He has just gotten married to a young woman of a good family, Saskia van Uylenburgh. He is all the rage without a serious rival. He is making lots of money and spends it lavishly. His private collection is among the finest in Holland, and he is becoming known in society. His compatriots are dazzled by his prodigality, his magnificence, the power of his work. His mixture of shadow and light is especially fascinating and imbues his pictures with a mysterious grandeur.

Christ at Emmaus

There still remain a few years of glory and happiness, and then twilight and night.

Rembrandt van Rijn, Rembrandt of the Rhine — this unusual name comes from his great-grand-mother, Reijmptje — was born in Leyden on the

July 15, 1606. He was the sixth child of a miller, Harmen Gerritszoon van Rijn, and Nelltjen Willems van Zuytbrœck, who would have seven children in all, five boys and two girls. Leyden was a small town, whose university, founded in 1575, had a well-established reputation and was marked by religious controversies between Calvinist and other religious sects, such as Anabaptist, Mennonite and Arminian. The city was criss-crossed by many canals, in which were reflected the great houses of rich cloth merchants and their mills. Nearby were the sea and the dunes, and the children of Leyden would often go there to play and swim. Rembrandt never painted the sea; no doubt his vision ranged further and higher. Indeed what attraction did the sea hold with its infinite expanse and fluffy clouds rolling through a gray sky, for a youth whose preoccupations were already inwardly directed. At seven he was a serious student, and went to Latin school, where he acquired a thorough grounding in religion. He was familiar with Abraham, Jacob and David, knew by heart the Temple of Jerusalem as well as in what circumstances Moses received the Ten Commandments from God on Sinai. At the unusually young age of fourteen he was enrolled in the University of Leyden to study ancient history, which was in effect the study of the Bible and the history of the Jews.

Now he found himself in the company of latinists, philologists, theologians, and legal scholars, of every country and every religious persuasion. All rubbed shoulders in Leyden, a humanist city where controversies were numerous and passionately engaged in. In this city, where the Reformation had emptied the churches of religious imagery, which it deplored, there were no altarpieces, no religious tableaus, no statues of the Virgin or of the saints. What was there for this future artist to see? Nothing to cause him anxiety, make him question, or exalt him, with the exception of an immense triptych, *The Last Judgment* by Lucas Huygens, called Lucas of Leyden, that had been removed from the Church of Saint Peter and installed in the Stadhuis. And perhaps here and there isolated works hanging in public buildings or private collections. No one knows why the miller's son decided to become a painter. Did he hope to open his mind to ways of comprehending the world different from those of the theologians and classicists? Or perhaps to accompany

the speculations of his spirit with the work of his hands? Or to reintroduce the Old and New Testaments into Dutch painting? Was he aware of what was going on in Italy? His first teacher, Jacob Izaacz van Swanenburgh, who had visited Italy, brought back with him several paintings and a beautiful young wife, Margherita. He liked to paint ruined landscapes and heroic and fantastic scenes. None of this held much interest for Rembrandt. His apprenticeship did, however, introduce him to the study of anatomy, perspective, the rules of composition and drawing, and he learned how to mix paints and prepare a canvas. He may have worked on the backgrounds of his teacher's paintings.

Pieter Lastman was an artist of a much higher caliber. Rembrandt only stayed in his studio for six months (1624-1625), but he lived with him in Amsterdam. The astonishingly precocious apprentice now was studying with a man who had known Caravaggio and Elsheimer at Rome. Lastman was the equal of the mannerist painters of Haarlem and Utrecht, but slightly more of a realist. His work did contain rhetorical elements that were somewhat forced, but its strong expressiveness was powerfully dramatic and unquestionably effective. This theatricality, sometimes a bit overdone, was strikingly different from most of what was being done in Holland. Its rich exoticism, nourished by mannerism and the baroque, made a deep impression on his young pupil.

Rembrandt fell in love with Amsterdam. Leyden was a city of culture, but, despite the intellectual fervor of the university, provincial nonetheless. Amsterdam was a bustling port, into which sailed vessels from all over the world, bearing fabulous cargoes. And with them in wildly variegated costume came men of all races, from every country. Orientals, Africans, Venetian merchants and American traders, all converged on the city. The streets resounded with the sounds of different languages. Rembrandt immersed himself in this riot of people discussing and interrupting each other in foreign tongues, selling and buying, trading in perfume, amber or cloth. Overwhelmed he soon discovered that the only common language, the one thread that bound all of them together, was numbers, that is, money.

One day he also would jingle gold coins in his hands, buy rich fabrics, jewelry, dress up like an Oriental potentate sporting a turban, or a heavy overcoat with a fur collar and gems stitched into the lining, or drape himself in a multi-colored coat and carry a long saber at his side.

In October 1962 Professor Horst Gerson, one of the leading Rembrandt specialists, uncovered in the vaults of the Musée de Lyons what is now considered to be the earliest authenticated painting of Rembrandt, *The Stoning of St. Stephen*. Acquired in 1844, it was never identified, and, as it was thought to be the work of a minor painter, it was never exhibited. It is, however, signed and dated "Rf 1625." At first glance it does not augur great things for its creator. It is strangely constructed, chaotic, with an abundance of superfluous detail, and the part of the canvas between the bright area, where the main action takes place, and the shadows encompassing the figures on the left, is overly intense.

Behind St. Stephen, whom the soldiers are in the process of stoning to death, Rembrandt has inserted his own face with his reddish features grimacing.

Who ordered this painting? Certainly no one from the Calvinist church. Was it a merchant or perhaps a collector? And why some months later did this same painter, who had just turned twenty, complete a strange scene inspired either by ancient history or the Old Testament, whose subject, a prince or a king condemning or absolving one or several knights, is unknown? (The painting, which is housed in the Stedelijk Museum in Leyden, has been tentatively identified as *The Clemency of Titus*.)

These beginning ventures were soon followed by more accomplished work: *Balaam's Ass* (Musée Cognacq-Jay, Paris) *Jesus Chasing the Money-changers from the Temple* (Pushkin Museum, Moscow), *Baptism of the Eunuch* (Archbishop's Museum, Utrecht), which was rediscovered in 1974, *The Flight into Egypt* (Musée des Beaux-Arts, Tours) and numerous engravings on religious subjects. Whom does he wish to impress with these strikingly dramatic works?

No one. It is a personal struggle; he remains alone, with his memories of his studies at Leyden, his passion for biblical history, his controversies with learned doctors. But it is necessary to live, and that

The Stoning of St. Stephen

Christ Chasing the Money-changers from the Temple

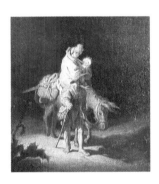

The Flight into Egypt

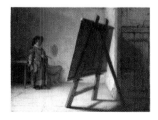

The Artist in His Studio

means to sell one's work, to sacrifice oneself to the tastes of the age, to the burghers' appetite for genre scenes and paintings of family life. Early on, Rembrandt paints *A Concert* (Rijksmuseum, Amsterdam), but it bears no resemblance to the intimate subjects that were the general rule in Dutch painting of that era. Enigmas abound. Why are these thick tomes of science or scholarship, that once were passionately read and reread, now dog-eared, crumpled and thrown to the ground like rubbish? Who is the oriental with dilated pupils, and long drooping mustaches, wearing an enormous turban and playing the cello with a dagger stuck in his belt? One could run into many similar types on the streets of Amsterdam.

Behind the richly dressed girl, who beats time while she sings, is an old, pensive woman. Is she the mother of the artist, who plucks the strings of a harp and wears an unbelievable hat decorated with feathers? He looks out at the viewer as if embarrassed by the masquerade.

But what is he looking at in *The Artist in His Studio* (Museum of Fine Arts, Boston)? He is standing, once again bizarrely dressed, in the shadow. A strong light shines on the easel and the painting, which we see from the back, but which Rembrandt, palette in hand, is in the act of contemplating or perhaps interrogating. Surrounding this encounter of man and his creation is emptiness. The studio is practically barren. Nothing except the artist's solitude and questioning. His meditation.

The painter, quite small, stands in the background, in the shadow. (The canvas was originally larger; two large pieces have been cut off from the top and bottom reducing the empty space of the studio and the floor.) The easel and the painting on it are brightly lit, but we do not see it. It is the adventure of the future, mystery. No doubt Rembrandt thought that we could imagine whatever subject pleased us. Let us not disabuse him of that notion.

In 1628 when Rembrandt was twenty-two years old, a lawyer from Utrecht, Arnoult van Buchell, noted: "The son of the miller of Leyden is being highly praised . . . prematurely." Was he being criticized for a certain arrogance at having already completed a number of works clearly different in composition, style and spirit from the rest of those of his compatriots? His friend and partner-to-be, Jan Lievens, also an ex-pupil of Lastman, had just arrived to work with him in his studio. The two represented the new style of painting in Leyden. Soon after, Gerard Dou arrived. Little by little Rembrandt changed his palette, emphasizing brown tones and the effects of chiaroscuro. *The Flight into Egypt* shines with a light not found anywhere else. He knows how to handle the striking scene of recognition in *Christ at Emmaus*, where Jesus is portrayed as a dark silhouette — an immense and moving diagonal of shadowy light — that expresses as much simplicity as grandeur.

Paradoxically, it is on the startled face of one of the disciples that the painter has concentrated all of the dazzling light, as warm as an autumn sunset on the Rhine.

But one ought not consider only the loftier aspects of the painting; Rembrandt presents the Resurrection but places it in counterpoint with a lowly spot of light, in which a servant is bent over his work. And above the pilgrim in the foreground a modest knapsack hangs on a hook. It is characteristic of the artist to present the mysteries of Christianity within the context of ordinary life. The blinding light of the miracle is not focused on Christ; it inundates a poor terrified man to whom, as if from within a cloud, appears the shattering presence of Life triumphing over Death.

This wonderful sense of setting, this charged atmosphere, which does not present a dramatic action as much as suggest and transcend it, is found in several of his paintings of 1630-1632. Of particular note are *Jeremiah Lamenting the Destruction of Jerusalem* (Rijksmuseum, Amsterdam), *The Presentation in the Temple* (Mauritshuis, The Hague) and especially *The Philosopher in Meditation* (Musée du Louvre, Paris) in which the sage sits in the golden light of a declining day in the hollow of his cell with its spiral staircase, which Valery compares to "the inside of a strange seashell." But isn't the source of the light the philosopher himself, whose entire being is turned within in silent reflection? He is Wisdom, as Rembrandt is Painting.

Rembrandt has now come into full possession

of his powers. He has established himself in Amsterdam. He moves into the house of the wealthy art dealer Hendrick van Uylenburgh and for one thousand guilders, probably left to him by his father, becomes his partner. At last he is part of a large city where art lovers are numerous, artists swamped with commissions and painting widely admired. Not only this, but in residence with a dealer who would become the publisher of his prints. Uylenburgh employed young painters to execute original commissions and copies; Rembrandt was kept very busy.

Van Uylenburgh secured for Rembrandt his first major commission, one which could make or break him, since it was a question of a corporate portrait, a kind of painting that was highly regarded in Holland. *The Anatomy Lesson of Professor Tulp* (Mauritshuis, The Hague) is a modern scene, in the sense that Rembrandt was painting a contemporaneous event, the first time he had done something of this sort. Furthermore it was a portrait of the eminent Professor Nicholas Tulp, city magistrate as well as surgeon, who twice had been elected to the head of the city council. He dissects the arm of a cadaver that lies nude on a table. He is neatly segregated from his pupils who are presented on the right in a pyramidal structure. Wearing a large hat, he discourses on the lesson, using his left hand to emphasize a point; the expressions on the faces of his students range from merely curious to deeply reflective. Two or three seem entirely engaged in the lecture, others show themselves less attentive, and some seem intrigued by the twenty-six year old painter at work in the dissection room. They surely have heard something of him and seem to regard him with as much interest as they do the work of their teacher.

The actors in this scene, Tulp in particular, were astonished by the final result. The portrait was unlike that of any other "anatomy lesson." Usually these tableaus were simply composed, stiff and compact. Here the scene has been transformed into a kind of liturgical event. Men are bent over a dead body, and the wisest among them explores death to offer a lesson about life.

The unexpected success of this painting was considerable. Amsterdam flocked to Rembrandt's door. Of the fifty works he would complete from 1632-1633, forty-six were portraits or studies of heads. These commissioned portraits all have their individuality, which make them worthy of note. But a day would come when he would only paint anonymous figures from that theater of shadow which is the source of painting, and a slash of light from who knows where, from the beyond, his true home, would hollow out their faces.

For his own pleasure he continued in this period of intense activity and success to add to his gallery of self-portraits, always conceived as studies in light and shadow. He would show himself in etchings as a beggar dressed in rags, or as an idiot, with disheveled hair, his mouth upturned in a kind of moue. Each time with a different expression: frowning, laughing, anxious, haggard. Or sometimes he would play the dandy and dress up in a lace collar, a hat with an upturned brim, his delicate strokes highlighting his features.

In oils he parades himself as an oriental potentate with turban, dressed in damask and rich fabrics, his dog at his feet, and at other times, perhaps out of respect for his clients as a Calvinist burgher dressed all in black. But most often he paints himself in everyday garb, with his curly mustache and slightly ironic glance, adorned with a gold necklace, wearing a hat also ornamented with gold. There is more than one source of light; it comes from his jewels, his face and the background, and as is his habit from the dark velvet of his cloak. In the self-portrait in the Louvre, one could say that he creates a space where the light that he receives can encounter the light that he radiates.

These self-portraits offer fascinating glimpses of the artist, particularly his fondness for theatrical props, often of an exotic and imaginary Orient — feathered turbans, velvet caps, strange trinkets and precious jewels. Certainly Rembrandt loved to dress up in costumes, but they were used not so much as an adornment as a travesty or a travesty of his double, the provocative, indulgent figure whose disguises were meant to shock the bourgeois society of Amsterdam. This image contrasts with the severe allure he sometimes possesses, as well as with the

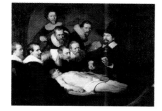

The Anatomy Lesson of Professor Tulp

portraits of himself at work painting, with his negligent appearance, his brushes and palette in hand and smock stained with colors.

This was not done as some have written out of a desire to abase or degrade himself, but as an act of defiance against the sacrosanct sense of propriety that all of his compatriots shared. Because he could do anything; after all he was the great Rembrandt.

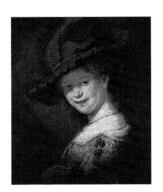

Portrait of Saskia Laughing

How could the twenty-one year old Saskia, the niece of van Uylenburgh, not fall head over heels in love with this fascinating provocateur, whom all Amsterdam embraced? She was an orphan, knew how to read and write, a rare accomplishment for women in that place and time, and brought with her a dowry of forty thousand guilders.

Rembrandt was immediately smitten. To show him that she belonged to him as much as his other love, painting, she offered herself by sitting for a portrait. But it is not with an expression of joy that she shows herself to us in *Portrait of Saskia Laughing* (Staatliche Kunstsammlungen Gemäldegalerie, Dresden). She does not laugh at all; she smiles with a slightly strained air, which wrinkles her round cheeks somewhat disagreeably. But her glance has a pretty sparkle from underneath her flowered bonnet. She seems to say: Here I am, the wife of the famous Rembrandt. They were married on June 22, 1634.

Happiness does not arrive unaccompanied. Scarcely had Saskia become his lover, when the Stadhouder Fredrick-Henry, Prince of Nassau, commissioned him through an intermediary, his secretary Constantin Huygens, to paint five episodes from the life of Christ. They are now housed in the Alte Pinakothek in Munich. Rembrandt was delighted. He had been waiting a long time for the opportunity to reintroduce New Testament scenes into an environment from which they had been exiled by the Reformation. He spent a number of years on this series of which the most moving painting is the first completed, *The Elevation of the Cross*. It is possible that he painted this on his own initiative in 1633 or 1634 before he received the commission and then tailored it to fit the order the prince had given him.

Under a stormy sky lit up in streaks a group of

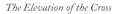

The Elevation of the Cross

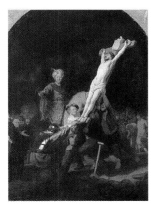

men hoist up the wood of the cross on which Christ is nailed. Rembrandt captures him as a striking diagonal of light in the darkness of Golgotha, where the crowd, the soldiers, the thieves, are no more than shadows, except for the High-Priest who presides over the proceedings. Simon the Cyrene, who came to Christ's aid in the procession to Calvary, has his arms around the cross as if to prevent the inevitable; his countenance is filled with grief and he wears an elaborate costume of an unexpected blue. He is Rembrandt. The painter also inserts himself into the *Descent from the Cross*. The Stadhouder and the public were astonished. It was not an accepted practice for a painter to include himself in the depiction of sacred subjects, especially in such a provocative and visible fashion.

What is Rembrandt trying to say? That each person is an accomplice to this crime. "That His blood falls on us and on our descendants." And now the blood from Christ's nailed feet has splattered the cloak of this son of a miller. Rembrandt identifies himself with his fellow-men, all accomplices in this death that takes away the sins of humanity.

There is without question something surprising in his demeanor, in the familiarity with which he treats the Passion and the mysteries of the Crucifixion and Resurrection; but should we reproach him for this? Rembrandt did not include himself in the other paintings in this series. One of the last he worked on was *The Entombment*, completed in 1639. The painting is broken up into three zones of light, in the upper right corner (not shown in the detail on page 72) light from the setting sun illuminates the three crosses against the sky, the light of an overturned lamp shines on the grief-stricken group of holy women and flickering candlelight projects trembling flames on the body of the shrouded Christ.

It is the time when the mourners carry his body held up by the winding clothes down to the tomb. It resembles the scene just a short while before when he was crucified. The workers are panting, their muscles strain, they groan with effort. Some because they want to get finished with an unpleasant task, others out of love for this man they call the Son of God. Rembrandt envisions it as the moment when the last rays of the sun fall upon the earth, revealing only fragments of the scene, the time to light the lamps. For Rembrandt is the

painter of evening, not only in the landscapes he painted during this period, but also that of life, the third age of man, represented by venerable figures from the Bible, philosophers deep in meditation and the notables of Amsterdam.

During this period he painted numerous portraits of Saskia: beautiful, animated, costumed as Flora, Minerva, Artemis, with plumed hat, or veil, adorned with jewels. There is an etching of her with the artist nearby working in his lovely studio on Bloemgracht where the couple resided after living for a while on Binnen Amstel. Then on May 1, 1639 they moved to a great house nearby that of Hendrick van Uylenburgh on the Sint Anthoniesdijk in the Breestraat, location of the present day Rembrandt House, number 4-6 Jodenbreestraat.

Rembrandt did not choose to live in one of the fancier residential neighborhoods of Amsterdam, but rather near the Jewish Quarter, which was not as isolated as the ghettos in some European cities. On the other side of the canal was the artists' quarter. There were many small shops of cloth sellers and embroiderers in the neighborhood where he acquired fine fabrics and exotic objects. He took many of his models from the Jewish community. To those who criticized this unusual behavior he said, "When I wish to relax my mind, I look for freedom, not honor."

There were indeed many ill-wishers who wanted to equate his household arrangements with the libertine tone of the picture painted in 1634-1636 and entitled without any real evidence *The Prodigal Son* (Staatliche Kunstsammlungen Gemäldegalerie, Dresden).

It is true that Rembrandt's work of this period is filled with ambiguities. The bon vivant with plumed hat and sword at his side laughs heartily, raises his glass for a toast, a frolicking girl sits on his knees. By them on the table is a plentiful dinner. Is this a tavern scene? Towards whom does the man turn? Whom does he challenge in his hilarity with his glass brandished on high? His in-laws accused him of squandering the dowry of his wife on expensive arms and armor, luxurious clothing, paintings and prints, a stupid accusation since he was rich in his own right. And so it remains a mystery. Certainly it is a bit difficult to imagine that Rembrandt dared paint himself reveling with his wife on his knees. But it is not entirely a provocation. His inter-

est in the subject is demonstrated by his handling it in an etching done in same year. Here the atmosphere is entirely different.

His *Samson Blinded by the Philistines* (Städelsches Kunstinstitut, Frankfort) is a distillation of horror, but the *Danae* in the Hermitage, which he would rework a number of years later, is a beautiful nude caught as if surprised by the painter, as is his *Susanna Bathing* (Mauritshuis, The Hague). His *Angel Raphael Leaving Tobit* (Louvre, Paris) is entirely centered on the significance of the divine represented by the striking figure of the angel. It would be a prelude to several works on biblical themes. In the next few years he painted landscapes with vast, stormy skies, and portraits among which are those of the merchant and officer of the Dutch East Company, Philips Lucasz (National Gallery, London) and his wife Petronella (Private Collection, New York), of Anthonis Coopal (Neumann de Vegvar Collection, Greenwich, Conn.) agent of the Stadhouder, of Coopal's brother-in-law Jan Pellicorne and his son (Wallace Collection, London) and an arrogant character with his hand on his hip called *The Standard Bearer* (Private Collection, Paris). And always paintings of himself.

In December 1635 Saskia gave birth to a son. Rembrandt was exultant, but the baby died in February. Three years later in July of 1638 a daughter, Cornelia, was born, but she lived for only a few weeks and the same sad fate was in store for their second daughter born in July of 1640. Only their fourth child, Titus, baptized on September 22, 1641, at the Zuiderkerk, survived. The couple's new residence was a spacious, gabled house. Its three floors provided the painter with room enough to house his growing collections of art and accessories.

There was only a brief space of happiness around the cradle of Titus, for on June 14, 1642, Saskia died of consumption.

In his studio, despite the anxieties, hopes and pain of the long illness stood an immense canvas that he continued to work on. It shows Captain Banning Cock ordering his lieutenant Willem van Ruytenburgh to take their company out on its rounds. This painting under the misnamed title *The Nightwatch* (Rijksmusem, Amsterdam) has become one of the world's most famous paintings. Nonetheless it cannot be numbered among Rembrandt's greatest.

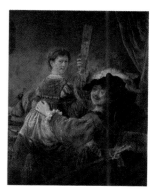

The Prodigal Son

The Nightwatch

Samson Blinded by the Philistines

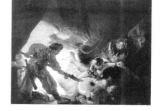

The action of *The Nightwatch* unfolds, in fact, in daylight, at dawn of a summer's morning. The entire company is in movement with a great tumult of swords, drums, spears and muskets. The flag bearer waves the standard aloft. The captain is dressed in black crossed with a scarlet scarf, the lieutenant in yellow, the musketeers in red, and the cloak of the drummer is deep green. Rowdy street urchins, one of whom is a pretty young girl with a hen tucked in her belt, glide in and out of the chaotic crowd.

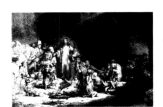

The Hundred Guilder Print

This troop is not posed; it marches toward the viewers, that is toward us. Although the painting has a certain grandiosity, it lacks the extraordinary aura of Rembrandt's religious works, his meditating philosophers, *Christ at Emmaus* or *The Jewish Bride*. The golden mist that surrounds it is only the lighting of a parade. Perhaps the subject did not merit the "sacrament of light" in Claudel's well-chosen words. Rembrandt, preoccupied with Saskia's illness and death, may not have been that interested in the false epic overtones of the bold posturing of these cavaliers. Holland was not at war, at least on land, and martial displays were confined to parades and shooting competitions.

The company, who commissioned the painting, felt that the portrayal was not sufficiently dignified and turned it down. The sand was beginning to run out of the glass. First the death of three children and soon after his wife, then the bitter rejection from Captain Cock, and finally, solitude.

In his atelier, crowded with marvels, Rembrandt painted a double portrait of Saskia and himself as a kind of exorcism. Amsterdam, which had never doubted his genius, began to voice certain reservations. Now he could be seen wandering through the countryside with the wind blowing through the folds of his cloak. During the nights, while Titus slept, Rembrandt engraved his *Landscape with Three Trees* and began work on *The Hundred Guilder Print*, completed in 1649. It was clear that Titus needed the presence of a woman, and Rembrandt hired a simple peasant, Geertje Dircks, widow of a bugle-player. Almost as a matter of course she became the painter's lover as well as his son's nurse. This helped to restore calm to the household but at the same time provided material for those inclined to gossip.

In his two paintings of *The Holy Family*, one at

The Three Crosses

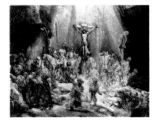

the Hermitage and the other in Kassel, and two versions of *The Adoration of the Shepherds* (London and Munich), Rembrandt uses his customary technique of modeling groups of figures with light. Rembrandt's light is neither that of the sun nor of an artificial source. It softly plays on the contours of faces, hands, everyday clothing and the ordinary objects in the crèche or the carpentry workshop of Joseph, and renders them all supple and vibrant.

There is nothing pious about the evangelical scenes that Rembrandt painted; they pay close attention to the humble and familiar. But they shine with a "glory" — in the way that mediaeval art enveloped Christ's entire body in an aureole of light — that is translucent and radiant. Luminescence scatters the shadows in the etching known as *The Hundred Guilder Print* (one hundred guilders was the amount, according to the historian Mariette, that Rembrandt had to spend to buy back this work at auction). Its real title is *Christ Healing the Sick*. The successive states of this work make clear Rembrandt's ambition: to realize, by enlarging his conception of the scene from one state to another, a great tapestry, where through the opposition of light and shadow variations on the same theme issue forth.

At the center of this astonishing assembly, which consists of bourgeois skeptics and ironical doctors of the law, as well as women offering up with trembling hands their children to be healed, sick people lying on the ground and aged cripples dragging their deformed limbs, stands Jesus. He welcomes all with benevolence and majesty. Rembrandt knows and affirms that He truly is the Son of God.

Throughout his life from his early attempts in 1626-1627, Rembrandt worked on engravings. His scenes of Christ on the cross all share a similar viewpoint, in that they make him the center of the composition; around him is the tattered darkness. Dead, he triumphs nevertheless as light. The technique of painting no longer attracted Rembrandt; now he was dreaming on copper. This visionary and emotional reverie was nourished by grief, roadblocks, and misfortunes of all kinds that kept multiplying for the rest of his life. Geertje Dircks fell ill and made a will in favor of his son, Titus. She then brought suit against Rembrandt for breach of contract. He in turn did not hesitate to bring before the

tribunal his new housemaid Hendrickje Stoffels, who had recently supplanted the plaintiff in Rembrandt's affections, to testify against Geertje. The murmurs of Amsterdam society grew louder.

It was said that he had wasted his inheritance from Saskia, which should have paid for Titus's education, on expensive purchases of art, arms, luxurious fabrics, prints — some of them certainly erotic — and medallions. The van Uylenburghs were outraged, and plotted against him. Now Rembrandt, learning that Geertje was trying to sell jewelry in her possession that had once belonged to Saskia, brought her to court . . . for immorality. This was a clear provocation, but Hendrickje was young, twenty years younger than he, and ardent and beautiful.

Rembrandt painted her with the same enthusiasm with which he had once painted Saskia. She is often solemn with a slightly forced smile, she wears brilliant pearl earrings and pearls around her delicately veiled throat (Louvre, Paris). And like Saskia, she becomes Flora. She will also model, though not with her name appearing, for *Woman Bathing in a River*, (National Gallery, London) daringly lifting her skirt, and *Woman at a Window* (Staatliche Museen, Berlin).

Twenty years after first painting *Christ at Emmaus*, Rembrandt took up this theme once again (Louvre, Paris). He had in the interval engraved it many times, but this new painted interpretation of the revelation of the Resurrected Christ serves according to Fromentin "to establish once and for all the grandeur of man." It differs from the first in the sense that Jesus has not yet revealed himself to the disciples he meets on their way to the inn. They do not know that he is the victor over death. But he is set apart by his emaciated and mournful face, by the two pieces of lamb bone brought to him on a plate by a servant, by the overturned empty glass, and the dog gnawing on a bone. All of these bear a symbolic weight.

One of the pilgrims, with his back toward the viewer, has perhaps a vague intuition of the miraculous presence. Hesitating, he joins his hands together, while the other pilgrim shown in three quarters seems seized by an inexplicable stupor, and with a brusque movement places his napkin on the table-

cloth. This turns out to be not the modest linen of a country inn, but a communion napkin embroidered in gold — the only part of the canvas starkly lit. Rembrandt has captured just that moment when divinity returns to the world. Breaking bread and encircled by an otherworldly light, Christ is about to make himself known.

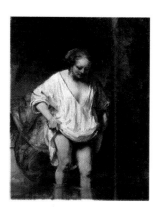

A Woman Bathing

Behind him is a vast space in which gradations of light divide the architecture, fill it with shadow. All is silent. This range of light is replicated in the shades of emotion apparent in the postures of the disciples: surprise, reflection, interrogation. The essential is communicated without any dramatic emphasis; neither contre-jour nor oblique light marks this canvas as they do the earlier one. The influence of the Italian masters is seen in this painting, notably in the frontal pose of Jesus. Despite the absence of a central axis the work is symmetrically balanced.

Jesus, Son of God, made flesh, condemned, crucified, resurrected is the painter's obsession. Because he is light. Not natural but supernatural light— "Light born out of light," in the words of the Credo — and that situates him outside of time and the phenomenal world. If he is the Truth, and Rembrandt does not doubt this, his nature can only be suggested never fully represented. In subjects of such precision as *The Elevation of the Cross*, *The Entombment*, *Chirst Healing the Sick* and *The Three Crosses*, the painter substitutes painting itself for the subject that cannot fully be painted. Gilded ochre tones reflect fire, copper and silver; Venetian ivory mixes with the pale purple and orange of sunset. Light from another world.

The light in *Bathsheba* is entirely different from that of Christ. The young woman — Hendrickje Stoffels no doubt — that King David discovers in his palace and immediately summons into his presence, is fully flesh and blood. She does not radiate light, rather she absorbs it. Nude, with head bowed, her face is sad, she is seemingly on the verge of tears. Her breasts are uncovered as is her smooth stomach. Her thighs are firm if a bit heavy. Her hand rests on a white sheet whose folds are exquisitely contoured. David was seduced by this beautiful woman, but the narrative pretext for the picture is almost beside the point. This sumptuous nude exhales a promise of love. She is passionate, filled with sensuality, and the painting, the texture, the colors all are of equal

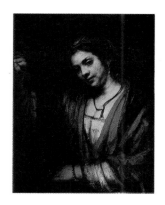

A Woman at a Window

magnificence. "Rembrandt knows that flesh is the clay out of which light manufactures gold, " wrote Paul Valery.

Everything in this picture speaks of desire and the glorious pleasure of life. It would be his last such painting.

While Rembrandt was working on *Bathsheba*, he learned that Hendrickje was pregnant. The Ecclesiastical Court of the Reformed Church had just come into session (June 25, 1654) to declare that the young woman was prostituting herself with the painter. The couple was summoned to appear before the court. When they didn't show up, they were called a second time. Finally Hendrickje, thoroughly frightened, agreed to come forth. She was roundly chastised by the court, treated as a prostitute and prohibited from taking communion.

Rembrandt was still trying to pay off his house. His creditors were descending upon him from all sides. In addition a Portuguese merchant, Diego Andrade, who had commissioned him to paint a portrait of his daughter, was dissatisfied with the final result (he said the likeness wasn't good enough) and refused to pay for it. Who would have dared to treat Rembrandt that way in his prime?

Hendrickje gave birth on October 30, 1654, to a girl named Cornelia, after the daughter that Rembrandt and Saskia had lost. The ecclesiastical court took advantage of the situation to pressure the couple into marrying. But if Rembrandt agreed, he would lose the benefits of Saskia's legacy. Though Hendrickje wanted to get married, she resigned herself to their unsanctified living arrangement. In the eyes of the church she remained a whore who had married a pariah.

The great Rembrandt had become an outcast from Amsterdam society. From the church because he had thumbed his nose at its law, from society because he could not pay his debts. Looking to pass on the title of his house to his son Titus, he was declared legally incompetent. A guardian was named to determine the best way to deal with matters between between father and son.

It was rumored that Rembrandt had engaged in some shady practices in selling his paintings. His commissions were coming with decreasing frequency. In 1653 he received an order from a noble Sicil-

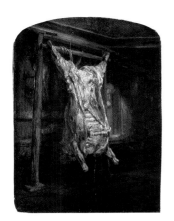

The Slaughtered Ox

Aristotle Contemplating the Bust of Homer

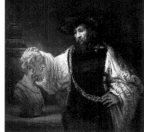

ian, Don Antonio Ruffo, for a work that would become *Aristotle Contemplating the Bust of Homer* (Metropolitan Museum of Art, New York). To forget his own anxieties and grief he executed several portraits of Hendrickje and himself. In a self-portrait of 1652 he wears a paint-spattered smock. (The Rembrandthuis has a similar drawing in which he wears an odd top hat.) In 1655 he is seen sporting a large black beret and a gold chain, and in one painting a garnet-colored breastplate.

In 1655 he painted Titus as well. The boy was now fourteen years old. His lovely blond hair curls under a dark red hat; his look is open and honest. He sits at his desk, in a kind of reverie, his chin resting on his hand (Museum Boymans-Van Beuningen, Rotterdam). Probably he is in the midst of doing his homework, since he was attending school at the time. He was not, however, destined for university. What is he thinking about? Perhaps his loving but eccentric father. Rembrandt would spend hours in the countryside walking up and down the dunes. Because billowing wind spread his long cloak like a pair of wings, the country folk nicknamed him the "owl." He would receive strange guests: rabbis and levites from the neighboring Jewish quarter, merchants from Venice and the Levant and Orientals from the Zeedijk, the international quarter in Amsterdam. These were his models in these unhappy years. Certain members of the Mennonite community, to which sect Hendrick van Uylenburgh belonged, were also frequent visitors. But the painter never joined this group. Their code of discipline was even stricter than that of the established church, and they would never have received a man who was considered to be leading an immoral life.

Rembrandt's contemporaries would have been surprised that *The Slaughtered Ox*, now in the Louvre, which Rembrandt completed in 1655, was called "disgusting" and "vulgar" when it was put on view at the end of the eighteenth century during the sale of the collection of Pieter Locquet. For them it was an example of the still life genre, linked to a theme with which they were very familiar, that of the transitory nature of human existence. The combination of still life with symbols of death and dying was very popular and formed a sub-genre, called *vanitas* painting. Is it this that Rembrandt wished to signify in portraying this huge bloody side of beef, behind which stands practically unnoticed a woman

in the shadow of a doorway, placidly looking on? But who or what is she looking at? The enormous carcass whose flesh still seems to pulse with life or the painter who has crept into this sordid back room? Or perhaps, as Malraux would have it, she looks at "the deaf presence of a universe of which this image is the embodiment, as if a moving symphony of plastic form was distilled in this bleeding piece of meat?"

The Slaughtered Ox is unusual and unexpected, almost an anomaly in Rembrandt's oeuvre. This gaping carcass is composed of flesh of muddy gold, of coagulated blood that blends colors and values. At the same time the structure of the painting has certain baroque elements. The uneven brushwork, thick and oily, builds up the mass with a formidable strength. This dead meat preserves its animation through the heavy unctuous workings of light. The artist has gone over it with his trowel, his brush and perhaps his fingers.

Visionary of the material world as much as he is of sacred things, the master of Leyden remains a mystery in the purest sense of the word. *The Slaughtered Ox* has fascinated writers and particularly, painters, many of whom, including Delacroix and Soutine, have made copies of it.

On July 29, 1655, Amsterdam celebrated the opening of the new town hall, the Stadhuis. The artists who received commissions for interior decor included Jordaens, the spiritual heir of Rubens, Govaert Flinck, Ferdinand Bol and Jan Lievens. Rembrandt was forgotten or perhaps deliberately passed over. Had he as a painter, aside from all of his personal problems, become passé?

Jan Lievens, his old friend and partner, was now the painter of the hour. Lievens had successfully imitated Rembrandt's style early on. But during a protracted sojourn in Anvers (1635-44) he had come to emulate Rubens, Brouwer and Van Dyke. Their influence can be felt in his portraiture, his allegorical works and his landscapes with their fantastic lighting. Despite hard times Rembrandt still had a small circle of faithful friends, but they could not stop his slide into financial distress or the sale of the collection of art that he had accumulated over a lifetime. His financial problems continued until finally the painter went belly up in 1658.

Despite his continuing misfortunes, he was called upon to execute a painting for Dr. Johan Deyman, a second anatomy lesson (Rijksmuseum, Amsterdam). Sir Joshua Reynolds, who saw the work before a fire destroyed most of it in 1723, judged that the colors evoked those of Titian. The foreshortened corpse is inspired by Mantegna's famous rendering of Christ, of which Rembrandt possessed an engraving.

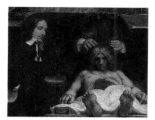

The Anatomy Lesson of Dr. Johan Deyman

The gratitude of his patrons for this painting (a Rembrandt drawing also in the Rijksmuseum done after the work shows its original state) only provided a brief respite. He was forced to hold more and more sales to save whatever he could, but all in vain. In front of his heavy Venetian mirrors, which he had had brought to him from Italy, Rembrandt looks at himself. It was his habit to do so at important moments in his life whether for good or for bad. His self-portrait of 1659 (National Gallery, Washington D.C.) is of a defeated man, his shrunken face unspeakably anguished. But in the self-portrait of the following year, now in the Louvre, he has regained his composure. He sports a white cap, and holds his brushes and palette in hand. His look seems to say: "If the man has been buried and forgotten, the painter still remains at his easel." Serene, resigned? No, rather, distant.

All that had happened, the pack out to get him unleashed, his creditors working to take away his home and whatever standing was left to him, the loss of his collections, and the exhaustion of all his financial resources, all of it no longer mattered. His family, Hendrickje, Titus and little Cornelia built up a kind of wall that surrounded him. The painter was no longer engaged in this world; he was absorbed in another, that of the Bible and the Christian mysteries over which God reigns and in which the painter's indomitable genius found its home. In this dreamlike world bathed in the dust of the centuries, the "owl" rediscovered the companions of his solitude: Jesus, the philosophers, prophets and even the saints, whom the Reformation had discarded.

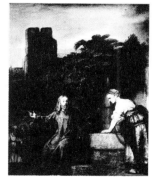

Christ and the Samaritan Woman

He painted *Christ and the Samaritan Woman* (two versions both signed and dated 1655, one in the Metropolitan Museum and the other in the Staatliche Museen Gemäldegalerie in Berlin), *Jacob Wrestling with the Angel* (Staatliche Museen

Christ and the Samaritan Woman

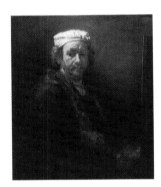

Self-Portrait

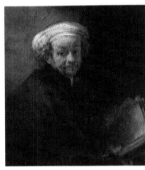

Self-Portrait as the Apostle Paul

Gemäldegalerie, Berlin) and *Moses Breaking the Tablets* (Staatliche Museen Gemäldegalerie, Berlin). During this period he continued to produce self-portraits. He presents himself wearing a rather strange white turban or a large black beret. He has the slightly bemused air of one who has seen the worst of what life has in store for him. In the self-portrait now in Kenwood House in London, his clothing, hair and the hand holding brushes and palette have been painted in broad strokes and in places look like they have been wiped with a rag. In the self-portrait entitled *Rembrandt as an Old Man in front of His Easel* (he was not even sixty at the time) the diagonal starkly divides the brightly lit area of his head from his hands. They hold the tools of his trade and are cast in the shadow. Only the face, this fine stew of red and copper color, bristling with hair, with its flabby cheeks and big red nose, has been carefully worked on.

In his extraordinary *Self-Portrait as the Apostle Paul* (Rijksmuseum, Amsterdam) the painter seems astonished or at the very least perplexed. He furrows his brow under a turban of yellow silk. His features are worn with experience. His mustache and beard are graying as is the hair at his temples. His lips are pressed together partly concealing his missing teeth.

With each self-portrait the contours of the face, the features and the expression change. It seems that each time we are seeing a different model. He paints his face by thickening out gradations of light, or by twists and turns that create more somber and hollow tonalities, by contrasting puffiness with volumes underlined by the smooth curves of his mottled cheeks. From his dark eyes with their deep circles he looks at the viewer. Yes it is the same man, but the self-portraits taken as a whole demonstrate an extraordinary range of emotions. Who does not see in his shifting expression, sometimes anguished, sometimes confident, doubtful or surprised his never-ending dialogue with the divine? In each self-portrait the painter shines his spotlight on the nuances of his facial expressions.

On December 15, 1660 an accord was reached in front of a notary between Rembrandt on one side and Titus and Hendrickje on the other. Rembrandt agreed to turn over to them all the ben-efits of his work including responsibility for and profits from all sales. He gave up the right to engage in any business dealings whatsoever concerning his own artwork. They on their side agreed to house and care for the aging painter.

Why then should they keep their great house, which the painter would wander through forlornly? He had nothing, not even his own paintings and engravings belonged to him. Whether one liked it or not Rembrandt was the greatest painter in Holland; his work was sought out by merchants and dealers; poets dedicated verses to him. He had even won the grudging respect of Amsterdam society for his dignity in the face of adversity. And yet it was solely due to the intervention of his mistress and son that he was able to survive. He owed them everything and was at their mercy.

The beautiful house on Breestraat was too large, too empty and too costly to maintain. Hendrickje found a small cottage on the Rozengracht in the west part of town where the now humbled artist could reside with his family. Around them were shopkeepers and small businessmen. They looked at the "owl" not without surprise and some pity, as he wandered down the thoroughfares and along the quays bustling with the activity of a thriving urban center. Sometimes he would venture into the Doolhof, a popular park on the other side of the street, where he and his daughter Cornelia would mingle with the noisy crowd. On one of his walks he climbed up to where he could see a panorama of the Amsterdam that had rejected him. His friends advised him to move to England or Italy, but he wouldn't leave. Govaert Flinck, who had received the important commission for painting the new town hall died in February of 1660. Rembrandt for reasons that remain unknown was chosen to replace him. His work was to be on a grand scale, five meters by five meters, with an arch at the top, designed to cover the outside of the Grand Gallery. This work is entitled *Claudius Civilis* or *The Conspiracy of the Batavians* (Nationalmuseum, Stockholm). The episode comes from Tacitus. In the course of a banquet the chief of the Batavians, Claudius Civilis, called for an uprising against Roman rule, and took a vow along with his followers to drive the Romans from their country. As the Batavians were held by tradition to be ancestors of

the Dutch, the painting could be read as the first salvo of independence from the land that had become the Netherlands.

This heroic act of defiance was transformed by Rembrandt into a hallucinatory meeting of phantoms clothed in gold and purple. The picture bristles with swords around the double-edged blade of Claudius, who is seen as a monolithic giant wearing an incredible, tiered tiara. From the banquet table a strange light seems to rise up and violently illuminate the conspirators, who are densely rendered by rough brush strokes or by the palette knife with clashing thicknesses. This light silhouettes the brown shadows of the foreground. As Malraux observed: "This historical painting was no more destined for city hall than Rembrandt's religious works were for Dutch churches." This powerful glorification of a one-eyed man decked out in cast-off clothing from some flea market (the same costume Rembrandt wears in his majestic self-portrait of 1658, now in the Frick Collection in New York), flanked by specters in chiaroscuro was violently at odds with the official conventions of lighting. It revolted the noble gentleman of Amsterdam. They took it as an affront to their good taste.

This banquet that evokes a mysterious ceremonial with a wholly otherworldly quality was hung in the Stadhuis for a brief period and then taken down. Rembrandt brought it home and, in order to sell it, cut it apart. Only the center portion has survived. No one made any comments about it to Rembrandt, nor was he asked to refund the payment. His canvas was replaced by a mediocre work of Jurgen Ovens, one of his ex-pupils, after a sketch by Flinck. This new *Conspiracy* was widely admired.

His career was finished; that much was clear. The art world also had banished the moral outcast.

On August 7, 1661, Hendrickje made her last will and testament before a notary. She named her infant daughter Cornelia as her sole heir. Rembrandt was to become the child's guardian with the usufruct of her inheritance. Titus drew up a will at about the same time. Did they have some premonition about their fate?

Rembrandt completed about twenty canvases in 1661. Among them were many portraits of unidentified people: friends and neighbors perhaps, a monk, a young Jew, a man with a falcon, two Africans, as well as a portrait of Jacob Trip and his wife, heads of Christ and the Virgin, *The Circumcision* (National Gallery, Washington DC) and *Alexander the Great* (Gulbenkian Institute, Lisbon). He was commissioned to paint *Pallas Athena* by Don Antonio Ruffo, who also bought a painting from him in the following year entitled *Homer Dictating to a Scribe* (Mauritshuis, The Hague).

Rembrandt also continued work on religious subjects, painting for himself apostles and evangelists. In his *St. Matthew and the Angel* (Louvre, Paris), which was not destined for any church, the celestial envoy has the features of Titus. (A comparison of this work with a portrait of Titus painted in the same year is revealing.) The pensive old man with his ravaged face is not Rembrandt, but rather his double. The gesture of his hand on his chest seems to speak for the painter himself in his misfortune: "Is it to me Lord that you wish to speak?"

There are five of them. We cannot be sure of their names, but the painting tells us all we need to know of their characters. Theirs are the predatory faces that the painter, who would immortalize them, surprises in the midst of their discussion of money, commissions, assessments and financial contingencies. These speculators are the directors of the Cloth Guild, and Rembrandt is the painter.

There is nothing recherché about the effects of light, no innovation in their traditional pose or the arrangement of figures on the canvas. For this commission, unlooked for after so many disappointments and humiliations, the painter keeps himself firmly in check. Behind a table covered by a fine garnet-colored cloth are the five businessmen and one employee. The syndics all done full face, well dressed in high collars and large hats, look out toward the painter. Only the servant with a bare head keeps his eyes down.

There is no movement; the space is bounded and limited by a finely rendered wood paneling. The group of figures has a pyramidal construction. One of the syndics holds a book, those in the middle of the painting are leafing through another — accounts no doubt — a third one holds a fat purse. The discussion has been interrupted; all is silence. There is

The Conspiracy of the Batavians (or Claudius Civilis)

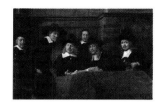

The Syndics of the Cloth Guild

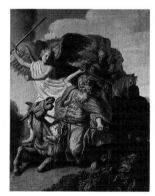

Balaam's Ass

nothing more to resolve; they simply look at the viewer. But the painter has worked his magic.

In their glances. Enigmatic, unusual, ambiguous, curious. None of the figures are looking at the same point, but all of them except for the servant, have in their attention, perplexity or surprise the same intensity. It is their glances that bridge the gap between the world of these secure, powerful and self-confident men and that of this downtrodden painter. Night comes; the sitting is over, he walks home across Amsterdam to his shabby dwelling. Does he notice the pallor and the hollow features of Hendrickje? Household cares, the education of Cornelia, as well as the small art business which she has started up with Titus have worn her out. *The Syndics of the Cloth Guild*, (Rijksmuseum, Amsterdam) painted in 1662, was hung in the guild hall, where drapers, silk and wool merchants and others working in the textile industry had their offices. The painting was well-received. It conformed to the conventions of the genre and the wishes of the models.

Why after his Claudius Civilis was rejected by the city fathers, did the powerful cloth guild ask him to do their portrait? Everyone knew of his misadventures, his financial problems, his condemnation for immorality by the church. And yet, despite everything, he was a famous painter, the most illustrious of the Lowlands. His work was still being handled by important dealers in Amsterdam, Rotterdam, Leyden and Dordrecht. Art lovers and collectors of the highest rank in society, such as the Stadhouder Frederick-Henry and Archduke Leopold, former governor of Belgium, recognized his genius. In Germany, Italy and England, where King Charles I had purchased several of his paintings, he was known and admired. In 1641 in Paris the French painter, Charles Vignon, saw *Balaam's Ass* in the home of a collector. He wrote Rembrandt to let him know that he had "appreciated it."

On December 29, 1667, Rembrandt received a visit from the grand duke of Tuscany, Cosimo de Medici III. His secretary, Corsini, briefly records the encounter with "Reinbrent the famous painter," in his journal, but he seems much more interested in the weather. Did the duke buy anything from Rembrandt? We don't know. Perhaps he brought back with him a self-portrait painted in 1664 that can now be found in Florence.

The students and imitators of Rembrandt developed his style and applied his "manner" too often by rote, producing pastiches of his themes. In a time when the "true" and the "false" were not in as stark opposition as they are today, works inspired by, and even forgeries, were a way of honoring one's master. "The school of Rembrandt" did, however, give birth to a rich and diverse body of work. Even in the last dramatic period of his life the painter continued to have pupils and followers.

On July 21, 1663, Hendrickje died.

An old man, a small child and youth of twenty-two years stood by the grave in Westerkerk, then returned home, Rembrandt with tears in his eyes and back bent. And once again he took up his brush.

A wealthy jeweler and collector, named Hermen Becker, had lent Rembrandt money that he could not repay. As compensation for the outstanding debt, he painted *Juno* (Middendorf Collection, New York). It was difficult for the painter to concentrate, but he finished the picture in the spring of 1664.

For the rich businessman, Frederick Rihel, he executed one of the only equestrian portraits done in Holland. His dapper patron, dressed in a yellowish gold, with pistols and sword at his side, sits smartly on his prancing steed in an autumnal park (National Gallery, London). The rider holds a token that makes it clear that he belonged to the honor guard of the young William III, when he arrived in Amsterdam in 1660. It is superb if you like equestrian portraits. At any rate one has to live. Rembrandt's obsession with collecting reemerges at this time. When Titus won back 6,000 guilders in a case involving the sale of Rembrandt's possessions, the painter bought a work by Holbein the Younger and dreamed of buying the house on Rozengracht, as the owner had just died.

There is nothing wrong with dreaming.... But one evening as he was painting another portrait of his son, he discovered something that had been hidden from him by all of his misfortunes, work, the trying circumstances of the previous few months, and most of all the other world that he had retreated into. Titus was sick, only a shadow of his former self. Rembrandt painted him, emaciated, glassy-eyed with prominent cheek-bones. This portrait of

Titus at age 23 is now in the Dulwich Picture Gallery in London.

An exceptional portrait, powerful in its psychological depth, its truthfulness, sensibility and mastery of pictorial means. It hammers away at the mask, claws at the clothing it seems to lacerate and tear to shreds. The contrast is striking with other portraits of the same period that were no doubt painted to order, such as *Man with Gloves*, and *Woman with an Ostrich Feather Fan* (both in the National Gallery of Art, Washington DC), *Portrait of Jeremiah de Decker*, a poet of the day, (Hermitage, St. Petersburg) and a portrait of the painter Gerard de Lairesse. All of these were much closer in spirit to the conventional style of Netherlandish portraiture, which was also the European style of the time. Rembrandt could paint anything. In the last years of his life he succeeded in placing himself among the greatest portrait painters of the day. The era of defiance and provocations had ended.

How to account for the *Jewish Bride* (Rijksmuseum, Amsterdam)? Certainly it is one of the most beautiful paintings of all time, "painted by a hand of iron," wrote Vincent van Gogh to his brother Théo. But beyond that? No one knows who is being represented in the painting, if she is in fact any particular person, or whether this was a commissioned work. The painter returns here to familiar ground, that of the Old Testament, and perhaps evokes the marriage of Isaac and Rebecca, which prompted some unknown person to give the painting the name that has remained with it. Let us look closely at this work. A couple in red and gold stand against a rather confused landscape. The couple's hands are intertwined on the breast of the young woman. The man looks on protectively, while she seems immersed in a dream.

The scene is opulent, admirably modulated, worked over with brush and palette knife. The woman's dress is a long and heavy carapace of a beautiful garnet color both textured and polished. It conceals almost her entire body. This is because she is pregnant; the flower she holds with her right hand on her stomach clearly indicates this. Her countenance is serious, she trusts in the tenderness that her husband shows her, his one hand resting protective-

ly on her breast and the other on her shoulder. This masterpiece is a poem of love.

Rembrandt had lost his three life companions one after the other. Titus although stricken with tuberculosis, as his mother had been, was about to marry a young girl, Magdalena van Loo. Their marriage would produce one daughter. In the hands of the artist love was tenderness, trust and hope. It was also color, shining silk, fine embroidery, rich red cloth and light. Deep rich color builds up the painting's volumes. A hot golden light emanates from the couple, mortal flesh that the gift of new life magnifies. Their glances do not meet, for the man looks at his bride, while she is contemplating the future that she carries within herself.

Rembrandt had lost three of the children Saskia had given him. Titus, who was wed on February 10, 1668, died in September of the same year. The child with whom Magdalena was pregnant was born in March of 1669, a young girl named Titia. Does the *Portrait of a Family* (Staatliches Herzog Anton Ulrich-Museum, Brunswick), which the painter left unfinished, represent them?

In this painting a young woman holds a baby girl on her knees. If it is Magdalena then beside her stands Cornelia, as well as her brother-in-law Francois van Bijlert and his son, who would later on marry Titia. The thick coloration of the dress of the young widow, quite similar to that of *The Jewish Bride*, is, like the child's clothes, created with broad strokes that in some places scratch the material.

Magdalena, no doubt infected by her husband, would die only a few months later.

Rembrandt achieved a great deal of success with his engravings, which were easy to sell. Before his financial problems overtook him, he bought certain of them himself to bump the price up before reselling them. But part of the settlement he was forced to sign required him to renounce all speculation in his own works, something that was frowned upon. A number of works inspired by the Old and New Testaments date from the years 1654-1660. In the extraordinary *Descent from the Cross with Torches* and *The Entombment*, the obscurity intensifies with each successive proof, until the terrifying shadow of the tomb weighs upon the broken body lit only by one last ray of light. This progressive deepening of shadows characterizes Rembrandt's last period of working with etchings, but does alternate with some

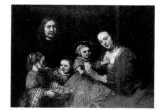

Family Portrait

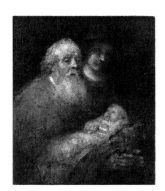

Simeon in the Temple

brighter scenes such as *The Samaritan Woman* or *St. Francis Kneeling* (1657). In *St. Peter and St. Paul at the Doors of the Temple* (1659), his last religious print, extremely fine engraving accentuates the areas of shadow. The volumes are set against a superb architectural decor. The light in which it is bathed evokes the Orient that fascinated the painter throughout his life.

From this same period also date several conventional portraits, but powerful nudes as well, such as *Black Woman Reclining* painted in grisaille. The nude woman seems to be caressed by the delicate cross-hatching; the dark areas are full of mystery whose suggestive intimacy reminds us that Rembrandt was a collector of erotic prints.

And with an explosion of light, with which it rises from the tomb, *The Phoenix* (1658) triumphs over ill-will, mediocrity and idiocy. Is this the painter's answer to those who sought to attack him, increase his burdens and to give free rein to those who despised him out of jealousy and envy? This etching is his final act of defiance. After *Jupiter and Antiope*, a work of carnal sensuality, a new version of the *Three Crosses* and *Nude with an Arrow*, Rembrandt did no more engravings, with the exception of one mediocre portrait of a doctor in 1665.

The Return of the Prodigal Son (Hermitage, St. Petersburg) also marks the return of paintings directly inspired by the Bible. This canvas, which is over eight feet high, is one of the most moving paintings of Rembrandt's last period (dated 1669). The son's clothes are in tatters; he is thoroughly exhausted from his travels. He kneels on the door of his family house at the feet of his father. The old man is worn out, trembling, on the threshold of death. Two other figures complete the scene.

This is not a celebration, but rather an act of extreme seriousness. No joy lights up the father's face, but his gaze is one of infinite tenderness. The harmony of earth tones, browns, reddish ochres, dark and clear, has a ceremonial effect. How could Rembrandt in completing this work not cast his thoughts to Titus, who had died just a few months earlier? The words that the father is about to say to his son, Rembrandt could never again utter. Had he sufficiently loved and understood his son who as an infant had lost his mother? He had neglected the boy and had not been able to give him the universi-

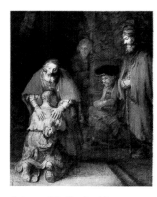

Return of the Prodigal Son

ty education that his own parents despite their modest means had provided for him.

For one last time Rembrandt looks at himself (National Gallery, London). His passionate dreams are silent, his face imprinted with anguish and sadness. His look is already that of absence. His hands are crossed, his jacket buttoned to the top as if he is about to set forth on a journey. There is nothing left for him; he does not know whether he is still the great Rembrandt. He is lost, broken.

One of his oldest admirers, Dirck van Catenburch, who had known him in his glory days, arrived with a commission for him. Was it he or Rembrandt who chose the theme: *Simeon in the Temple* (Nationalmuseum, Stockholm)? Mary has just handed her son into the arms of the aged Simeon. Admonished by the Holy Spirit that he would not die until he looked upon the Messiah, his emotion is such that his half-blind eyes sparkle and his hands tremble. It is indeed the Son of God whom he holds in his arms. What would be no more than an anecdotal account of a biblical episode in the hands of another painter, here by the very simplicity of its rendering attains an indescribable grandeur. This is not only because of the affecting expression on Simeon's face, or the juxtaposition of the old man just about to quit the world and the child who has just appeared; it is also due to the use of color and light. They create a spirituality that only Rembrandt could bring forth from matter.

Warm tones, brilliant or profound, purples, garnets and golds are replaced by browns and chilly ochres, by ivory and silver. This is no longer the light of some glorious sunset, but the diffuse clarity of a Dutch winter's afternoon, in a confined space without perspective or depth. Rembrandt decided not to add spectators to the scene, as he did with *The Prodigal Son*. The work was never finished.

Rembrandt died on October 4, 1669, at the age of sixty-three. His small estate, which included some of his own works and the meager collection he had managed to reassemble in his last years, were all left to Hendrickje and Titus according to the agreement he had signed ten years before. Now it was the property of their heirs, the widow of Titus and the painter's daughter with Hendrickje, Cornelia. The house on Rozengracht was immediately put up for sale. An inventory of his possessions was taken, and

he was buried on October 21, in Westerkerk, in the presence of his family and a few friends. The body was lowered into a vault on the north side of the church at the foot of a column.

The death of Rembrandt went practically unnoticed. Six years later Joachim van Sandrart in his *Teutsche Academie* along with many gross critical errors, praised him "as a painter of great worth" and his "art of color," and added that he "was held in high esteem and great renown." There appeared in Florence in 1681 *Notizie de professori del disegna da Cimabue in qua* of Filippo Baldinucci; errors and downright stupidity are rife. Rembrandt is said to be "a painter whose prestige exceeds his real worth." In France in 1685 Félibien notes "his universal appeal," and Roger de Piles in 1699, in the course of many wrong-headed judgments asserts that "his intelligence in the use of chiaroscuro was unequaled," and that "his carnations are no less real no less fresh and refined than those of Titian." Certain of these early critics were astonished that he had never left Holland, that contrary to the practice of his day he did not evince the need for an extended sojourn in Rome, even though he knew its painting well. As with many of his compatriots he wanted to free himself from its influence and opposed History with everyday life. To be independent, master of oneself, is one of the guiding motives of the Dutch character: of this Claudius Civilis offered the first example.

For a number of years research has been undertaken into the role played by students and followers of Rembrandt in the master's oeuvre. The publication, beginning in 1982, of a catalogue raisonné of the painter's work, *The Corpus of Rembrandt Painting*, undertaken in the name of the foundation "The Rembrandt Research Project," by a team of universally respected specialists under the direction of Jacques Bruyn, has provoked astonishment, consternation, skepticism and anger.

Forty-four pictures out of a total of ninety-three for the period 1625-1631 have lost their status as undisputed Rembrandts; thirty-seven out of one hundred for the years 1632-1634 and thirty-nine out of eighty-six for the years 1635-1642. The third volume dealing with this last period was published in 1989. When the project is finally complete, perhaps in another ten years, it may be that only three hundred authentic Rembrandts will remain. Among the works that have already been excluded are two that are world famous: *Man with a Golden Helmet*, so greatly admired by Malraux, and *David and Saul* in the Mauritshuis.

The Louvre, which could boast at the beginning of the century of twenty-two Rembrandts, can claim today only fifteen whose pedigree seems incontestable, and the final volumes of the catalogue still remain to be published. Three important recent exhibitions of Rembrandt, in Amsterdam, Berlin and at the Louvre, all had the aim of showing the evolution of the painter and his principal themes. In the course of tracing his development attention was also paid to the stylistic relationships between the master and his students, followers and imitators.

Over three hundred years have now elapsed since Rembrandt was laid to rest under Westerkirk. Excavations undertaken in 1989 uncovered fragments of skeletons, but so many people have been buried in the church. On an unadorned wall of this austere house of worship, is engraved the epitaph of this painter, who once triumphed in Amsterdam and then was forgotten. It is a verse by Aragon. "I will always be the king of pain . . ."

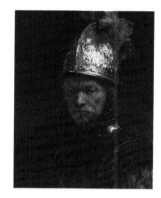

Man with a Golden Helmet

David Playing the Harp before Saul

Page 8. *Christ Chasing the Money-changers from the Temple*, 1626
Painting. 43 x 33 cm. Pushkin Museum, Moscow.

Page 8. *The Flight into Egypt*, 1627.
Painting on Wood. 26.4 x 24.2 cm. Musée des Beaux-Arts, Tours.

Page 10. *The Elevation of the Cross.*
Oil on canvas. 96.2 x 72.2 cm. Alte Pinakothek, Munich.

Page 11. *Samson Blinded by the Philistines*, 1636.
Oil on canvas. 236 x 302 cm. Städel Kunstinstitut, Frankfurt.

Page 13. *Woman at a Window*, ca. 1656
Oil on canvas. 86 x 65 cm. Staatlische Museen, Berlin-Dahlem.

Page 14. *Aristotle Contemplating the Bust of Homer*, 1653.
Oil on canvas. 143.5 x 136.5 cm. Metropolitan Museum of Art, New York.

Page 15. *Christ and the Samaritan Woman*, 1655.
Painting on wood. 46.5 x 39 cm. Metropolitan Museum of Art, New York.

Page 15. *Christ and the Samaritan Woman*, 1655.
Painting on wood. 62 x 49.5 cm. Gemäldegalerie, Berlin-Dahlem.

Page 16. *Self-Portrait*, 1660.
Oil on canvas. 111 x 85 cm. Louvre, Paris.

Page 19. *Family Portrait*, ca. 1663-68.
Oil on canvas. 126 x 167 cm. Herzog Anton Ulrich-Museum, Brunswick.

Page 20. *The Return of the Prodigal Son*, 1659-69.
Oil on canvas. 262 x 206 cm. Hermitage, Leningrad.

Rembrandt's Youth

In a guide to Leyden by Johannes Orlers published in 1641, is found the only mention of Rembrandt's date of birth: July 15, 1606. He was the eighth child of Harmen Gerritzoon van Rijn (so named because his mill was located on the banks of the Rhine), and of Nelltjen Willems van Zuitbrœck, whose father was a baker. The van Rijn family was well established in the city: the mill had been in their hands for four generations, and Harmen's eldest son was to follow in his father's footsteps. Nelltjen could anticipate a considerable inheritance from her parents. On her death she left an estate worth 10,000 guilders. (This was a considerable sum at a time when skilled laborers earned three or four guilders a day.) In fact the van Rijn family was quite affluent in what was then Europe's most prosperous country. In 1640, Leyden, a city of fifty thousand, provided employment for twenty thousand workers in textile manufacturing, its principal industry. To work in the mills children were recruited from the streets and orphanages of the region. In 1646 these child laborers were the

1.
This detail of a map of Leyden drawn at the beginning of the seventeenth century shows the neighborhood where Rembrandt was born and perhaps the family windmill.

2.
In 1598 there were thirteen Dutch merchant fleets spread throughout the Indian Ocean. In 1602 they joined together to form the Dutch East India Company, which from that point on set prices and established offices as far off as Bengal.

beneficiaries of a decree that limited their work day to fourteen hours.

No doubt life was hard in the Netherlands. The population was mobilized against ever-present threats from water and fire: sea water ate away at the innumerable wooden dikes, and fire menaced homes that were for the most part built of wood. In this society Harmen van Rijn with his stone house and his standing in his community, lived a privileged existence, contrary to the long-held thesis that Rembrandt was born into poverty. The young Rembrandt was accorded special privileges within the family itself, since he

Previous spread. *Joseph Relating His Dreams* (detail), 1647.
Grisaille sketch. 51 x 39 cm.
Rijksmuseum, Amsterdam.

1. *Town Plan of Leyden*, 1600.
Pieter Bast. Engraving. 37.5 x 14 cm.
University of Leyden.

2. *Office of the Dutch East India Company at Horly in Bengal,* 1655.
Hendrick van Schuylenburgh. Oil on canvas. 201 x 316 cm.
Louvre, Paris.

3. *Town Plan of Leyden*, 16th century.
G. Braun and F. Hogenberg.
Bibliothèque Nationale, Paris.

3.
Map of Leyden in 1574 soon after the Spanish had laid siege to it. In Rembrandt's time the city, with its textile industry, university and 50,000 inhabitants was the second largest in Holland.

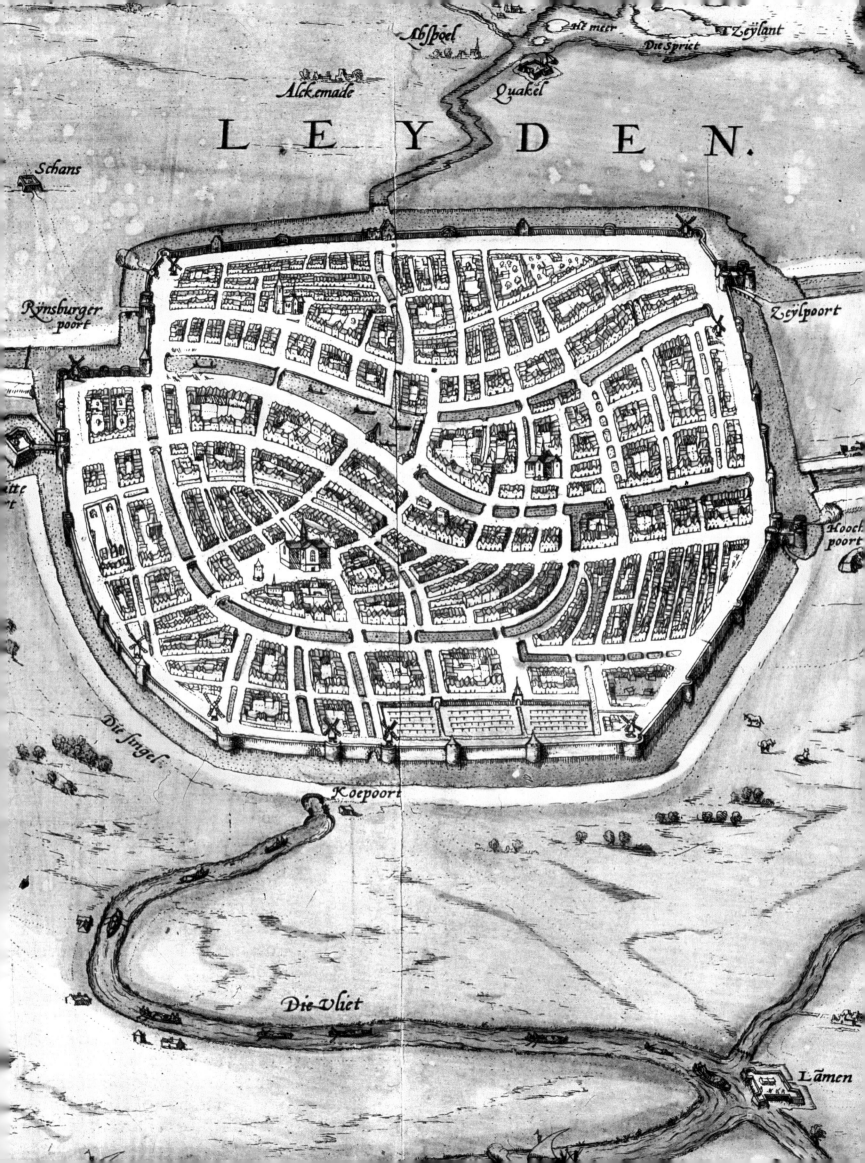

LEYDEN.

Abspoel

Alckemade

'tlt meer

Die Spriet

T Zeylant

Quakel

Schans

Rijnsburger poort

Zeylpoort

Hooch poort

...tte ...rt

Die Jingel

Koepoort

Die Vliet

Lamen

was given the opportunity to pursue an education. He was enrolled in the University of Leyden on May 20, 1620, at the age of fourteen.

Founded in 1575 in the name of the king of Spain, the university was renowned for its many celebrated students. It numbered among them Hugo Grotius, the great legal theorist, Constantine Huygens, future secretary to the prince of Orange and the "discoverer" of Rembrandt, as well as René Descartes. Leyden offered instruction in many fields and was known for its important library and its amphitheater where

1. 2. 3. 4.
During his apprenticeship Rembrandt made a number of portraits of his parents. His family embodied many of the conflicts and compromises of the time. Rembrandt's father converted to Calvinism in 1587. His mother, Nelltjen, remained Catholic, but she sided with the orange (i.e. the Protestant) party.

I

2

medical students learned anatomy by witnessing dissections of human subjects. In addition it produced groundbreaking discoveries and inventions in areas diverse as cartography, hydrology, astronomy and naval construction.

Students wrote and conversed in Latin, and sometimes they had to latinize their names. Thus the monogram RHL which appears on Rembrandt's earliest works signifies Rembrantus Harmensis Leyden, Rembrandt, son of Harmen of Leyden. Like all the great intellectual debates of the period, the religious controversy of the day crystallized within the confines of the university. Here two major Calvinist theologians confronted each other. On one side was Franciscus Gomarus, who with his followers, called Gomaristes, upheld a strict form of Calvinism; on the other was Jacob Arminius, who preached a less rigid adherence to doctrine.

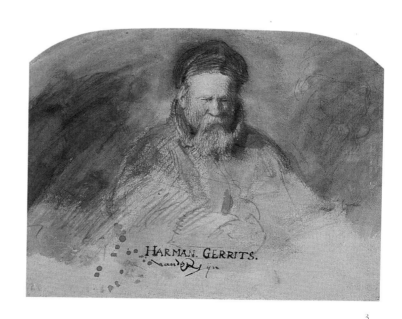

3

1. *Rembrandt's Father Wearing a Gold Chain*, 1630.
Etching, second state. 11.8 x 9.7 cm.
Bibliothèque Nationale, Paris.

2. *Old Woman Seated with Folded Hands*, 1638.
Red chalk. 23.2 x 15.7 cm.
Louvre (Rothschild Collection), Paris. RMN.

3. *Rembrandt's Father Shortly before His Death*, 1630.
Red and black chalk. 24 x 18.9 cm.
Ashmolean Museum, Oxford.

4. *Rembrandt's Mother Wearing a Hat*, 1631.
Etching. 14.5 x 12.9 cm.
Bibliothèque Nationale, Paris.

R̄ · 1627

To understand how closely religion and secular authority were intertwined, it is only necessary to consider that their conflict resulted in the government embarking on a kind of witch hunt. Rather arcane theological differences played out as struggles for power (in this case between Jan van Oldenbarnevelt, a highly-placed, staunch republican, and Maurice of Nassau, the Prince of Orange) and resulted in 1619 with the expulsion of the Arminians from the university and the synod of Dordecht, which recognized the claims of the Gomaristes. The university was closed on account of the controversy and took upon itself the purgation of disavowed Arminian elements.

Rembrandt had friends who were Arminians. In his brief stay at the university he did not have time to participate in any prominent way in the quarrel. His university career lasted only two months. But even that was long enough to give the lie to his first biographer, Joachim von Sandrart, who six years after the painter's death in 1675 maintained that he "could read only Dutch and that badly, and did not gain much from books." In any event at the age of fourteen Rembrandt already knew that it was through painting that he could make the most significant contribution.

28

2

3

1. *Inside the Library of the University of Leyden*, 1610.
Swanenburgh. Engraving.
Bibliothèque Nationale, Paris.

2. *Anatomy Theater of the University of Leyden*, 1610.
Swanenburgh. Engraving.
Bibliothèque Nationale, Paris.

3. Frontispiece from the First Edition of Statenbijbel
(Official Bible), printed in Leyden in 1637.
Bibliothèque Nationale, Paris.

1. 2.
Founded in 1575, the University of
Leyden was one of the most highly
regarded in Europe. Among its
famous students it could boast of
Hugo Grotius, father of maritime
law, and the mathematician and
philosopher, René Descartes. Its
library was famous. Its books were
all chained to reading tables. The
most eminent physicians practiced
dissection on humans and animals
in the great anatomy theater.

3.
Published in 1636 after the Synod
of Dordrecht (1618-1619), which
came out in favor of the Gomarists
against the Arminians, this edition
of the Bible was the only one
officially recognized by the Calvin-
ists. It was also evidence of the
importance of Leyden as a
center of printing.

29

Years of Apprenticeship

His parents did not oppose the career choice of their son, even though he had chosen to leave the glorious University of Leyden after only two months of study. The status of the painter in seventeenth-century Holland was not particularly enviable. He was looked upon less as an artist than as an artisan who produced works, sold them and remained narrowly constrained by the regulations governing his profession. It was a long way from Italy where artists were treated with great honor. In addition official commissions were rare. The aristocracy had lost its standing in this early bastion of republicanism, and the church, despoiled by the iconoclastic leanings of the dominant Protestant sects, strictly forbade all artistic representations of divine matters. Patrons of the arts were for the most part ordinary citizens who wanted works that offered a faithful and familiar reflection of everyday realities. They were the engine that drove the expanding market for art. In 1640 an English traveler, Peter Mundy, commented in his diaries that Holland stood alone in its taste and appetite for works of art and that they could be found not only in private homes, but in butcher shops and bakeries.

It was now a question of finding a master who could teach Rembrandt the technical aspects of painting. His parents hesitated. The names of Jacob Pynas and Joris van Shooten have often been put forward, but the first teacher who has been definitely linked to Rembrandt was Jacob van Swanenburgh. Rembrandt's father was reassured by van Swanenburgh's reputation, which had been handed down from his father Isaac, renowned for his depictions of Leyden's booming textile industry. After studying in Italy, Jacob established himself in his father's studio with Margherita, his Neapolitan wife. Rembrandt was to be his apprentice for three years, until he was seventeen. Though Swanenburgh was not an inspirational teacher he did provide his pupil with the basic tools of the trade. It is worthy of note that the two themes dearest to his master, architecture and infernal scenes along the

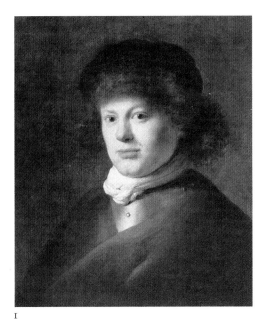

I

1. 3.
At this point Rembrandt appears at better advantage under the hand of his friend Jan Lievens (1) than his own (3). Unlike his contemporaries who painted self-portraits to present themselves in the best possible way, Rembrandt used them to experiment with light and form. Rembrandt gave his hair extra curls by scratching the final surface of the painting.

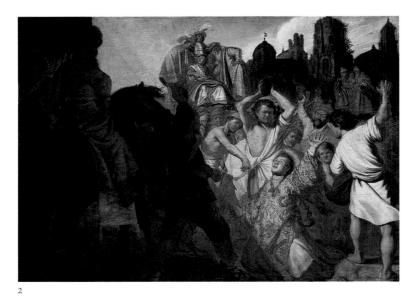

2

2. First canvas known to be signed by Rembrandt, *The Stoning of St. Stephen*, was identified in 1962. Its subject clearly indicates the young painter's fondness for biblical history. The face grimacing behind St. Stephen is none other than Rembrandt's own.

1. *Portrait of Rembrandt with High Collar*, ca. 1629.
Jan Lievens. Oil on panel. 57 x 44 cm.
Private Collection.

2. *The Stoning of St. Stephen*, 1625.
Oil on canvas. 89.5 x 123.6 cm.
Musée des Beaux-Arts, Lyon.

3. *Self-Portrait* (detail) 1629.
Oil on canvas. 22.6 x 18.7 cm.
Rijksmuseum, Amsterdam.

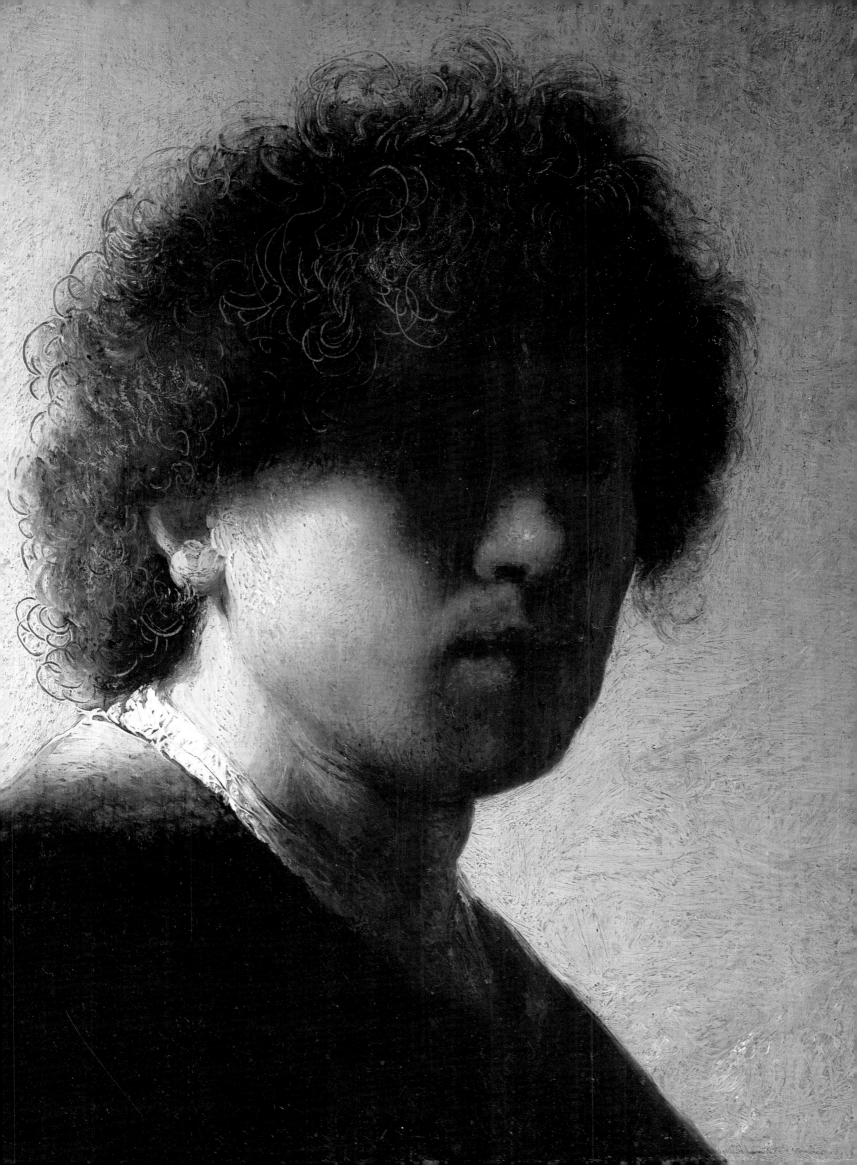

lines of Hieronymous Bosch, play almost no role in Rembrandt's oeuvre.

But by the time he had left Swanenburgh Rembrandt knew how to make a picture frame, mount a canvas, compound pigments, prepare the binder and arrange colors on the palette. No doubt his master had also instructed him in the rudiments of drawing and etching. Johannes Orlers notes in 1641: "Rembrandt's progress was astonishing. There was every reason to believe that in time he would become an exceptional painter." His father decided to place his further training in the hands of the celebrated painter Pieter Lastman, who lived in Amsterdam, so that he could receive the benefits of a finer and more profound instruction.

Rembrandt spent six months in Lastman's studio in Amsterdam. Like Swanenburgh, Lastman had studied in Italy. He was strongly influenced by the work of Caravaggio and the German painter, Adam Elsheimer. It was under Lastman's tutelage that Rembrandt learned the secrets of chiaroscuro. He adopted bright colors and the fondness for grand dramatic gestures that characterized Lastman's popular historic paintings.

1

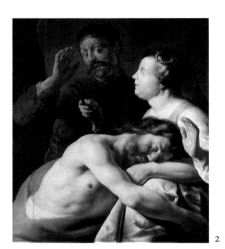

2

3

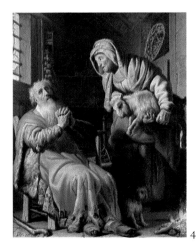

4

1. 5.
Compare the student and the master. Rembrandt's composition is powerful and dynamic. Lastman's while not lacking in poetry, is considerably more static.

2. 3.
Lievens sought nobility in his choice and handling of subject (3). Rembrandt and his followers strove for dramatic intensity (2).

4.
This small picture vibrantly recreates a biblical episode in which the aged Tobit falsely accuses Anna of stealing a kid.

Rembrandt returned to Leyden and became a teacher himself. He opened a studio, probably located in his family's home, which he shared with another ex-pupil of Lastman, Jan Lievens. Though a little younger than Rembrandt, Jan had been practicing his profession for a number of years. A real friendship and a close working relationship bound the two young painters together. They were so close that their contemporaries sometimes had a hard time telling their work apart. This is illustrated in an inventory of the collection of Stadhouder Frederick-Henry made in 1632, wherein a work entitled *The Presentation in the Temple* bears the attribution: "by Rembrandt or Lievens."

1. *Balaam's Ass before the Angel,* 1622.
Pieter Lastman. Painting.
Private Collection, England.

2. *Samson and Delilah.*
Rembrandt's Studio. Oil on panel. 27.5 x 23.5 cm.
Rijksmuseum, Amsterdam.

3. *Samson Betrayed by Delilah,* ca. 1629-30.
Jan Lievens. Oil on canvas. 131 x 111 cm.
Rijksmuseum, Amsterdam.

4. *Tobit and Anna with the Kid,* 1626.
Oil on canvas. 39.5 x 30 cm.
Rijksmuseum, Amsterdam.

5. *Balaam's Ass,* 1626.
Oil on canvas. 63 x 46.5 cm.
Musée Cognacq-Jay, Paris.

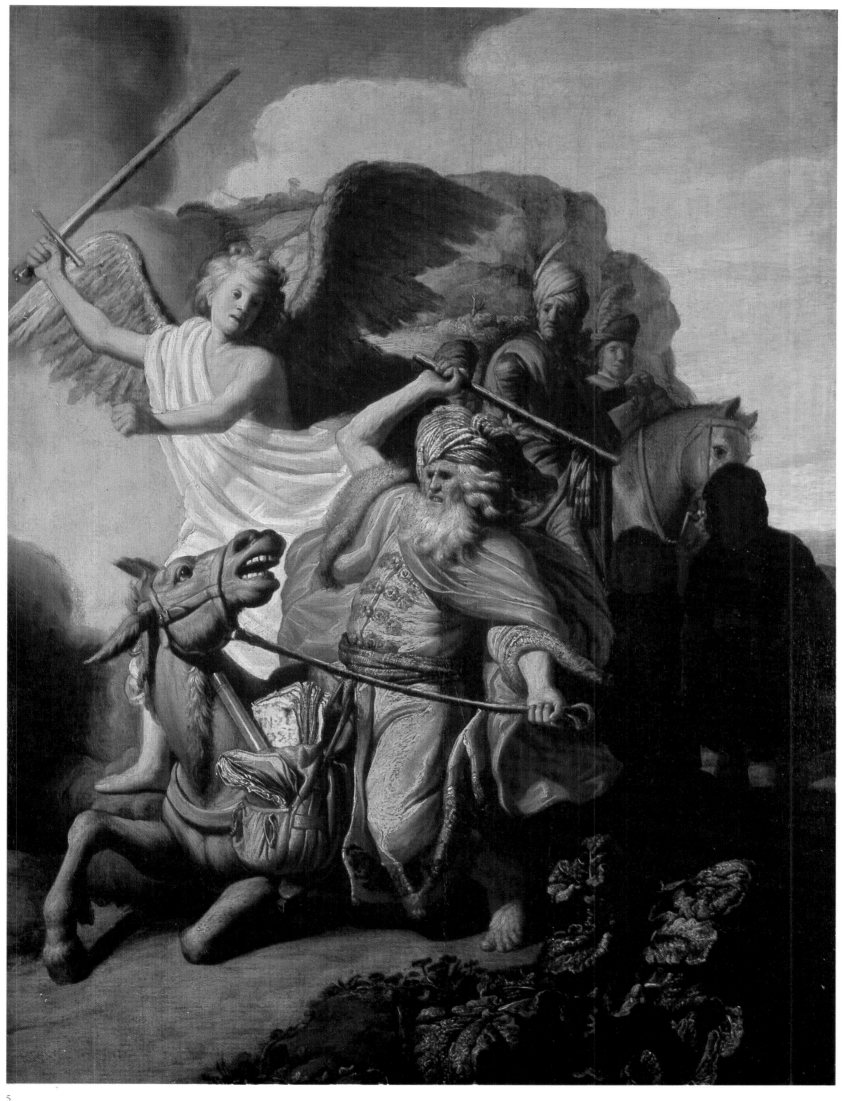

Discovery of Jacques Callot's beggars

Rembrandt was first exposed to engraving in Swanenburgh's studio. Prints, which were less expensive and more easily transported than canvases, offered the best way for unknown artists to establish their reputation. Rembrandt studied the works of Buytewech, Seghers and even van de Velde. Then he came upon the French graphic artist Jacques Callot. Callot's series *Caprices* (a satiric gallery of the beggars and crippled and maimed veterans of the Thirty Years War) made a deep impression upon him.

From 1628 to 1635 Rembrandt made engravings of the beggars of Leyden. Like Callot, he sketched the misery of daily life but was attentive to his subjects' humanity, and never turned them into figures of ridicule.

Among the most beautiful etchings of Rembrandt there are some that give the impression of having been engraved with a splinter of wood or the point of a nail. ... He knew the rewards of working by hand without interposing all of those instruments that make today's workshops look like dentists' offices.

(Renoir)

1. *Beggar with a Cane, Les Gueux,* ca. 1627.
Jacques Callot. Engraving.
Bibliothèque Nationale, Paris.

2. *Beggar Urinating,* 1631.
Etching. 8.2 x 4.8 cm.
Rembrandthuis, Amsterdam.

3. *Crippled Beggar Known as Captain Eenbeen,* 1630.
Etching, first state. 11.4 x 6.6 cm.
Rembrandthuis, Amsterdam.

4. *Woman Urinating,* 1631.
Etching. 8 x 6.4 cm.
Teylers Museum, Haarlem.

I

Amsterdam

1.
The bourgeoisie, who were all-powerful in Holland in the seventeenth century, liked seeing themselves represented in the midst of merry-making.

Jan Lievens was becoming famous. His talent attracted many of the leading lights of Holland's artistic world to their studio. One encounter was to have a shaping effect on Rembrandt's career. It was at this time that he first met Constantine Huygens, the private secretary to the Stadhouder Frederick-Henry, Prince of Orange, and one of the most influential art critics of his day. It was probably Huygens who persuaded Rembrandt to move from Leyden to Amsterdam, the economic and cultural capital of the country. The young artist had lost his father and eldest brother in the same year and offered no objections.

Amsterdam of 1631 was a bustling, prosperous city. Herbs and spices and the fine fabrics from the extensive Dutch colonial market decorated its markets. Its port, one of the most important in Europe, was home to a thriving international trade. One did business in every language in the arcades of its stock exchange. Melchior Fokkens describes the city in 1662: "This city, after having been crushed by the implacable tyranny of the Spanish monarchy, overthrew the yoke of slavery and its religion and churches. Now it can hold its head high, and its government knows how to remain discreet. For we know a form of social order that no people have ever before experienced."

Thus Fokkens offers us a progress report a half century after the Twelve Years' Truce that was signed in 1609 and signaled independence for Holland and the triumph of the reformation under the auspices of the House of Orange. Holland (named after the

2

2. Van Mieris, a student of Gerard Dou, took up a theme that was quite common during this period. The omnipresent eroticism is seen in the coupling dogs, the drinker's pulling at his hostess's apron, the bed linens hanging over the balcony and the woman and man, who is the artist himself, embracing in the doorway.

1. *Peasants Celebrating in a Tavern*, 1674.
Jan Steen. Oil on canvas. 118 x 161 cm.
Louvre, Paris, RMN.

2. *Brothel Scene*, ca. 1650.
Frans van Mieris. Panel. 42.8 x 33.3 cm.
Mauritshuis, The Hague.

3. *View of Amsterdam*, 1538.
Cornelis Anthonisz. Oil on canvas. 116 x 159 cm.
Historical Museum, Amsterdam.

3.
This aerial view dating from 1538 is the oldest map of Amsterdam. The Amstel cuts the city in half with canals running parallel to it. More canals were dug as the city was enlarged.

Daily Life in Amsterdam

1.
Jacob van Ruysdäel moved to Amsterdam in 1657 and specialized in landscapes.

2.
Opened in 1655 the Town Hall was Amsterdam's most ambitious architectural achievement of the period. Rembrandt was commissioned to paint *Claudius Civilis* to decorate the interior, but his work was rejected in favor of that of one of his students.

1

2

3

3. 4.
A diamond cutter and engravers at work:
two crafts that enriched Holland in the
seventeenth century. Rembrandt probably
used a press similar to the one represented
here by Abraham Bosse for his proofs.

4

5

5.
Market scenes were commonplace in this city
where commerce was king. Like Jacob van Ruysdäel,
Gabriel Metsu settled in Amsterdam in 1657.
He is known mainly for his genre scenes.

1. *View of the Old Fish-Market of Amsterdam*, 1660.
Ruysdaël. Oil on canvas. 53.3 x 67.2 cm.
Boymans-van Beuningen Museum, Amsterdam.

2. *The Old Town Hall of Amsterdam*, 1657.
P. G. Saenredam. Oil on wood. 64.5 x 83 cm.
Rijksmuseum, Amsterdam.

3. *Workshop of the Diamond Cutters.*
Jan Luyken. Engraving.
Historical Museum, Amsterdam.

4. *Printers at Work*, 1642.
Abraham Bosse. Engraving.
Rembrandthuis, Amsterdam.

5. *Herb Market of Amsterdam* (detail), 1660.
Gabriel Metsu. Oil on canvas. 97 x 84.5 cm.
Louvre, Paris, RMN.

I

1.
Winter scenes were a very popular genre that the Dutch (van Breem, Anvercamp, Esais van de Velde) borrowed from Belgium. The first generation was realist in its approach, but its successors depicted imaginary, often mountainous, landscapes.

most populous and powerful province in the confederation) confirmed at the same time its separation from the ten southern provinces. Finally after eighty years of war it could begin to enjoy its economic and cultural dynamism.

In this country of canals, land required extensive drainage, and the Dutch looked to painting rather than real estate as an investment. Not infrequently simple farmers would pay two or three thousand guilders for paintings and then resell them at country fairs at a considerable profit.

Rembrandt's renown preceded him. Upon his arrival he was introduced to the art dealer, Hendrick van Uylenburgh, who offered him a position in his academy. A contract was signed on June 20, 1631, that made over to the art dealer the sum of one thousand guilders. The profession of art dealer was relatively new, but already profitable. Uylenburgh offered room and board to young painters in his "academy," which was more like a factory, where the works of the great European masters were copied, then distributed and sold by the dealer. There was no question of fraud or deceit. It was customary to copy works that were considered beautiful and were pleasing to the public. Within a short time Rembrandt had demonstrated his artistic gifts; soon it was his works that Uylenburgh had his pensioners copy.

2

2.
This is a drawing by one of Rembrandt's students of Westerkerk, where the painter was buried in 1669 next to his son Titus.

1. *Winter Scene* (detail), 1611.
Adam van Breem. Oil on canvas. 52.5 x 90.5 cm.
Rijksmusuem, Amsterdam.

2. *The Tower of the Westerkerk*, 1640-1650.
Student of Rembrandt. Drawing. 19 x 14.7 cm.
Historical Museum, Amsterdam.

3. *The Artist in His Studio*, ca. 1628.
Oil on canvas. 24.8 x 31.7 cm.
Museum of Fine Arts, Boston (Z.O. Sherman Collection).

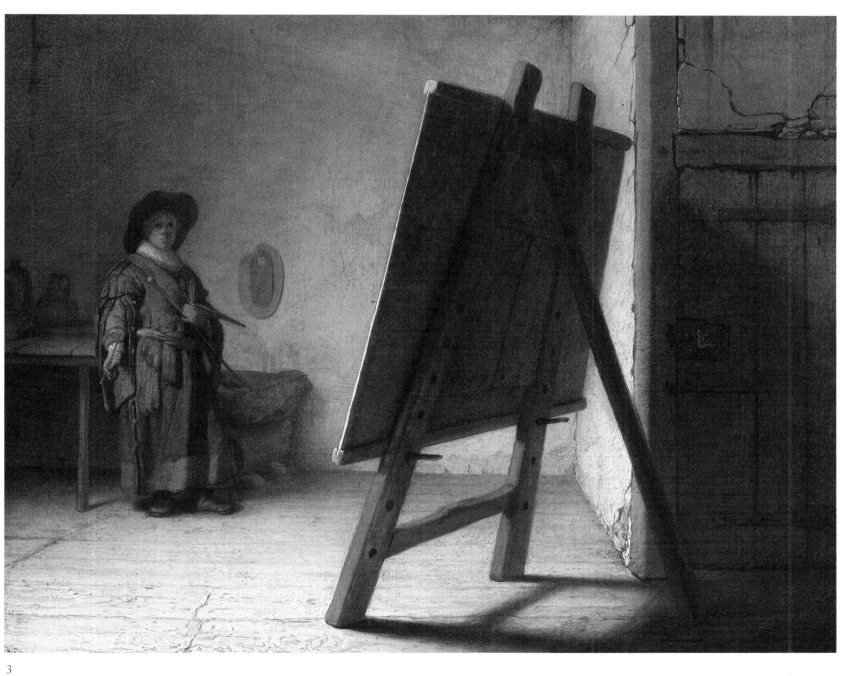

3

3.
On the threshold of his career as an artist
Rembrandt chose to represent himself alone, quite
small, in a practically empty studio. The light is
focused on the painting which we do not see.
The Artist in His Studio suggests the challenge
that the artist would take up in his
work to come.

Rembrandt's Studio

Between the years 1630 and 1640 about fifty painters worked as apprentices in Rembrandt's studio. Among them were Gerard Dou, Carel Fabritius, as well as Govaert Flinck and Ferdinand Bol. There were so many that Rembrandt had to rent a warehouse, which he divided into individual cubicles where his apprentices worked among hanging canvases and papers.

It was customary for the master to provide room and board for about one hundred guilders a year. Apprentices agreed to be governed by the regulations of the Guild of Saint Luke (the painter's guild). Their training lasted three years during which time their works remained the property of their master.

Try to introduce into your work what you already know. Then you will soon discover what has been missing and what you wish to discover.

(Rembrandt to his students, reported by Hoogstraten)

1. *Artist Drawing a Model,* 1639.
School of Rembrandt. India ink and bister. 18.5 x 16 cm.
British Museum, London.

2. *Artist Drawing a Model,* 1639.
Etching, drypoint and burin, second state. 23.2 x 18.4 cm.
Rembrandthuis, Amsterdam.

3. *Self-Portrait Dressed for Painting,* ca. 1655.
Pen and brown ink. 20.3 x 14.3 cm.
Rembrandthuis, Amsterdam.

4. *The Artist's Studio,* 1650.
School of Rembrandt. Charcoal with white highlights. 18 x 31.7 cm.
Staatliche Kunstsammlungen, Weimar.

5. *Old Woman* (Rembrandt's mother).
Gerard Dou. Oil on canvas. 12 x 9 cm.
Louvre, Paris. RMN.

6. *The Artist's Studio,* 1650.
School of Rembrandt. Pen and watercolor. 20 x 18.9 cm.
Ashmolean Museum, Oxford.

7. *The Artist's Studio,* ca. 1648.
Pen and watercolor. 17.5 x 23.2 cm.
Louvre, (Print room), Paris. RMN.

8. *Self-Portrait,* 1654.
Carel Fabritius. Oil on canvas. 65 x 49 cm.
Boymans-van Beuningen Museum, Rotterdam.

9. *The Artist's Studio,* 1650.
School of Rembrandt. Pen and ink. 12 x 20 cm.
Staatliche Kunstsammlungen, Weimar.

5

6

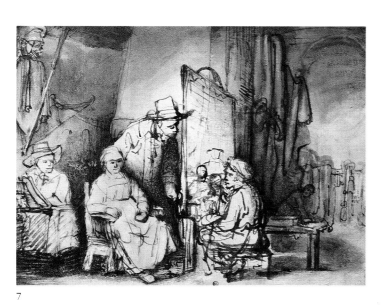

7

8

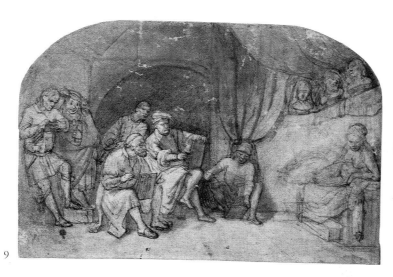

9

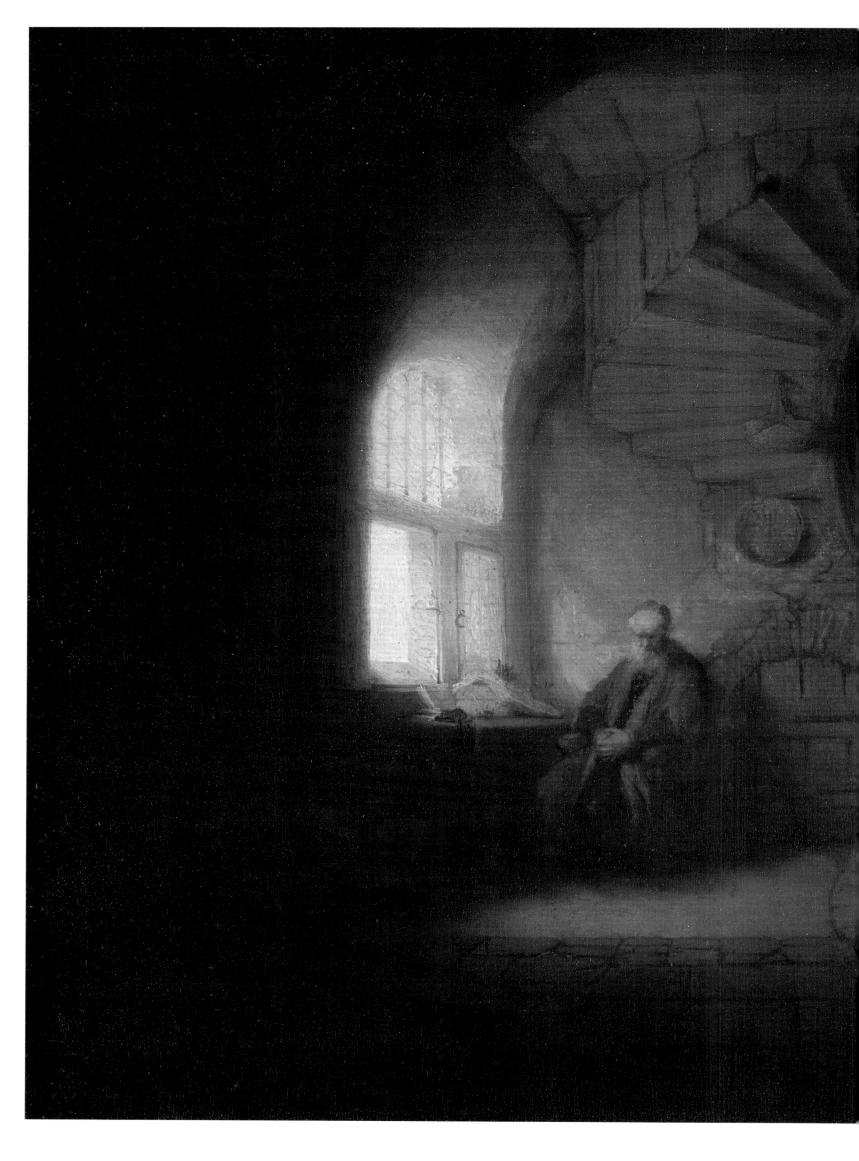

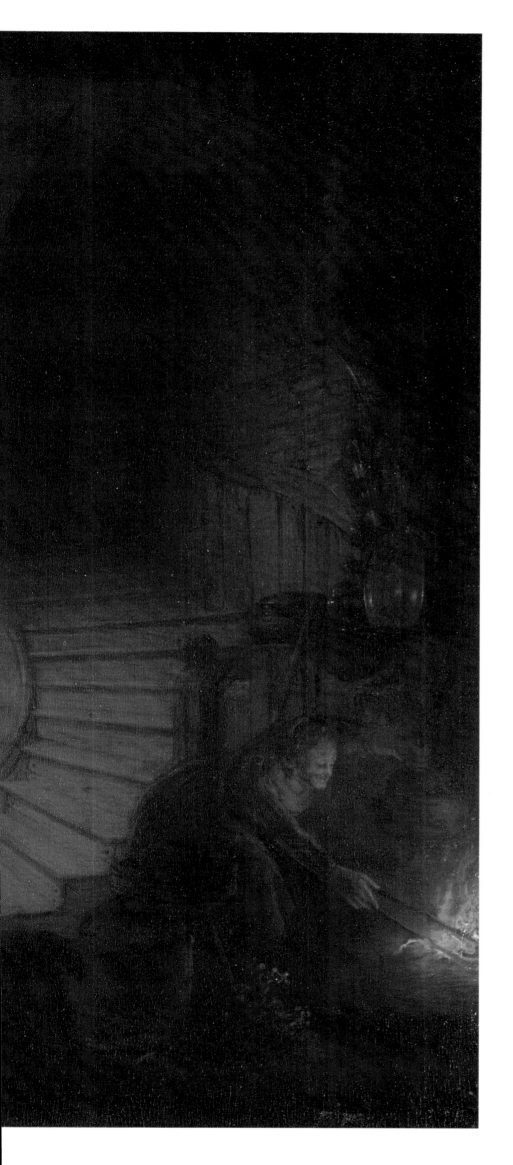

The Philosopher in Meditation, 1632.
Oil on wood. 28 x 34 cm.
Louvre, Paris.

Rembrandt, Master of Chiaroscuro

I

He liked dramatic oppositions of light and shadow. His studio was rather dark and so arranged that it received light from only one source, making it similar to a camera obscura. The artist could control the flow of light and make it shine on whatever part of the canvas he wanted.

(Adam Bartsch, 1797)

Rembrandt was twenty-four years old in 1630. His use of light and shadow to reinforce the density of his paintings and deepen their power and mystery had already made him the incontestable master of the technique of chiaroscuro. Paul Valery eloquently observes: "While conscious awareness discovers and names well-defined objects, the significant givens of a particular painting, we are engaged at the same time in the silent and oblique action of brush strokes and zones of light and dark. This topography of shadow has no significance for the intellect...but the eye perceives what the mind cannot define. ...Thus there are two levels in each painting: one composed of the bodies and objects represented and the other of the disposition of light."

2

1. 2. 3.
Rembrandt returned to a theme that had been previously treated by Lastman. His work shows that he has assimilated all of the teachings of this disciple of Elsheimer and Caravaggio. It is by a more highly structured composition that Rembrandt surpasses his teacher. Christ's upraised hand is the apex of a triangle of which the group of onlookers and Lazarus form the base. By isolating Lazarus, who in Lastman's work is practically lost in the crowd of astonished spectators, Rembrandt gives reality to the miracle and instills a sense of fear, as does his student Carel Fabritius in a painting patterned after the master's.

1. *The Raising of Lazarus,* 1622.
Pieter Lastman. 64 x 97 cm.
Mauritshuis, The Hague.

2. *The Raising of Lazarus,* ca. 1642-1643.
Carel Fabritius. Oil on canvas. 210 x 240 cm.
Narodowe Museum, Warsaw.

3. *The Raising of Lazarus,* 1630.
Oil on panel. 96 x 81 cm.
Los Angeles County Museum of Art
(Gift of H.F. Ahmanson), Los Angeles.

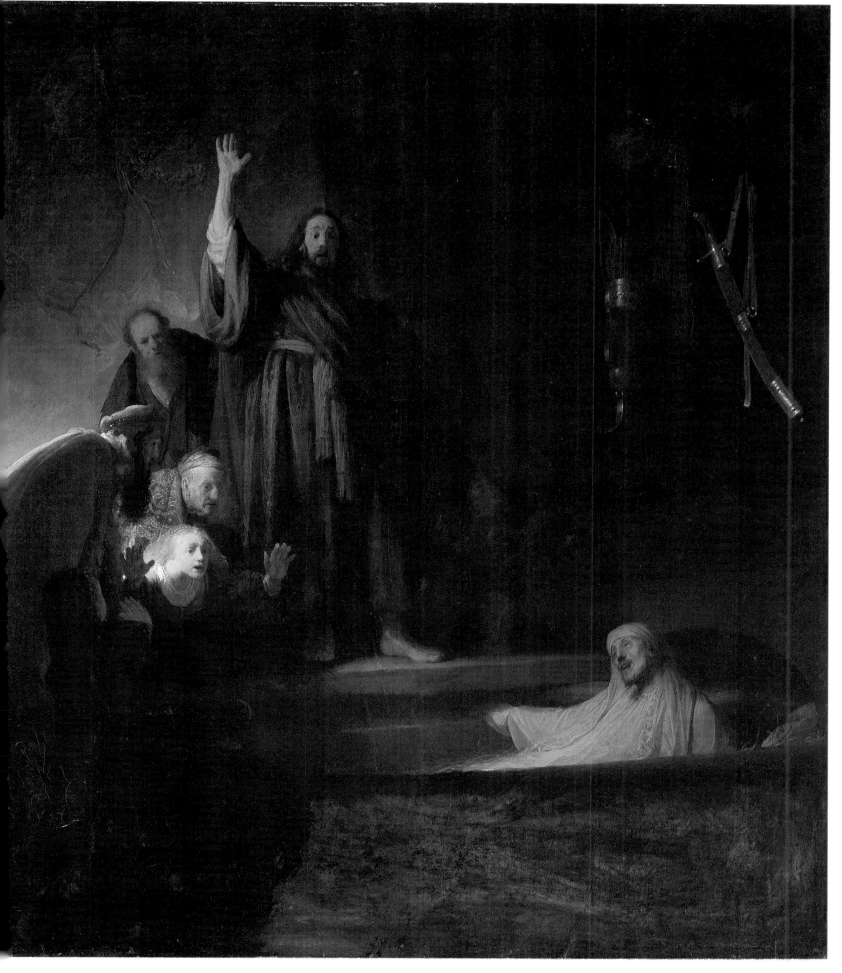

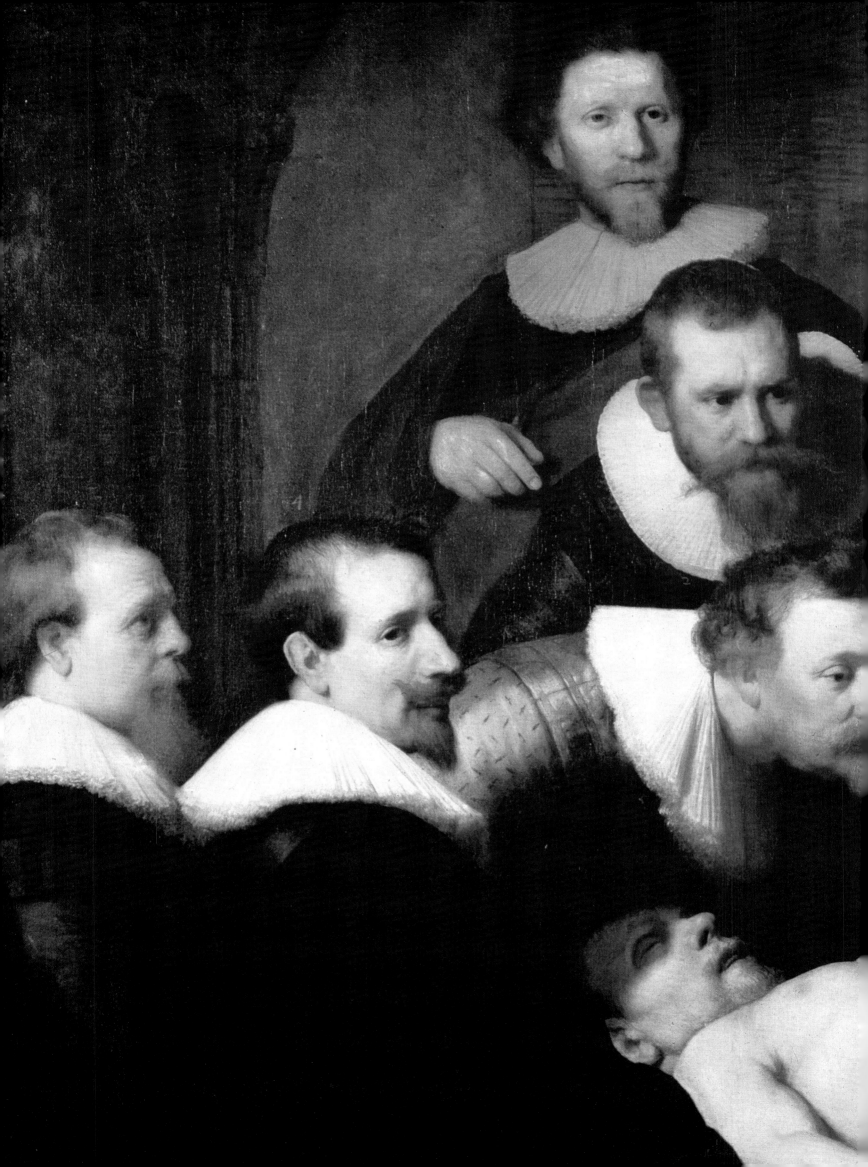

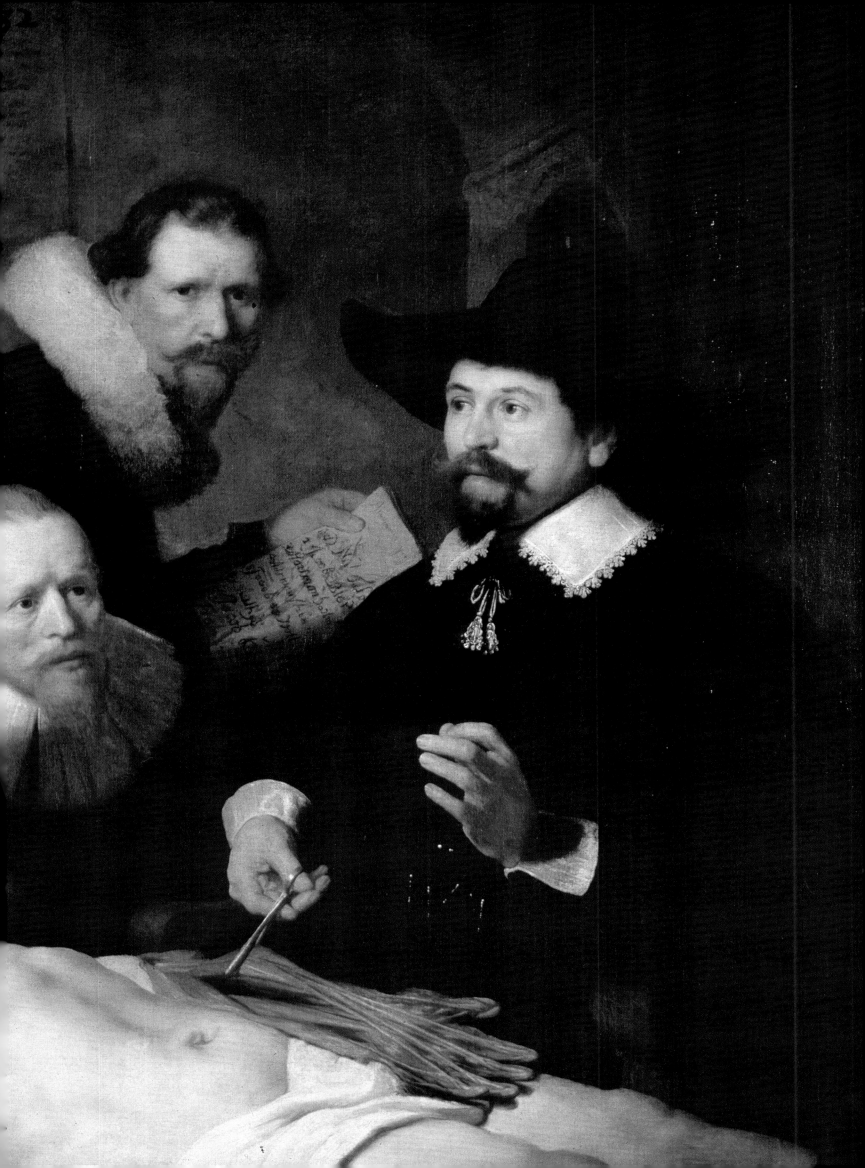

First Success: *The Anatomy Lesson of Professor Tulp*

By the age of twenty-seven Rembrandt was signing his canvases with his first name only in the style of the masters of the Italian renaissance.

He received many commissions; it is reported that he painted as many as fifty works between 1631 and 1632.

The dealer Uylenburgh made him a partner and obtained a particularly important commission for him. The eminent surgeon Nicholas Tulp, who was twice elected chief magistrate of Amsterdam, asked Rembrandt to paint him giving an anatomy lesson in the presence of a number of important members of the community. Corporate portraits, destined to be hung in a place of honor in guild halls, were symbols of intellectual and social

1

1.
Rembrandt succeeds in avoiding monotony through pyramidal construction and by giving each figure a different orientation.

2. 3.
Rembrandt's painting is part of a tradition mapped out by Mierevelt and Thomas de Keyser (2). The genre of corporate or guild portraiture would survive into the eighteenth century. The challenge of this kind of composition was that each figure had to be readily identified without being monotonously lined up on the canvas.

2

3

4.
Instruments used
for trepanning by late
sixteenth-century
surgeons.

1. (and detail on preceding pages)
The Anatomy Lesson of Professor Tulp, 1632.
Oil on canvas. 162 x 216 cm.
Mauritshuis, The Hague.

2. *The Anatomy Lesson of Doctor Sebastian Eghertsz of Vry,* 1619
Thomas de Keyser. Oil on canvas. 135 x 186 cm.
Historical Museum, Amsterdam.

3. *The Anatomy Lesson of Doctor William Roell,* 1728.
Cornelis Troost. Oil on canvas. 200 x 310 cm.
Historical Museum, Amsterdam.

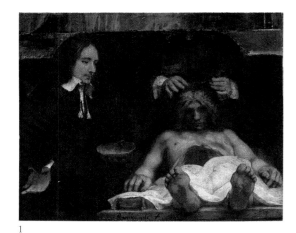

1

1. 3. 4.
Successor to Professor Tulp, Dr. Johan Deyman conducted a lecture and demonstration on January 29, 1656 on the structure of the brain. Twenty four years after his first "anatomy lesson" Rembrandt is much more audacious, since he shows the cadaver full face, foreshortened. He was certainly influenced by Mantegna's Dead Christ (3). Only a portion of this work survives; the rest was destroyed in a fire in 1723.

success for the various professional groups. The commission carried a great deal of prestige; first because of the high standing of the one who commissioned it and also because of the genre itself. In this case it was even more pronounced because the college of surgeons authorized the dissection of an executed prisoner only once a year. The subject of Rembrandt's first great public work took place on January 31, 1632. The lecture was on the physiology of the arm.

There were particular challenges inherent in this genre of painting that Rembrandt, like his predecessors Miervelt and Thomas de Keyser, had to confront. None of the personages represented in the painting, except Professor Tulp himself, were actually surgeons. It had become the custom with this kind of painting for notable citizens to have themselves included and placed in prominent positions, hoping in this way to be memorialized for posterity. Between six and twenty patrons — each paid his share of the costs — had to be represented one along side the other, often in monotonous arrangements.

But Rembrandt escaped this trap. He satisfied the demands of his patrons by inscribing their names on the document that the figure in the painting who looks at the spectator holds up. At the same time he broke up the monotony of the composition with a pyramidal construction. Most importantly he directed the gaze of each figure in a different direction.

Thus without sacrificing solemnity, the painter breathed life and mobility into a somewhat stale genre.

2.
Constantin Huygens was the secretary of the State Council under the Stadhouders Frederick-Henry, William II and William III. A great connoisseur and patron of the arts, he wrote poetry, composed music and played a number of different instruments. He was the first to encourage the talents of Rembrandt and Lievens. Huygens was greatly pleased with this portrait that Lievens painted of him.

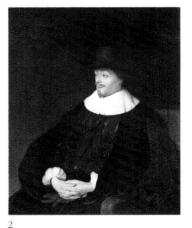

2

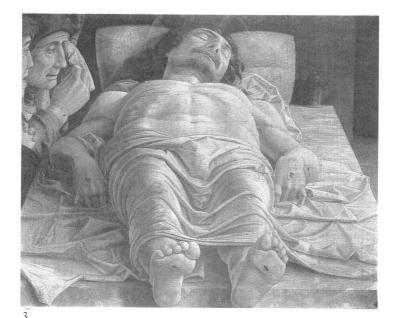

3

1. *The Anatomy Lesson of Doctor Johan Deyman*, 1656.
Oil on canvas. 100 x 134 cm.
Rijksmuseum, Amsterdam.

2. *Portrait of Constantin Huygens*, 1626-1627.
Jan Lievens. Oil on wood. 99 x 84 cm.

3. *Cristo scorto (The Dead Christ)*, 1480.
Andrea Mantegna. Tempera on canvas. 68 x 81 cm.
Pinacoteca di Brera, Milan.

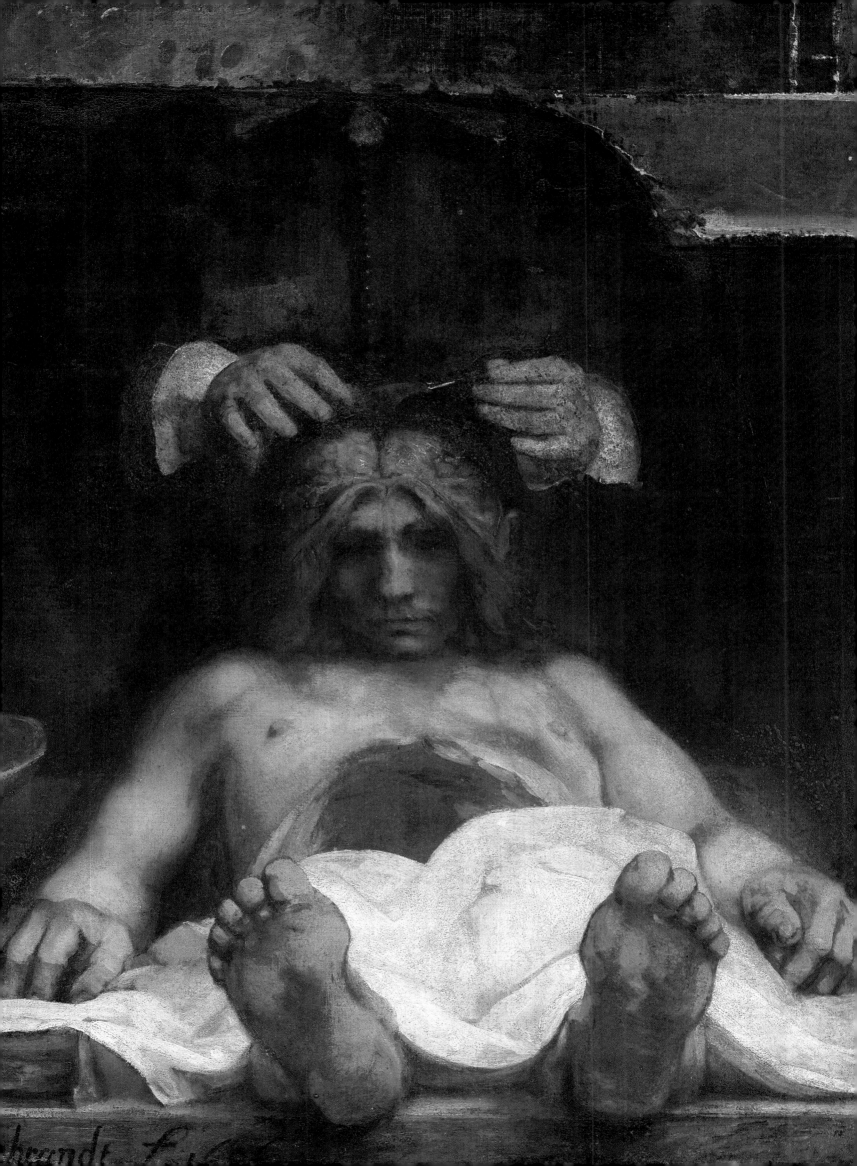

Rembrandt as Portraitist

The great success of *The Anatomy Lesson of Professor Tulp* brought Rembrandt many commissions for portraits. Portraits were the most profitable work that an artist of the time could undertake. This is illustrated by the painter Miervelt who was said to have completed more than ten thousand during the length of his career.

Rembrandt painted at least forty-six from 1632 to 1633 receiving commissions from a number of important individuals. Amalia van Solms, the wife of the Stadhouder, and Maria Tripp, daughter of the wealthiest merchant in Amsterdam, are but two examples.

I

Also among the sixty-five portraits executed in the 1630s that have survived are found many of anonymous individuals (an old Jew, a young officer, an Oriental), and he continued to paint and draw self-portraits. But the face that figures most often in his portraiture of this period is that of a young woman, Saskia van Uylenburgh, niece or cousin of his associate, Hendrick. She was twenty-one and he was twenty-six when they met. She was pretty with an enchanting gaiety: they were engaged to be married on June 5, 1633. Saskia came from an excellent family. Her brothers were lawyers and officers. Her father, a burgomeister and member of the tribunal in the province of Friesland, died when she was twelve years old, leaving her a dowry of forty thousand guilders. With his marriage to her on July 22, 1634, Rembrandt radically changed his social position.

2

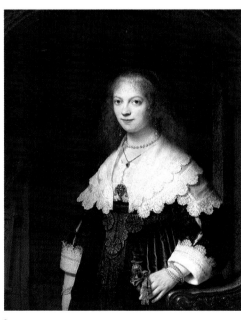

3

2. 4.
At the left is a portrait of Saskia with Rembrandt's handwritten inscription: "This is a portrait of my fiancé at the age of twenty-one, three days after our engagement." At the right in a portrait done only a few months later, Saskia has taken on all the charms of a woman in full flower.

3.
The Trip family owned iron mines and armory works. Immensely influential and rich, Maria honored Rembrandt with several commissions.

1. *Self-Portrait with a Fancy Sword*, 1634.
Etching and drypoint. 12.4 x 10.2 cm.
Rembrandthuis, Amsterdam.

2. *Saskia Wearing a Straw Hat*, 1633.
Drawing with silver pen. 18.5 x 10.5 cm.
Gemäldegalerie, Staatliche Museen, Preussicher Kulturbesitz, Berlin.

3. *Portrait of Maria Trip*, 1639.
Oil on panel of Indonesian wood. 107 x 82 cm.
Rijksmuseum (Gift of the Van Weede family) Amsterdam.

4. *Portrait of Saskia Laughing*, 1633.
Oil on wood. 52 x 44 cm.
Staatliche Kunstsammlungen, Gemäldegalerie Alte Meister, Dresden.

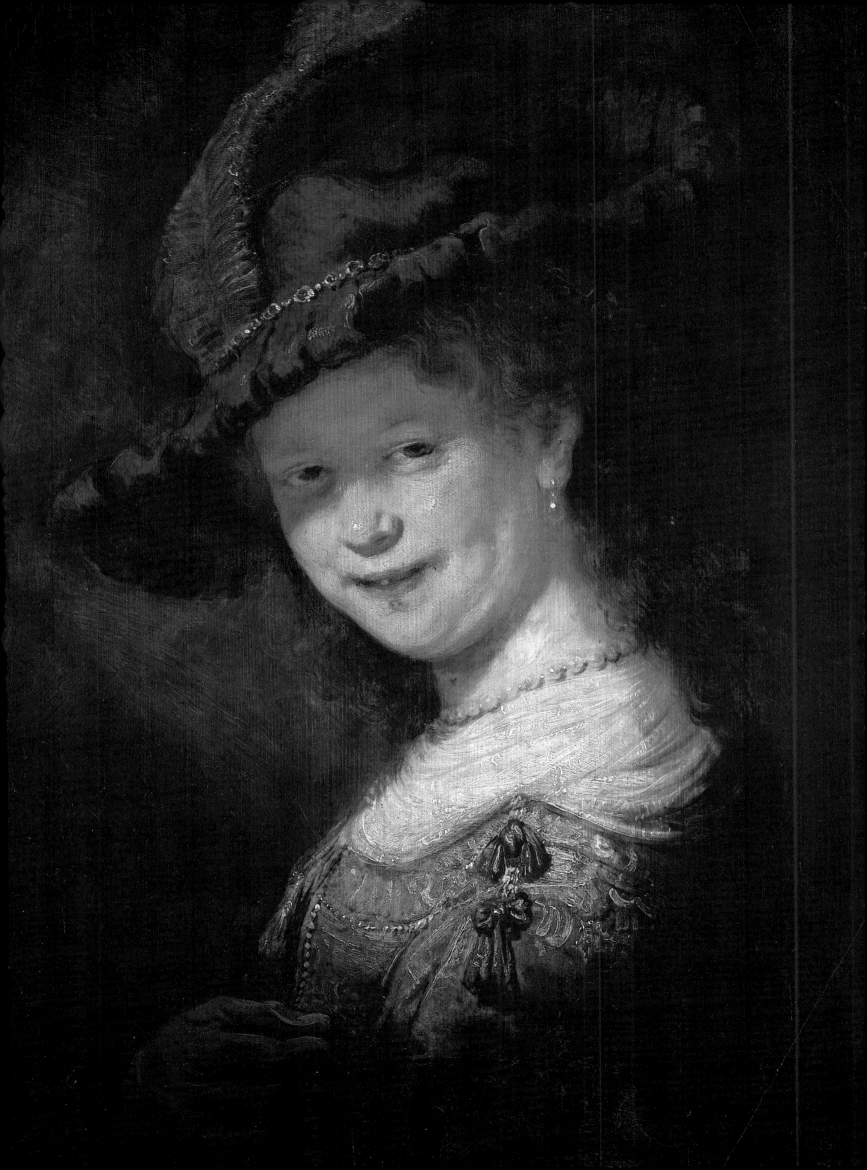

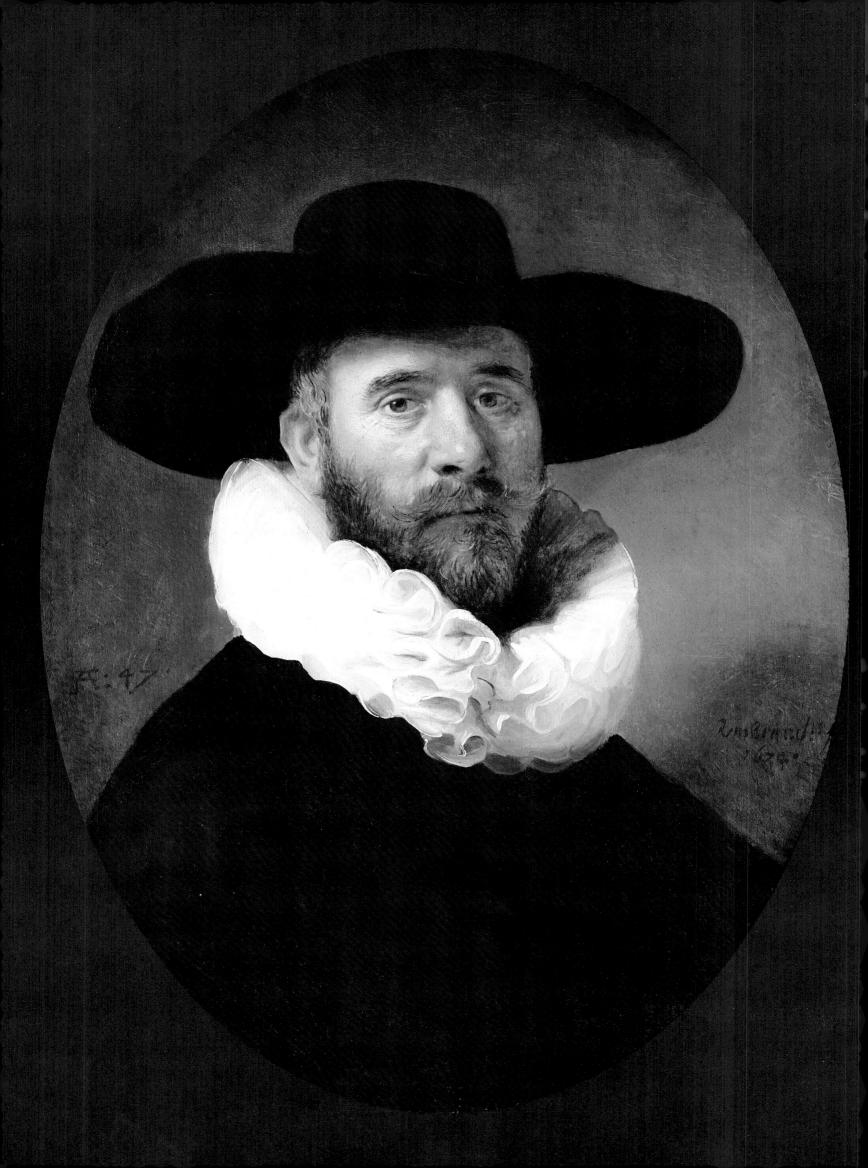

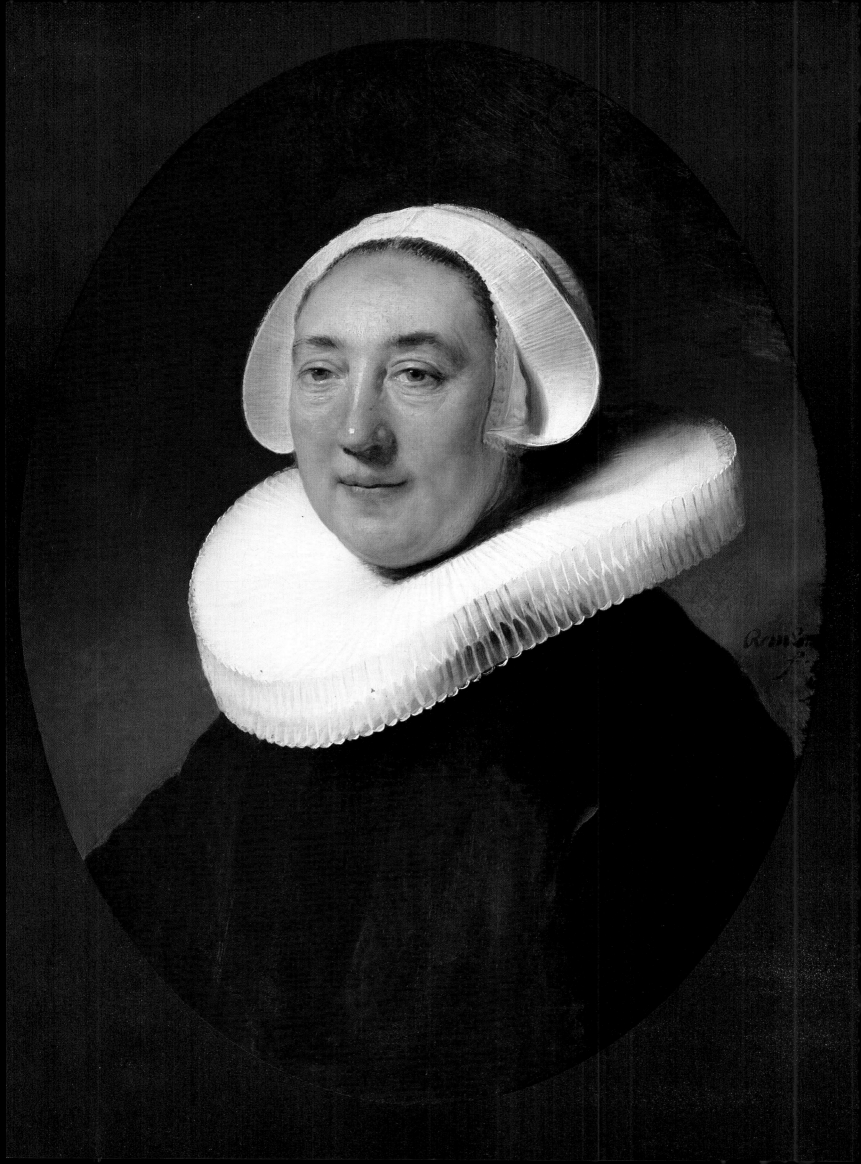

1

1. 2.
These two engravings are most
likely portraits of the artist's mother
after the death of her husband
Harmen. Although Rembrandt does
not identify her specifically in any
of his paintings or engravings, the
model is clearly identifiable from one
work to another, and all of these
were done while he was still
living at home.

2

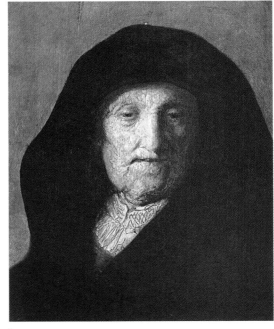

3

Rembrandt painted and engraved numerous portraits of his mother, Nelltjen (short for Cornelia). They all convey the wisdom and gravity of the old woman and communicate a deep sense of her humanity. She was a loving, devoted parent and believed early on in her son's genius, which she sustained and encouraged up to the end of her life.

Rembrandt's departure in 1631 for Amsterdam added to her loneliness. Harmen, her husband and her eldest son, Gerrit, had both died in the same year. Worn out, she could not attend her son's wedding and had to send an affidavit giving her consent. She died on September 14, 1640, leaving an estate of 9,960 guilders, which was equally divided among her surviving children. Rembrandt received a half share in the family's mill. She was buried with her husband in the crypt of Saint Peter's Church in Leyden. Some fourteen years later Rembrandt would give his newborn daughter the name Cornelia, in honor of a grandmother whom the child would know only through her father's engravings.

PRECEDING PAGES

1. *Portrait of a Man with a Large Hat* (Dirck Pesser?), 1634.
Oil on panel. 67 x 52 cm.
Los Angeles County Museum of Art, Los Angeles.

2. *Portrait of Haesje van Cleyburg*, 1636.
Oil on panel. 68 x 53 cm.
Rijksmuseum, Amsterdam.

1. *Rembrandt's Mother in a Black Veil*, 1631.
Etching, second state. 14.9 x 13.1 cm.
Rembrandthuis, Amsterdam.

2. *Rembrandt's Mother in a Nightcap*, 1633.
Etching, second state. 4.2 x 4 cm.
Rembrandthuis, Amsterdam.

3. *Rembrandt's Mother*, 1630.
Oil on wood. 35 x 29 cm.
Private collection, Essen.

4. *The Prophetess Anne*, (Rembrandt's mother?) (detail)
Oil on wood. 60 x 48 cm.
Rijksmuseum, Amsterdam.

4.
This painting of an old
woman reading has often been
interpreted as representing the
prophetess Anna, who was the
first to recognize Jesus as the
Messiah. Once again
Rembrandt's mother is the
model. This is one of his last
works from Leyden, a period that
was characterized by miniature
painting on wood.

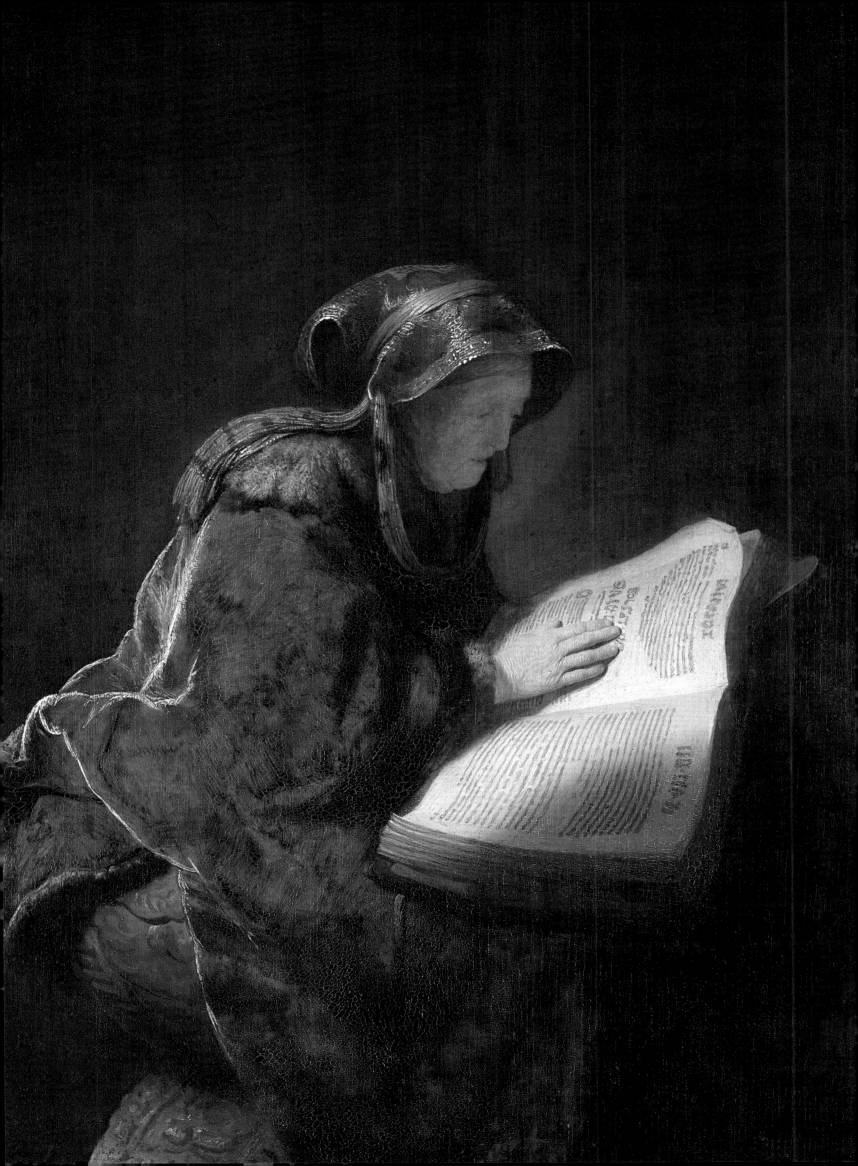

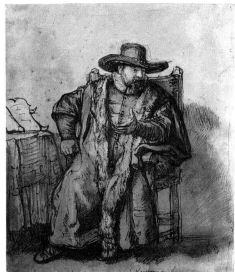

1. 4.
The scholar and writer Ephraim Bueno was one of Rembrandt's numerous Jewish friends. He enjoyed painting them and used their facial features in his biblical paintings.

2. 3.
In 1641 Rembrandt made an engraving of the Mennonite pastor Cornelis Claesz Anslo, whose portrait he had painted the year before. The poet Joost van den Vodel wrote at the time: "Rembrandt should have painted Anslo's voice. To see him was to hear him." His remarks influenced Rembrandt. Immediately afterwards he painted a portrait of the pastor addressing a woman.

Religion in the new Calvinist state was not monolithic. Aside from the two official churches (Dutch Reform and Wallensian) numerous sects flourished. Rembrandt was brought up in a tolerant home. His father had converted to Calvinism, while his mother remained Roman Catholic, and he was open minded having friends of many different denominations. He has given us portraits of the Calvinist Jan Corneliszoon Sylvius, of the Arminian Jan Uytenbogaert, of the Jewish teacher and writer Ephraim Bueno and of the Mennonite merchant and preacher Cornelis Claeszoon Anslo. The artist frequently socialized with Catholics at a time when the practice of their religion was banned from the city. Although Rembrandt devoted much of his artistic energy to painting biblical scenes, we cannot say for certain what his religious convictions were.

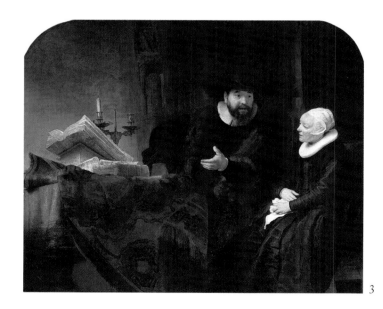

1. *Portrait of Ephraim Bueno*, 1647.
Etching, drypoint and burin, second state. 24.1 x 17.7 cm.
Rembrandthuis, Amsterdam.

2. *Portrait of Cornelis Claesz Anslo*, 1640.
Drawing.
Louvre (Rothschild Collection), Paris. RMN.

3. *Portrait of Cornelis Claesz Anslo with a Woman*, 1641.
Oil on canvas. 176 x 210 cm.
Gemäldegalerie, Staatliche Museen, Preussicher Kulturbesitz, Berlin.

4. *The Jewish Doctor Ephraim Bueno*, ca. 1647.
Oil on panel. 19 x 15 cm.
Rijksmuseum, Amsterdam.

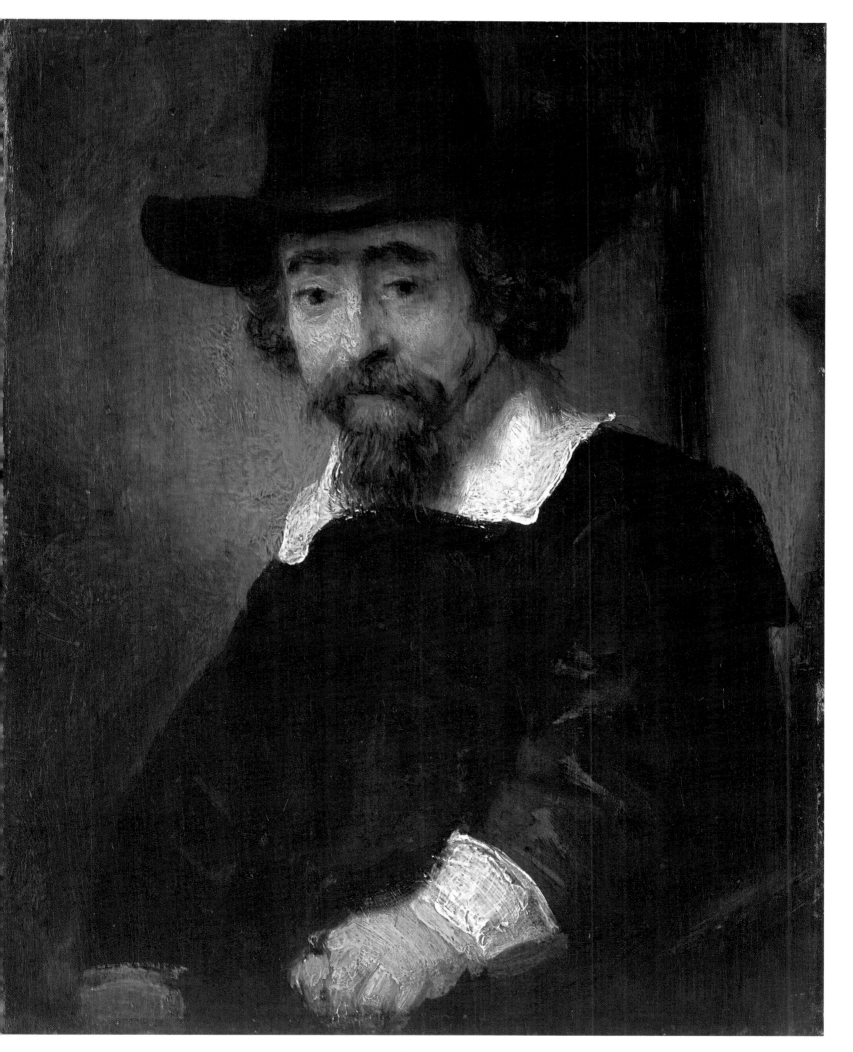

The Self-Portraits

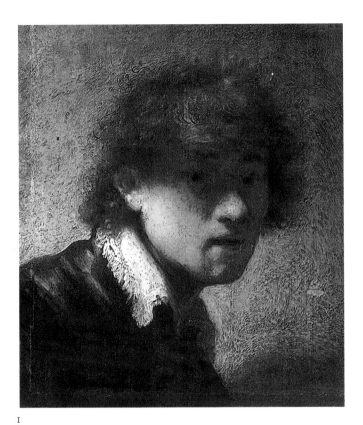

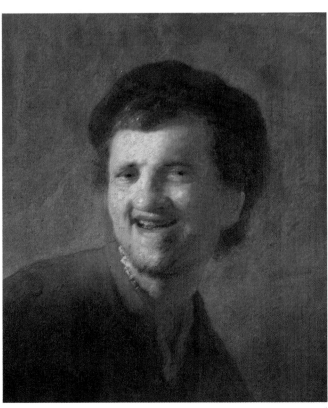

1.
Rembrandt is
twenty-three years
old. Before the mirror
he scrutinizes his
own face.

From 1625 until the time of his death Rembrandt painted about one hundred self-portraits. Narcissism? Defiance of passing time? It really doesn't matter. Rembrandt's quest was lifelong and it is painting — his own painting — that his self-portraits interrogate. Unlike most of the painters of his day, Rembrandt did not paint self-portraits solely to affirm his respectability and social status. He examined his own countenance, transcribing the various fleeting expressions of which it was composed. He was his own model, ever ready, ever being questioned. He enjoyed dressing up (in a gorget or in oriental costume for example) and making faces (with eyebrows raised, pouting or laughing). His visions of himself range from stark simplicity to arrogant grandiosity. But late in life it is alone in his studio at work painting that he most often chooses to represent himself.

Recently art historians have challenged the authenticity of a number of his self-portraits. Since 1982 a team of scholars has been engaged in the Rembrandt Research Project, reevaluating the totality of the artist's production with an implacable scientific and

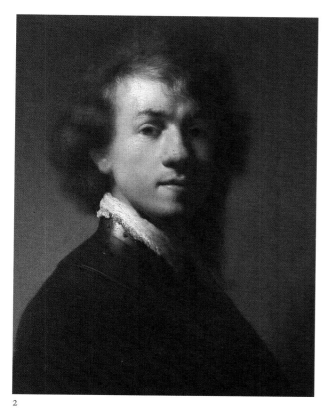

2

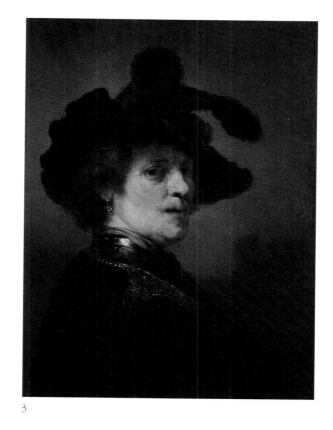

3

2. 3.
This self-portrait is often
considered as a response to a
portrait of Rembrandt painted by
Lievens in the same year. Rembrandt
never saw military service, but one
could speculate that the high
collar and the officer's dress
(3) symbolize the pride of
the newly independent
United Provinces.

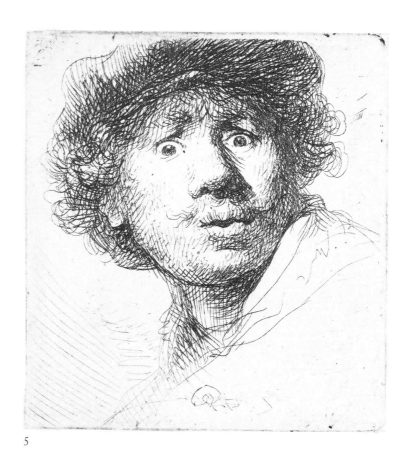

5

1. *Self-Portrait*, 1629.
Oil on wood. 15 x 12 cm.
Alte Pinakothek, Munich.

2. *Self-Portrait with a High Collar*, 1629.
Oil on panel. 37 x 29 cm.
Mauritshuis, The Hague.

3. *Self-Portrait with a Hat (or Portrait of an Officer)*, 1637.
Oil on wood. 62 x 47 cm.
Mauritshuis, The Hague.

4. *Self-Portrait*, 1630. (also attributed to Lievens)
Oil on panel. 41 x 33 cm.
Rijksmuseum, Amsterdam.

5. *Self-Portrait with Haggard Eyes*, 1630.
Etching. 5.1 x 4.6 cm.
Rembrandthuis, Amsterdam.

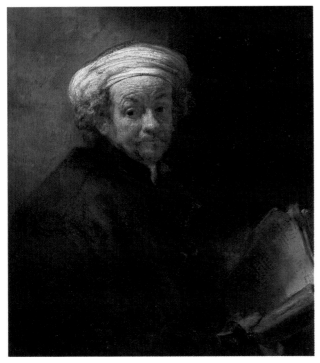

1

critical scrutiny. His corpus has been divided into three categories: authenticated Rembrandts; suspect works; wrongly attributed works. At the beginning of the century Rembrandt's catalog included over one thousand paintings, engravings and drawings. In the late 1960s the eminent Rembrandt historian Horst Gerson reduced the number to about six hundred. It is likely that by the end of the Rembrandt Research Project (probably in the year 2,000) only three hundred works will remain as indisputably his.

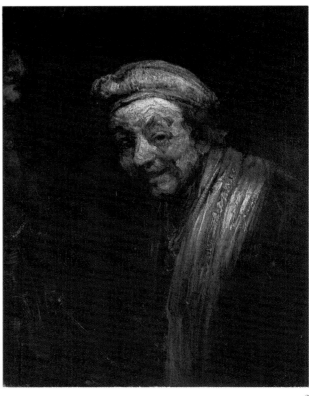

2

1. 2.
Rembrandt liked to represent himself in his self-portraits in the guise of other figures. Here he assumes the persona of the apostle Paul, who persecuted Christians before his conversion and then was persecuted himself and finally beheaded. His self-portrait laughing perhaps evokes the Greek painter Zeuxis, celebrated by Aristotle for his effects of light and shadow.

1. *Self-Portrait as the Apostle Paul,* 1661.
Oil on canvas. 91 x 77 cm.
Rijksmuseum, Amsterdam.

2. *Self-Portrait (or Rembrandt Laughing),* 1665.
Oil on canvas. 82 x 63 cm.
Wallraf-Richartz Museum, Cologne.

3. *Self-Portrait* (detail), 1669.
Oil on canvas. 59 x 51 cm.
Mauritshuis, The Hague.

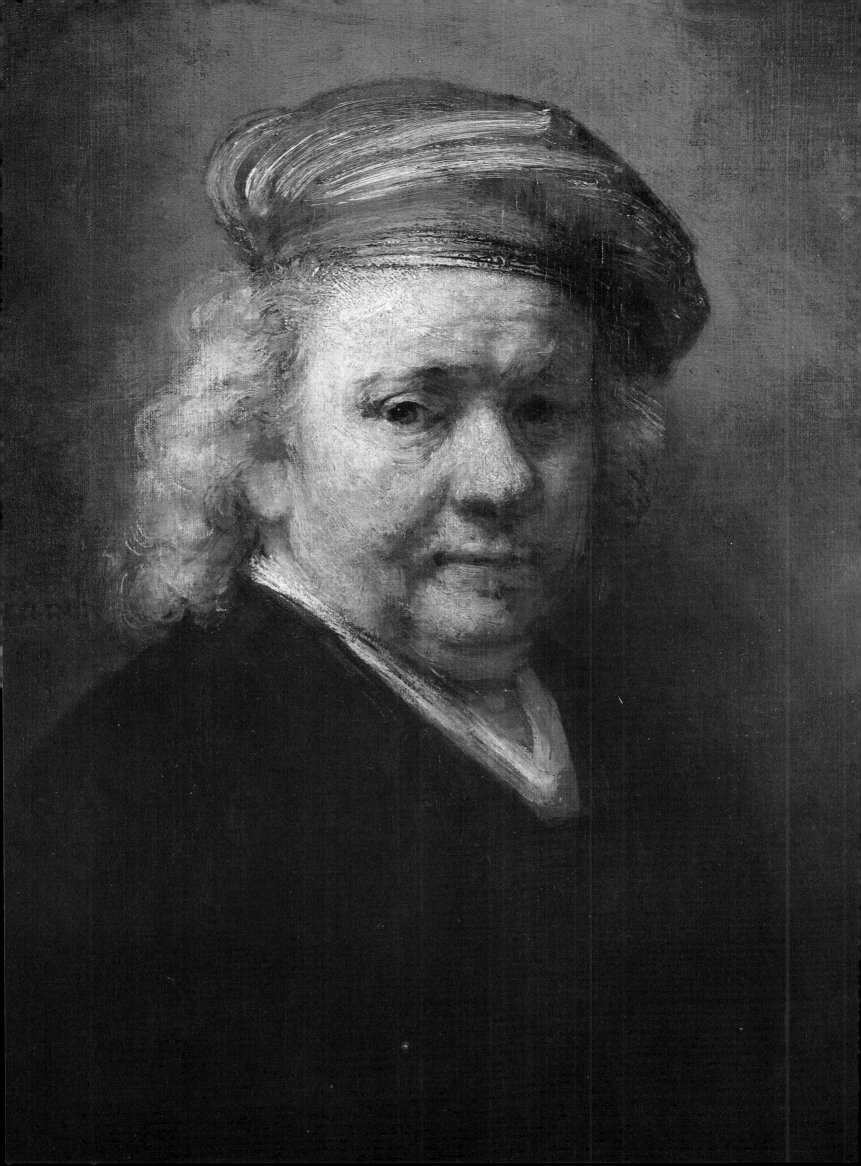

Influence of the Old Masters

I

Perhaps in time we will come to recognize that Rembrandt was a much greater painter than Raphael.

(Delacroix, Journal)

2

3

1.
Rembrandt only knew da Vinci's *Last Supper* from a reproduction. Nonetheless he succeeded in capturing the power of the original, while adding a baldaquin in the center of the picture. This eliminated the linear perspective used by da Vinci and characteristic of Italian Renaissance painting.

4

3. 4.
Raphael painted his famous portrait of Balthazar Castiglione, author of the *Book of the Courtier*, in 1516. A wealthy Spanish merchant, Alphonso Lopez, paid 3,500 florins at auction in Amsterdam on April 9, 1639. Rembrandt executed a rapid sketch of the painting during the auction.

Despite the judgment of Arnold Houbraken, whose biography of Rembrandt appeared in 1720, that Rembrandt "never submitted to any rule dictated by others," it is undeniable that his painting was inspired by the masters of the Italian renaissance and the greatest of his contemporaries and shows the imprint of his own century.

He made his own the shadows and chiaroscuro of Caravaggio and Elsheimer, whose secrets his teacher, Pieter Lastman, had passed on to him. But his greatest admiration was for Raphael, Titian and Michelangelo. As he became wealthy, Rembrandt began to collect prints, becoming a regular in the auction houses of Amsterdam. His biographer Baldinucci reports that "his first offer would be so high that no one ventured to bid against him. He would say that he did this to increase the prestige of his profession." On April 9, 1639 Raphael's famous *Portrait of Balthazar Castiglione* was sold to a wealthy merchant, who already had Titian's *Aristotle* in his collection, for the sum of 3,500 guilders. Rembrandt had to content himself with drawing the painting during the sale.

1. *The Last Supper* (after da Vinci), 1633.
Red chalk. 36.5 x 47.5 cm.
Metropolitan Museum of Art (R. Lehman Collection), New York.

2. *The Last Supper*, 1496-1498.
Leonardo da Vinci. Fresco in tempera and oil. 460 x 880 cm.
Santa Maria delle Grazie, Milan.

3. *Portrait of Balthazar Castiglione*, 1516.
Raphael. Oil on canvas. 82 x 67 cm.
Louvre, Paris, RMN.

4. *Balthazar Castiglione* (after Raphael), 1639.
Drawing in pencil and watercolor. 16.3 x 20.7 cm.
Albertina, Vienna.

5. *Self-Portrait at the Age of 34* (detail), 1640.
Oil on canvas. 102 x 80 cm.
National Gallery, London.

5.
Critics have observed the influence of Titian in this self-portrait painted when Rembrandt was 34 years old. He was beginning to enjoy considerable success in Amsterdam's art world. He adopts here a pyramidal construction and the horizontals (stone balcony, right arm and hat brim) typical of the Italian renaissance.

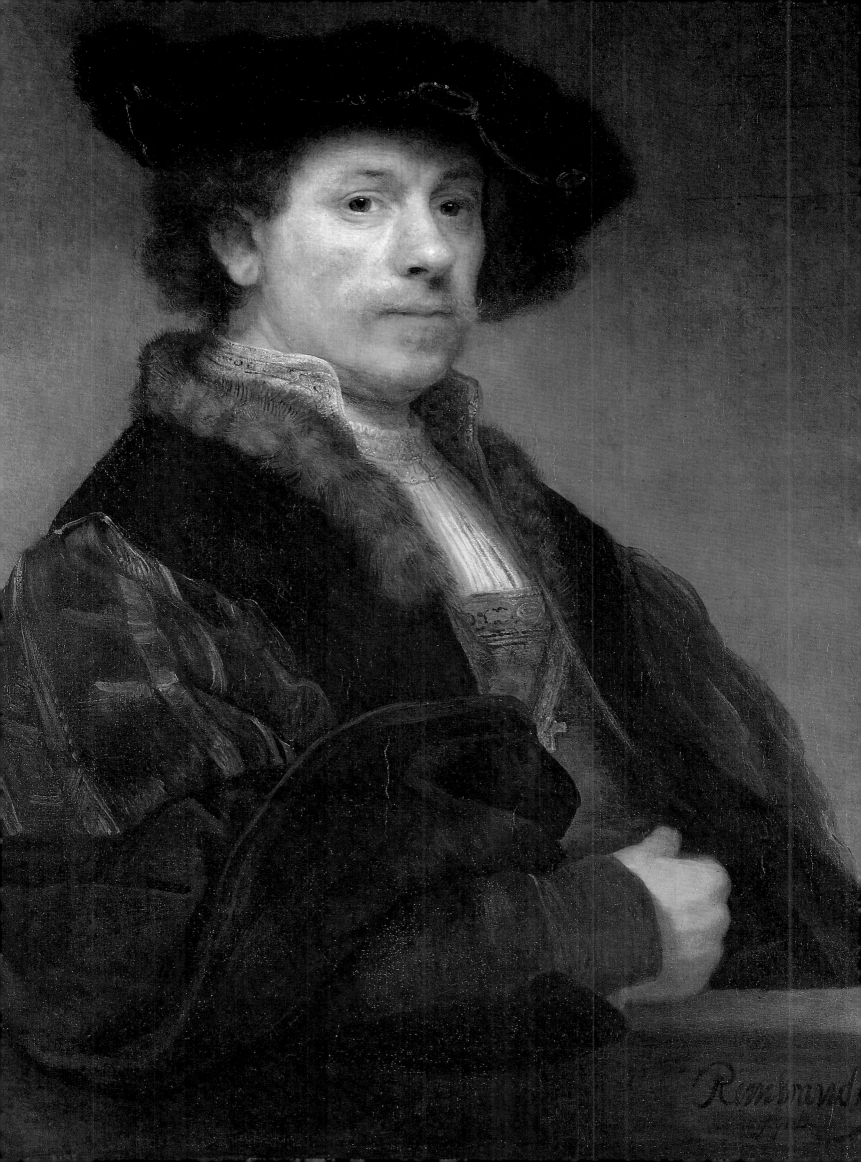

A Commission from the Prince

My most gracious lord, I hope that Your Lordship will inform His Excellency that I am in the process of finishing with as much diligence as possible the three paintings on the subject of the Passion, that His Excellency has ordered: The Entombment, The Resurrection and the Ascension, to accompany The Elevation of the Cross and The Descent from the Cross.

(Letter from the artist to
Constantine Huygens, 1635)

1

2

3

1.
Frederick-Henry became Stadhouder in 1625. He was the first prince of the House of Orange to amass an important art collection. He was helped in this by his secretary Constantin Huygens.

2. 3. 4.
There have been many versions of *The Descent from the Cross.* In the renaissance Roger van der Weyden emphasized the splendor of the costumes and the compositional elements (the diagonal of the body of Christ and of the Virgin, and the verticals of their arms and the cross). Rubens was more interested in the emotions generated by the scene, which he expresses by a daring use of contrasting colors. Rembrandt simplified Rubens's composition, which he probably had studied in reproductions. The tangible weight of the slumped body of Christ and his nudity are enough to convey the agonized grief of the moment. Rembrandt includes himself in the painting. He is the Roman soldier on the ladder who helps to hold up the broken body.

In 1634, three years after his arrival in Amsterdam, Rembrandt received a commission from the Stadhouder Frederick-Henry of Orange. The young artist had truly arrived. The subject decided upon was the Passion of Christ, which was to be treated in five works. The choice of subject must have delighted Rembrandt. The Reformation had deprived painters of the opportunity of handling New Testament themes, and these were especially dear to him. One can suppose that he took his inspiration for *The Elevation of the Cross* from one of his earlier treatments (1633-34) of the same subject. Rembrandt was late in delivering the work; perhaps he was holding out for a higher price than the six hundred guilders the prince had promised him for each canvas.

1. *Portrait of Fredrick–Henry of Orange and His Wife,* 1637-1638.
Gerrit van Honthorst. Oil on canvas. 213 x 201.4 cm.
Mauritshuis, The Hague.

2. *The Descent from the Cross,* 1612.
Rubens. Oil on wood. 420 x 310 cm.
Notre-Dame Cathedral, Anvers.

3. *The Descent from the Cross,* ca. 1435.
Roger van der Weyden. Oil on wood. 220 x 262 cm.
Prado, Madrid.

4. *The Descent from the Cross,* 1634.
Oil on canvas. 89.4 x 65.2 cm.
Alte Pinakothek, Munich.

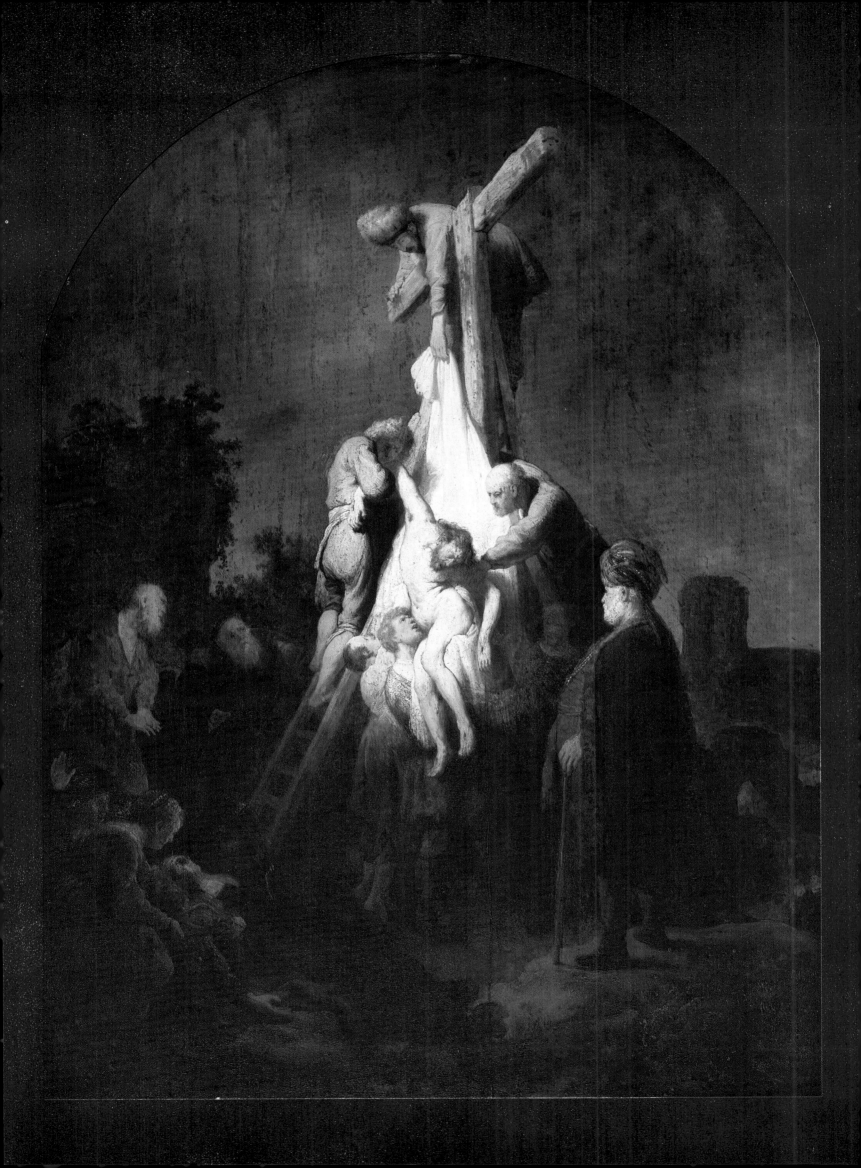

Saskia and Happy Days

Even before their marriage, which took place in a Calvinist church on June 22, 1634, Rembrandt delighted in painting Saskia. She became his muse, magnificently clothed, or a heroine of legends, by turns Sophonisbe, Minerva and Esther.

Aside from her natural poise, which allowed her to wear the most sumptuous costumes with an unaffected dignity, Saskia was an educated woman. She could read and write, a rare thing for a woman in that time. It was she who introduced Rembrandt to Amsterdam's high society.

With the dowry he received from his bride and the money he was realizing from numerous commissions, Rembrandt experienced a period of real affluence. The young couple felt somewhat confined in the house of Saskia's relative (and Rembrandt's partner) Hendrick, where they were surrounded by canvases. They moved in 1635 to lodgings in Nieuwe Doelenstraat, and Rembrandt found a warehouse on the Bloemgracht that he turned into a studio. He reveled in his new-found celebrity and could at last fully indulge his taste for collecting. In time he built up an important collection that included reproductions of the great Italian masters as well as original works by Van Eyck, Rubens and Seghers.

His in-laws accused him of squandering his wife's inheritance. This culminated in his bringing a lawsuit against them for defamation of character, in which one of his brothers-in-law supported him.

The paintings of this period reflect Rembrandt's pleasure in life: he depicts himself as an oriental potentate and it is perhaps he and Saskia that pose for his painting of the prodigal son (p. 89). These works and others of this period are filled with rare and costly fabrics. The newly married couple were so happy together that even the death of their infant son, Rombertus (born December 25, 1635, he lived only a few months), did not dampen their enthusiasm and enjoyment of life.

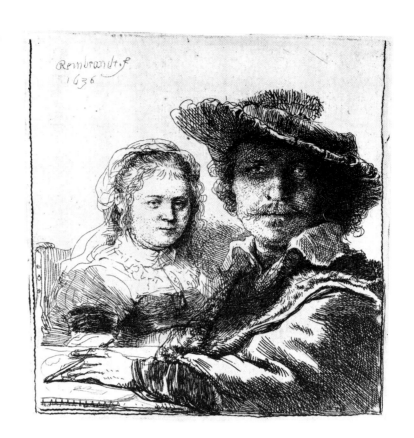

1.
In this etching Rembrandt portrays himself with his wife Saskia. Not only does it express the closeness of their relationship, but also their affluence is indicated by Rembrandt's rich costume and hat.

2.
Saskia's sumptuous clothing in this portrait was by no means typical of the fashions of the day. She holds a carnation, symbol of marriage. Rembrandt paints her in profile following the Italian manner.

1. *Self-Portrait with Saskia*, 1636.
Etching, third state. 10.4 x 9.5 cm.
Rembrandthuis, Amsterdam.

2. *Saskia van Uylenburgh*, 1634.
Oil on wood. 99.5 x 78.8 cm.
Staatliche Kunstsammlungen,
Gemäldegalerie Alte Meister, Kassel.

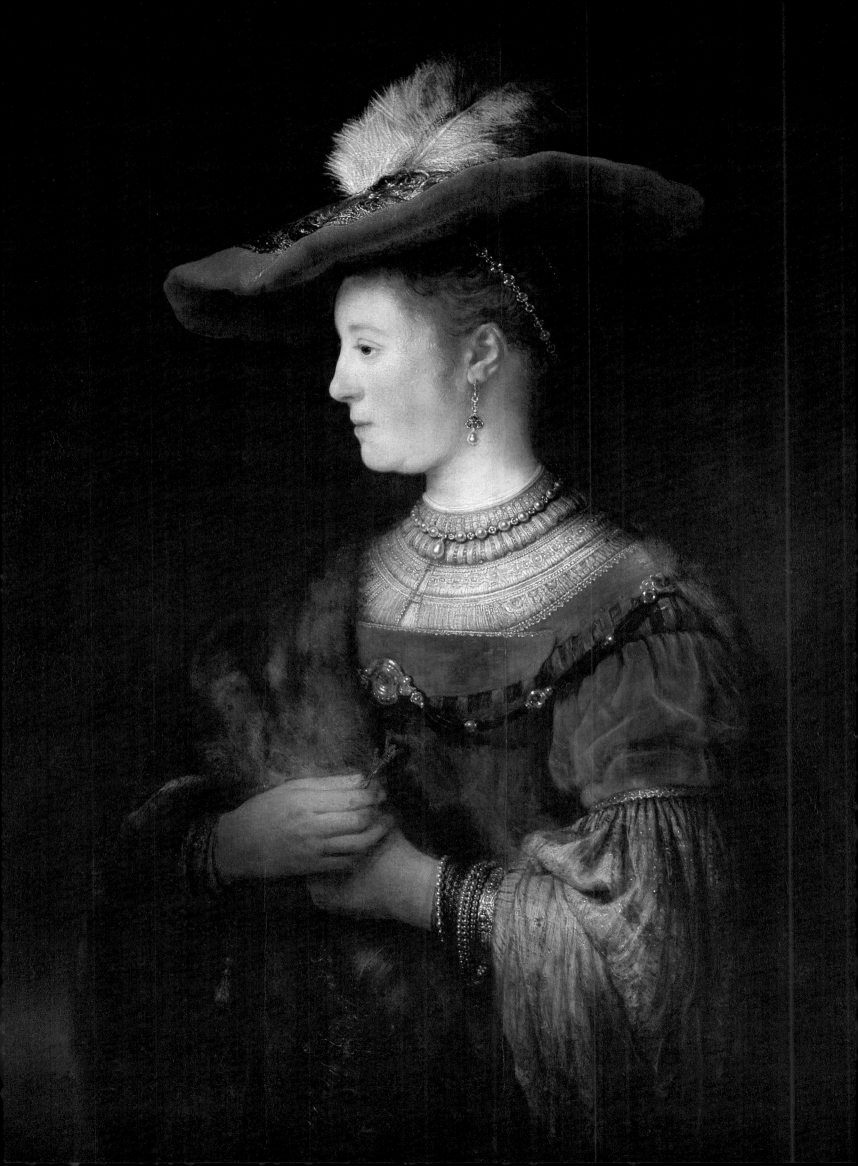

I

Biblical Scenes

1. 2.
Pieter Lastman, Rembrandt's teacher, painted *The Entombment* following the conventions of the Italian renaissance tradition. He accentuated the aesthetic values of the composition and the richness of the clothing to evoke the nobility of the subject. Rembrandt, on the other hand, renders the whole in a brownish monotone. Red and gold light make the body stand out and plunge the rest of the canvas into obscurity. This work was probably a study for one of the five works on the Passion that were painted at the behest of the Stadhouder.

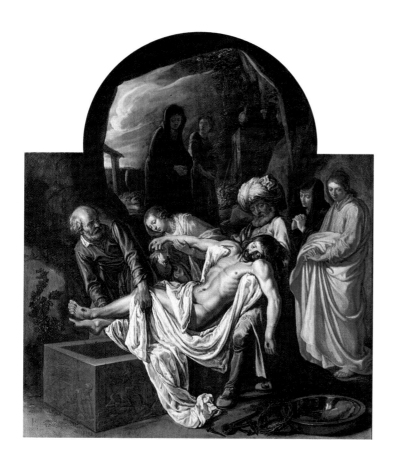

1. *The Entombment*, 1639.
Oil on wood. 32 x 40.5 cm.
Hunterian Art Gallery, Glasgow.

2. *The Entombment*, 1612.
Pieter Lastman. Oil on panel. 123 x 122.5 cm.
Musée des Beaux-Arts, Lille.

One hundred and sixty paintings, eighty engravings and more than six hundred drawings inspired by biblical passages have been attributed to Rembrandt. This is all the more astonishing as these for the most part were done on his own initiative. As mentioned before, commissions for religious paintings were rare in Protestant Holland. André Malraux observed in 1951: "The heroic age of Protestantism took place in a country where one was Protestant by birth, not by resolving upon it before God. And Rembrandt's extraordinary religious painting had less impact on his contemporaries than it does upon us. To continue in this vein, as was the case with Dostoyevsky, he needed to be not only a great painter, but also driven by his inner self toward a dialogue with Christ." For art historians the question remains whether he disassociated himself from the established church or was drawn to practice Protestantism. It is impossible to say with certainty what were his true inward leanings and his religious affiliation. He drew his friends from many different religious backgrounds. (Some of them were actually considered heretics by the powers of the time.) It has been said that Rembrandt was especially drawn to the teachings of the Mennonite preacher Cornelis Anslo and considered for a time adopting the principles of the Anabaptists. The Mennonites believed in the literal text of the Bible and aspired to simple and austere lives. One finds in Rembrandt's work themes dear to Menno Simonsz the founder of the Mennonites: Jesus blessing the children, as well as Old Testament figures such as David, Esther and Hagar, all of whose stories tell of the solitude of man encountering the judgment of God. These ideas are by no means unique to the Mennonites but are fundamental to Protestantism itself. Rembrandt completed many versions of the story of Tobias, the pilgrims at Emmaus and the presentation in the temple, all of which illustrate a Calvinist vision in contradistinction to the apocalyptic themes (the deluge, the massacre of the innocents . . .) which are so much a part of the repertoire of the Italian mannerists.

This may have been the reason that Frederick-Henry chose Rembrandt to execute the series of paintings on the Passion. He would ask him to do two more religious paintings for him. In 1640 he commissioned *Christ and the Woman Taken in Adultery* and also a treatment of the Circumcision. Rembrandt might for a time have been considered the official painter of the Protestant state. His small canvases in contrast to the huge paintings that decorate catholic churches

One of the artist's most important engravings both in size and in complexity, *The Three Crosses* was completed in 1653 at a time when all of his work, both painted and graphic, tended toward dark color and mood.

I

The Hundred Guilder Print

2

2.
Many explanations have been given for
the alternate title of this engraving, *The
Hundred Guilder Print*. One hundred
guilders may have been the price that the
print fetched or perhaps the estimated price
for a print by Marc Antoine Raimondi for
which he traded this work. The artist made
use of a soft pen, a burin and drypoint. He
brings together several incidents from the
Bible: the healing of the sick (on the right),
the dispute with the Pharisees (on the left)
and the young man (on the left covering his
face with his hand) distributing his
possessions to the poor.

1. *The Three Crosses*, 1653.
Drypoint and burin, 4th state. 38.5 x 45 cm.
Rembrandthuis, Amsterdam.

2. *Christ Healing the Sick*
(or *The Hundred Guilder Print*), 1649.
Engraving. 27.8 x 39.6 cm.
Rijksmuseum, Amsterdam.

were intended for private homes and state
buildings. His public was very familiar with
the Bible. Consequently, Rembrandt could
explore subjects that interested him, giving
biblical characters the faces of the Jews who
lived in Amsterdam's ghetto. Often he and
Saskia would make an appearance in these
paintings. Like Shakespeare, to whom he has
often been compared, Rembrandt tried to
understand the human soul, its violence,
weakness, contradictions and ugliness.
Breaking with the aesthetic conventions of
his time, he did not shy away from painting
sweaty bodies or the urine, blood or fear that
defiled them. His reverence for the sacred did
not distance him from his fellow men; on the
contrary it brought him closer and led him
to the experience of compassion and grace. It
is thereby that Rembrandt's work attains its
depth of humanity.

The Bible from Life

1

1.
Rembrandt never hesitated to break with tradition. Conventional depictions of the Fall always included certain set symbols (serpent, dragon, parakeet, cat or hare). Adam and Eve reflect the paradise from which they are to be expelled; they are young and beautiful. Rembrandt pictures them as old and fearful and shows the anxiety the temptation has filled them with. They have already become human.

3.
Rembrandt drew portraits of old people whom he met in the street. These same figures served as his models for his paintings of biblical figures.

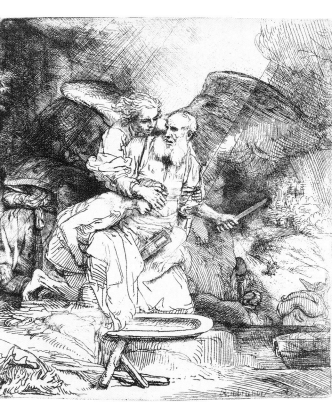

2

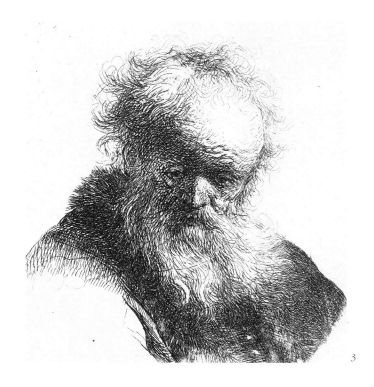

3

1. *Adam and Eve*, 1638.
Etching, second state. 16.2 x 11.6 cm.
Rembrandthuis, Amsterdam.

2. *The Sacrifice of Abraham*, 1655.
Etching and drypoint. 15.6 x 13.1 cm.
Rembrandthuis, Amsterdam.

3. *Old Man with Long Beard*, 1630.
Etching. 7.1 x 6.4 cm.
Rembrandthuis, Amsterdam.

4. *Simeon in the Temple*, 1666-1669.
Oil on canvas. 98 x 79 cm.
State Art Museum, Stockholm.

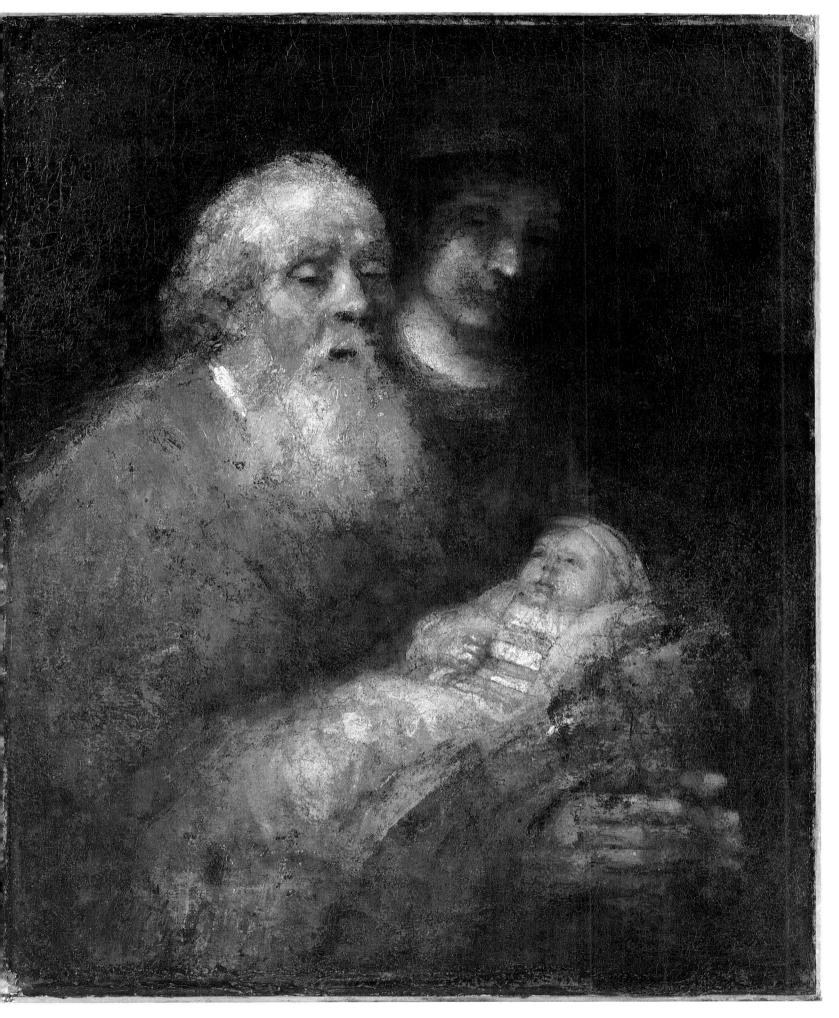

The Prophets

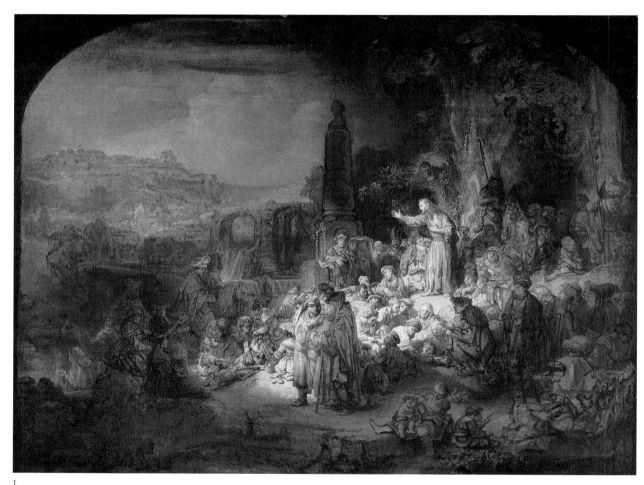

I

1.
Houbraken, Rembrandt's
biographer, wrote in 1718 of
the strong impression that
*The Preaching of John the
Baptist* made on him.
"[This picture] is admirable
in its rendering of the faces
of the audience and the
variety of costumes."

1. *The Preaching of John the Baptist*, 1634.
Grisaille on canvas. 62 x 80 cm.
Staatliche Museen, Gemäldegalerie,
Preussicher Kulturbesitz, Berlin.

2. *The Presentation in the Temple*, 1631.
Oil on canvas. 61 x 48 cm.
Mauritshuis, The Hague.

2.
This version of *The
Presentation in the Temple*
distinguishes itself from
those of 1628 and 1629 by a
compositional quality
infrequently met with in
Rembrandt's work: the
figures are elongated
and architectural
elements predominate.

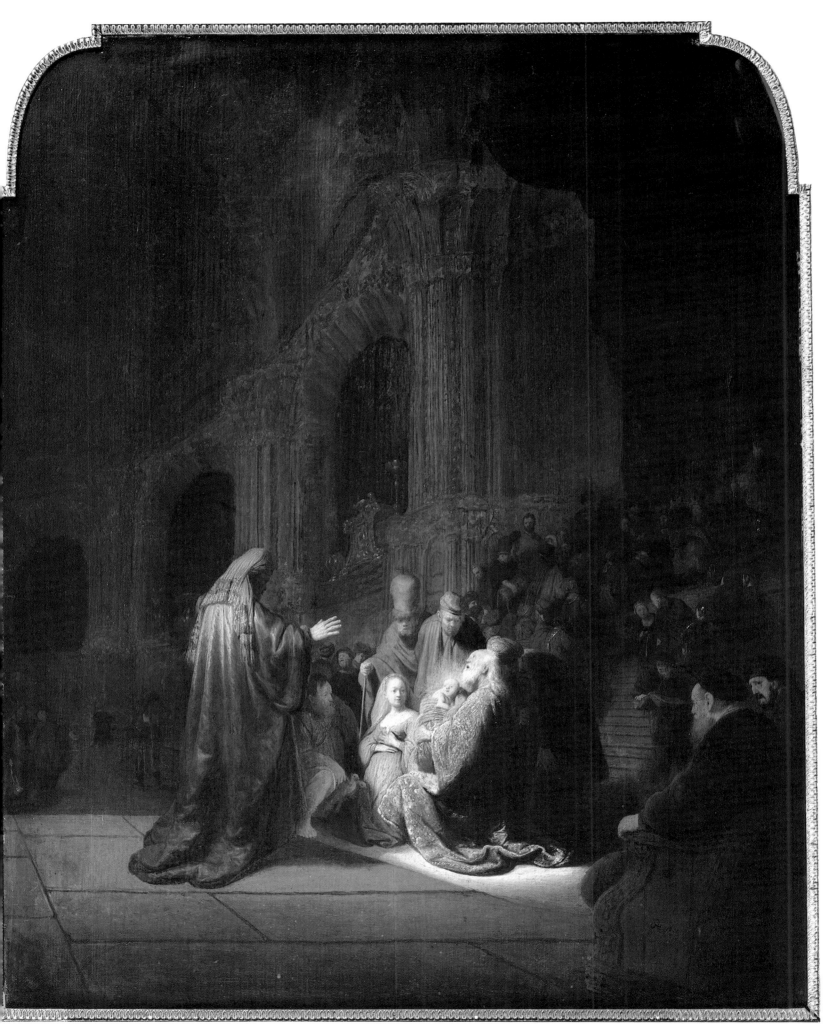

1

2

2.
Aert de Gelder was
Rembrandt's last student.
(He studied with him until
1663.) He preferred warm
shades of brown and gold and
like his master derived much
of his inspiration from the
Bible and mythology.

3.
Jeremiah prophesied the
destruction of Jerusalem, which
came to pass in 586 BC on the
orders of Nebuchadnezzar.
Rembrandt represents the
moment of prophetic vision or
perhaps Jeremiah's grief upon
hearing that his prophecy has
come true. The fine details
of the composition and its
relatively small scale are
typical of the artist's
Leyden period.

1. *Preliminary Study for Judas Returning the Thirty Pieces of Silver*, 1629.
Ecole Nationale Superiore des Beaux-Arts, Paris.

2. *Judas and Tamar*, 1700.
Aert de Gelder. 80 x 92.5 cm.
Rembrandthuis, Amsterdam.

3. *Jeremiah Lamenting the Destruction of Jerusalem*, 1630.
Oil on panel. 58 x 46 cm.
Rijksmuseum, Amsterdam.

Christ at Emmaus

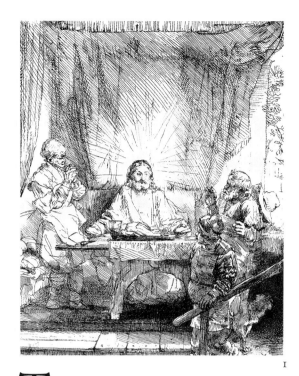

I

I know of no other artist so adept at rendering the same subject in different ways. This was the result of close observation of the different emotions an action could inspire, and how they are apparent on the features of the human face...

(Houbraken)

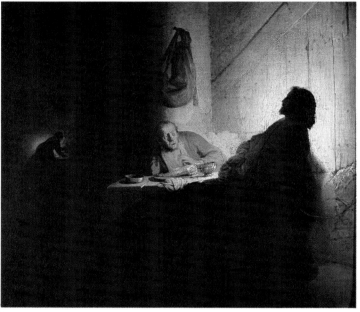

2

Three days after his crucifixion the resurrected Christ revealed himself to two of his disciples while they were having dinner in the small village of Emmaus, a two hours' journey from Jerusalem. Rembrandt was preoccupied with this theme throughout his life, depicting it in fine sketches, engravings and paintings. The most important treatments are those of 1629 and 1648. The space of twenty years between the two works allows us to follow Rembrandt's spiritual and artistic development. At twenty-three Rembrandt concentrates on the instant of revelation. A chair is overturned, the disciple kneels and Christ in the foreground breaks the bread in his hands. At the age of forty-two he focuses on the serenity of Christ, rendered by the simplicity of his attitude and the classical arrangement of the composition. Rembrandt no longer had to add importance to the scene through sudden movement. Gravity and a slow pace seem better to befit the emotional weight of the moment. The artist has grown older and his painting has attained full maturity with a mastery of light and shadow that remains unsurpassed even to the present day. In the painting of 1629 light is treated in the manner of Caravaggio that was in favor in Utrecht (half-light behind the screen, the lamplight behind the old servant) creating an astonishing contrast between the luminous zone in the foreground and the rest of the tableau which is plunged in darkness. In the work of 1648, however, it is impossible to localize the source of the light. Light is part of the miracle; it issues from itself, creating shadows that defy reality but obey the rigorous symmetry of the composition.

1. 3.
Rembrandt worked on numerous versions of *Christ at Emmaus*. In his later painting he gave precedence to the evidence of revelation over the stupefaction that it causes in the disciples.

2.
In this youthful work Rembrandt assimilates the technique of half-light practiced by his teacher, Lastman, and the followers of Caravaggio in Utrecht. Its repetition (in the foreground behind Christ and in the background behind the servant) creates a parallel between the lines of the oblique lighting.

1. *Christ at Emmaus*, 1654.
Etching with burin and drypoint, second state. 21.1 x 16 cm.
Rembrandthuis, Amsterdam.

2. *Christ at Emmaus*, ca. 1629.
Paper mounted on wood. 39 x 42 cm.
Musée Jacquemart-André, Paris.

3. *Christ at Emmaus*, 1648.
Oil on panel. 65 x 65 cm.
Louvre, Paris, RMN.

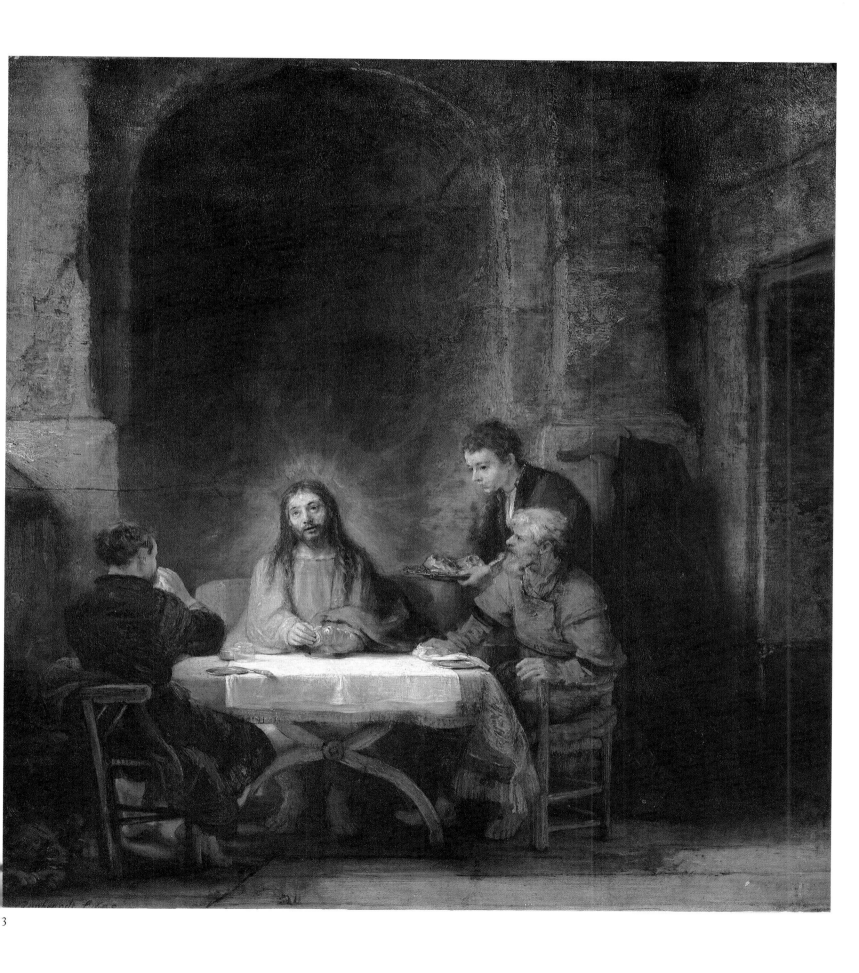

Fascination with the Orient

One sees in his canvases precious stones, pearl necklaces and oriental turbans painted with such thickness that they seem to be in relief. For this reason the paintings have a powerful effect even when seen from far away.

(Houbraken)

1. 2.
From the beginning of their partnership in 1631 Rembrandt and Lievens often worked on the same subjects and sometimes even the same works. Here Rembrandt amuses himself by copying Lievens's etching in reverse.

Since 1602 the all-powerful Dutch East India Company and its offspring the West Indies Company, which explored Brazil, had traversed the Indian and Pacific Oceans, opened bureaus as far away as Formosa, and founded the city of New Amsterdam, which would be handed over to the English and later be renamed New York. With a navy of over fifty sailing vessels and three thousand men the Dutch brought home from their expeditions the perfumes and colors of the orient. Grains, luxurious fabrics, spices, cane sugar and mahogany piled up on Amsterdam's docks. The East India Company was in fact comprised of innumerable anonymous shareholders: in 1650, they were to realize a gain of 500% on their investments. It is not known whether Rembrandt was one of them, but all sources agree that he was immoderately fond of exotic cloths, which he collected and enjoyed studying and painting.

1. *Head of an Oriental with Beard and Turban.* 1635.
Etching, 4th state.
Rembrandthuis, Amsterdam.

2. *Head of an Oriental,* 1635.
Jan Lievens (retouched by Rembrandt?)
Etching. 15.5 x 13.4 cm.
Rembrandthuis, Amsterdam.

3. *Bust of a Man in Oriental Costume,* 1635.
Oil on panel. 72 x 54.5 cm.
Rijksmuseum, Amsterdam.

3.
From the beginning of the 1630s, that is upon his arrival in Amsterdam, Rembrandt was attracted to oriental costumes, as is seen works such as *Man in Oriental Costume* and *King Uzziah Stricken with Leprosy.* The artist was already frequenting the auction houses of Amsterdam and making purchases of fine fabrics from Holland's far-flung colonial empire.

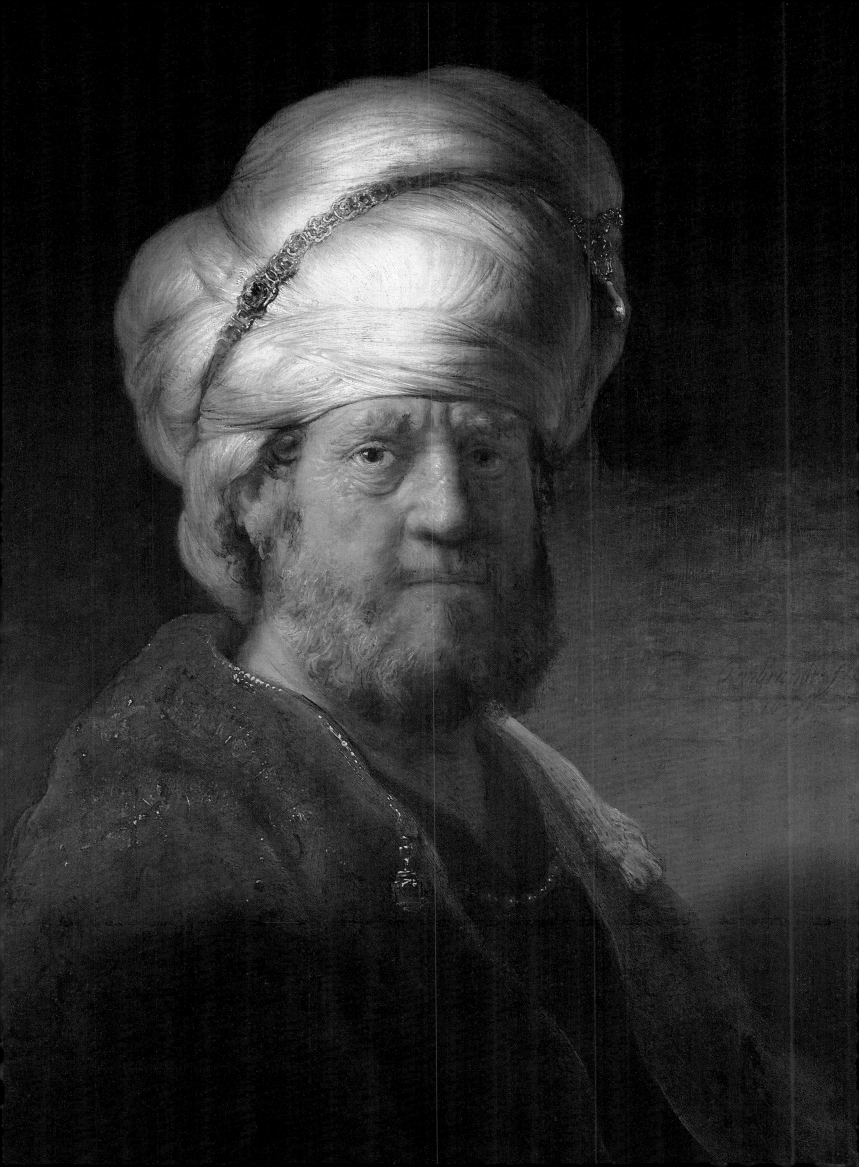

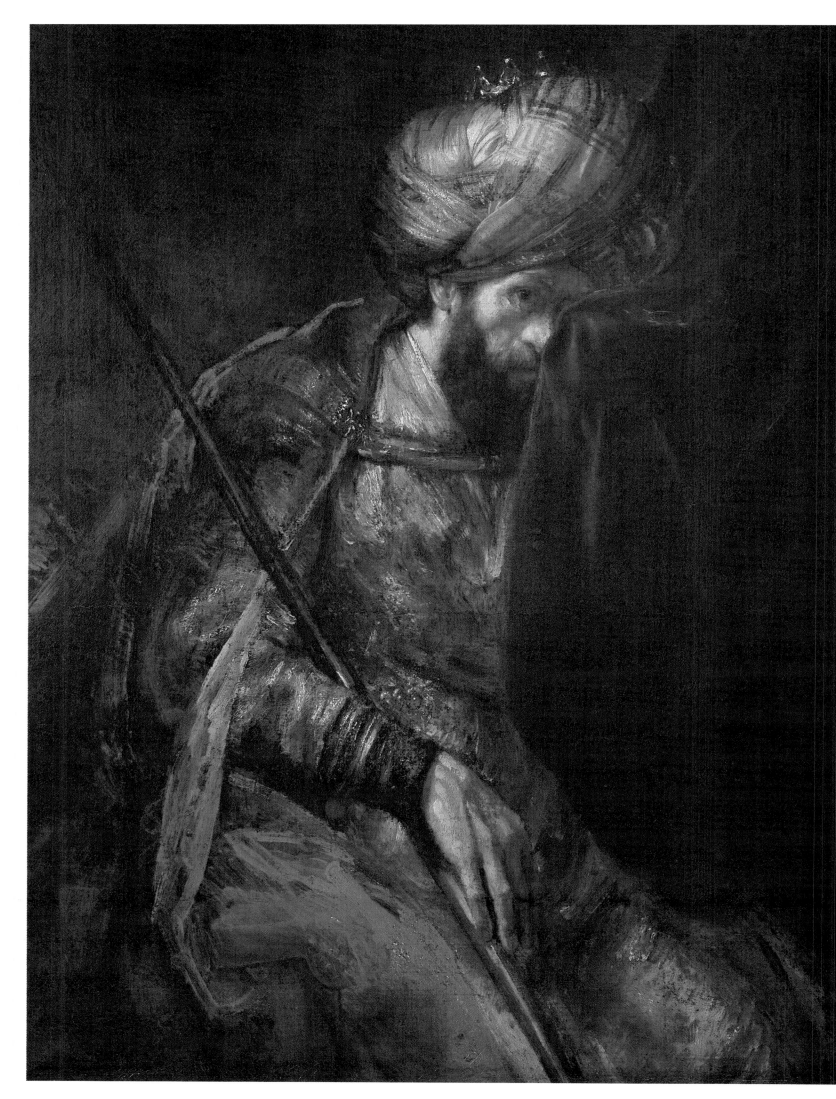

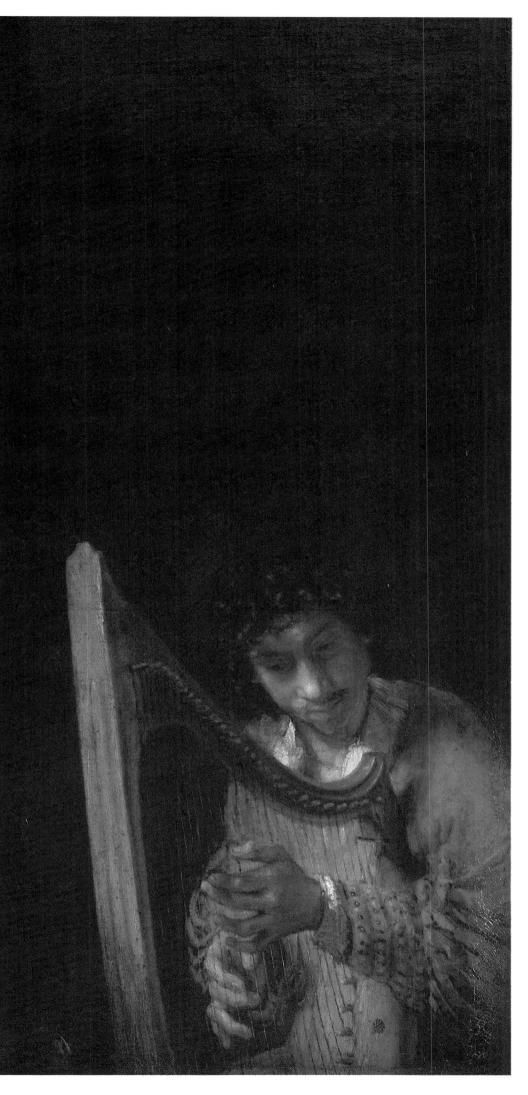

Joachim van Sandrart, who knew the painter, wrote in 1675: "He was a great collector of many different things: paintings, drawings, engravings, all sorts of exotic curiosities, which he possessed in great number, evincing a perspicacity in many different fields." The inventory of Rembrandt's possessions taken in 1656 permits a glimpse into this side of the artist: Chinese baskets, Indian pottery, shells, Japanese helmets, as well as arms and musical instruments from the Near East. He made a number of drawings after Indian miniatures. He also drew musicians and black mimes in an age when slavery was a booming business. Each year the Low Countries purchased fifteen thousand black Africans from Angola and the Gold Coast at a price averaging thirty guilders a head and then sold them for ten times that in the Americas.

But it was fine and rare textiles that most interested Rembrandt; he was always buying them to clothe Saskia and the other models who sat for him. Baldinucci describes his going "often to public auctions where he purchased costumes that were no longer in fashion, but seemed to him bizarre or picturesque. It did not even deter him if they were filthy, for then he would hang them on his walls among the other beautiful, curious objects that he possessed."

David and Saul, 1657.
(Rejected Rembrandt) Oil on canvas. 130.5 x 164 cm.
Mauritshuis, The Hague.

A Life of Ease

He was a particularly active and persevering man. He also lived very well. His house was filled with the scions of Amsterdam's elite who had come to study under him. Clearly he knew how to maintain good relationships with people and had a good head for business. He could have amassed a considerable fortune.

(Joachim Sandrart, 1675)

On January 5, 1639, Rembrandt bought a large residence in the Breestratt on Sint Anthoniesdijk. He took out a mortgage in the amount of thirteen thousand guilders to be payable in five or six years. It was a luxurious three-story gabled house built in 1606. Wealthy and famous, he could finally offer Saskia a home worthy of her station and one that was only a stone's throw from that of Hendrick. Although the asking price for the house was high, Rembrandt's rapid success let him look to the future with every confidence. The commentary of his biographer, Arnold Houbraken, is quite eloquent on this score: " His works were so highly appreciated and in such great demand, that it was not enough to pay, one had to entreat the artist. In addition he had a large number of students, all of whom paid him one hundred guilders a year. Sandrart, who knew him personally, confirmed that he received an annual income of twenty-five hundred guilders from his teaching alone."

Rembrandt's move into the heart of the Jewish quarter set many tongues wagging, but he paid this little mind. Being rich agreed with him, and he understood the art of living well. In 1699 Roger de Piles, his first French biographer wrote: "Although he had made a great deal of money and was a man of discerning taste, he enjoyed conversing with people of low birth. Some who made his affairs their own business would reproach him for this, but he would reply: 'When I wish to relax my mind I look for freedom, not honor.'"

For those who accused him of squandering his wife's fortune in the auction houses, he painted the *Prodigal Son*. Here he portrays himself with Saskia. He looks insolently at the viewer; laughing he raises his glass to the health of those who are attacking him. The provocation no doubt increased the animus of his ill-wishers. It was of little importance. Rembrandt wanted to leave an image to posterity of himself as a successful artist, one who at the age of thirty-three could count himself among the wealthiest merchants of Amsterdam.

1.
Rembrandt bought this house, built in 1606, for the considerable sum of 13,000 guilders, payable over five or six years. The family lived on the second floor, while the top floor was reserved for his studio. The house was filled with paintings and objets d'art (more than one hundred paintings on the ground floor of which half were his own). The house was restored and enlarged in 1911 and turned into a museum.

1. *View of the Artist's House in Amsterdam*, 1868.
J.M.A. Rieke. Brush, pencil, brown ink. 34.6 x 19 cm.
Rembrandthuis, Amsterdam.

2. *The Prodigal Son*, ca. 1635.
Oil on canvas. 161 x 131 cm.
Staatliche Kunstsammlungen, Gemäldegalerie Alte Meister, Dresden.

2.
The Prodigal Son pictured during a night of debauchery before his return to his father's home was a subject often treated. Rembrandt makes use of this theme to thumb his nose at those who accused him of squandering his wife's property.

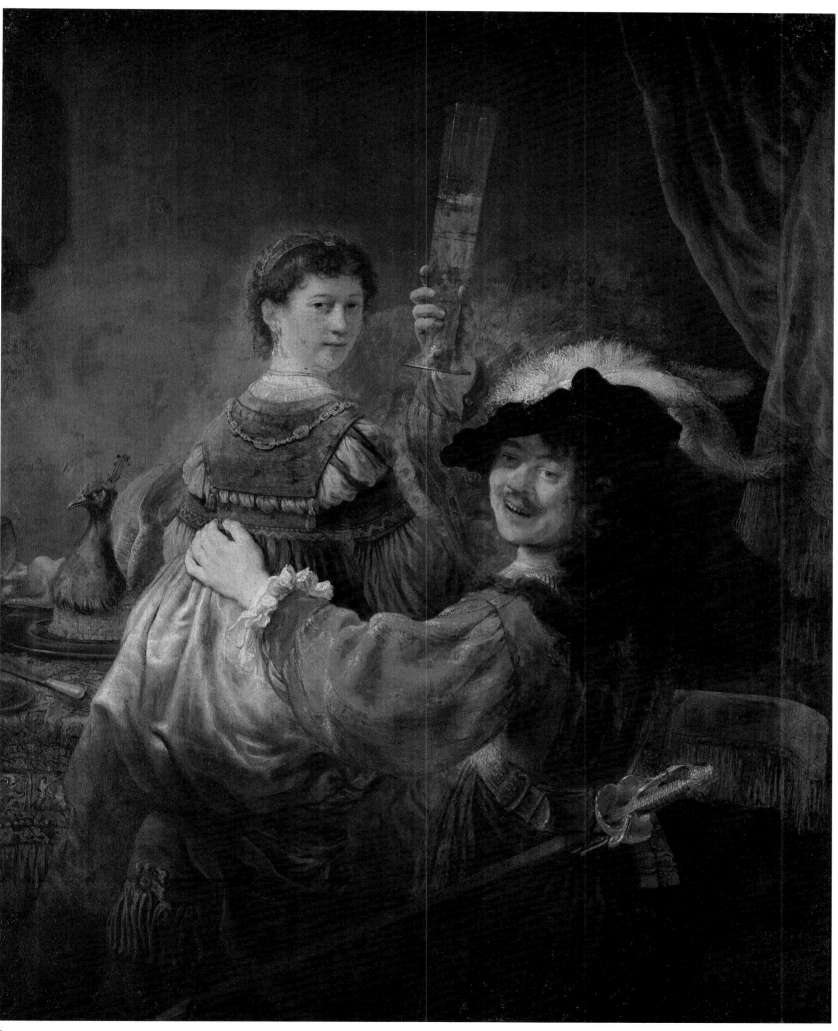

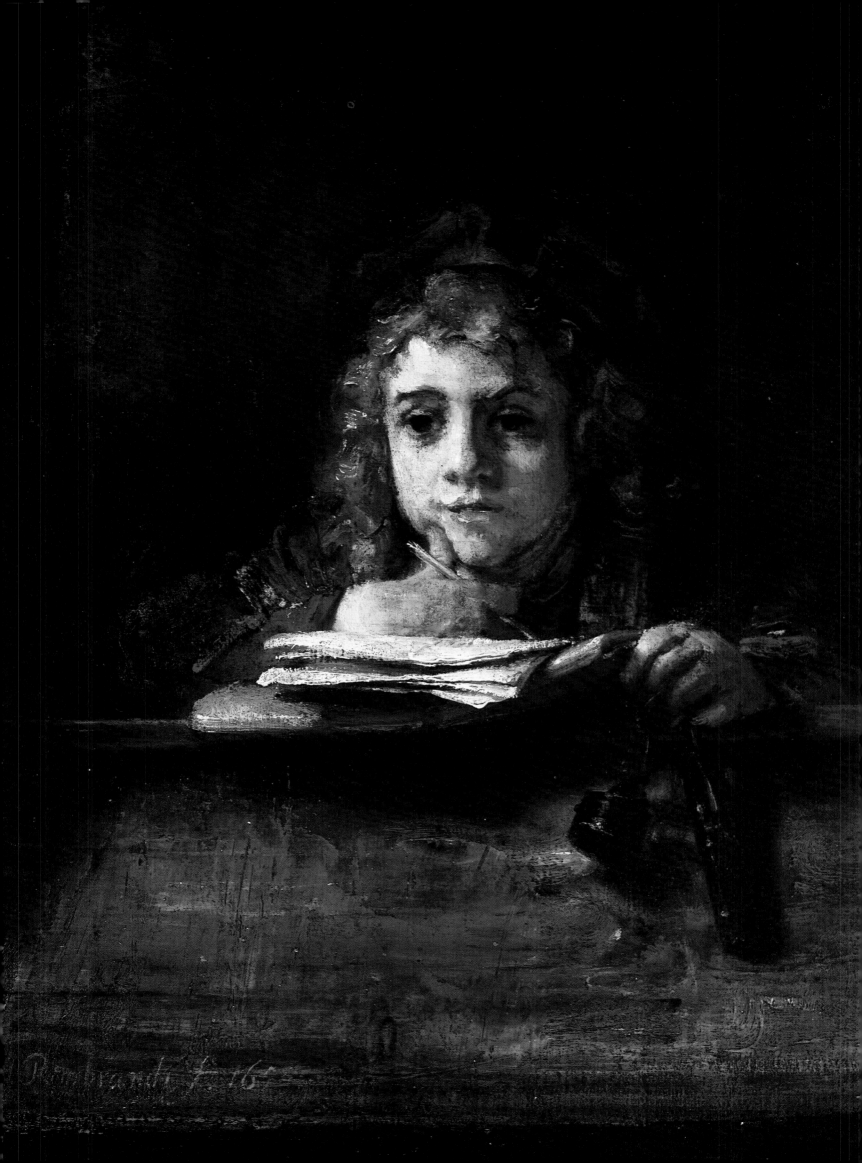

He spent very little on pleasure and less on his household, where he lived very simply. He often ate only some bread and cheese or herring for supper.

(Houbraken, 1720)

1.
Titus was fourteen years old when this picture was painted. He liked to spend time in his father's studio, dreaming of becoming a painter as well. Rembrandt often painted him; his face can be recognized as it changed over the course of the years.

2

2. 3.
Dutch painters were especially fond of domestic scenes. Here Rembrandt (3) uses Saskia and her baby as subjects. Rembrandt's student, Nichols Maes, followed suit in this 1648 work inspired by his master's.

3

1. *Titus at His Desk,* 1655.
Oil on canvas. 77 x 63.
Boymans-van Beuningen Museum, Rotterdam.

2. *Woman with Babe in Arms,* 1650-1660.
Nicholas Maes. Pencil and brown ink. 8.9 x 4.1 cm.
Rembrandthuis, Amsterdam.

3. *Woman with Babe in Arms,* 1635-1640.
Pencil and brown ink. 10.4 x 8.7 cm.
Rembrandthuis, Amsterdam.

The parable of the prodigal son immortalized his social success, but it does not provide an accurate picture of his daily life with Saskia. The pleasurable excitement of moving was no doubt some consolation for the death of their baby daughter Cornelia, born July 22, 1638. She lived for only three weeks. Rembrandt had already paid homage in his Danae to the triumphant femininity of Saskia despite the death of their two-month old son Rombertus. And once again the couple was destined to lose a child, also named Cornelia. She died in August of 1640 after only two weeks of life. Finally their son Titus was born and was baptized on September 22, 1641, at Zuidekerk. Innumerable sketches on little scraps of paper bear witness to a father's delight in all the quotidian details of domestic life. However it was on the second floor of his house on Sint Anthoniesdijk that the artist spent the great bulk of his time. Here he had his studio in which he taught, gave his students work to copy, and retouched their work, all of which render the question of authenticity a thorny one.

Rembrandt also received many commissions. Baldanucci writing in 1681 gives us a verbal portrait of the painter at work: "His rough, awkward countenance was set off by his dirty, neglected dress. He had the habit while painting of wiping his brushes on himself and doing other similar kinds of things. He would not interrupt his work to grant an audience to the greatest monarch in the world." However, the unaccommodating habits of the painter began to put off some of his patrons, and sometimes he let his private life interfere with his paintings. Houbraken tells an amusing story: "One day he was working on a large portrait of a group consisting of a couple and their children. He was just about finished with it when his pet monkey died. Not having another canvas on hand, he included his dead monkey in the painting. Needless to say his models were not happy with presence of this repugnant corpse figuring in the family portrait . . . Rembrandt was delighted at not having to hand over the work, so that he could keep it as a souvenir of his little monkey."

The Dutch Family

Rembrandt's interest in his own family is attested to by the many sketches he made of Saskia and Titus. He also took up the same theme from a religious angle in many

I

1. 2.
Jan Steen, an innkeeper by profession, loved the liveliness of happy, noisy parties. The Calvinist preachers did not object to his works, since they saw in them cautionary examples against excess in food and drink.

2

renderings of the Holy Family. All aspects of domestic life were being thoroughly treated by the Dutch painters of the seventeenth century and this genre deserves serious consideration. The Stadhouder of Amsterdam presented Charles II a painting by Gerard Dou, one of Rembrandt's pupils, of a nursing mother for his accession to the throne of England. Calvinist society smiled upon representations of the family that could boast of an edifying purpose. The role of the mother as teacher is thrown into relief in interiors where she attends to domestic tasks under the gaze of her children. Love and sexuality are treated delicately. Often paintings of interiors contain samplers on walls or little placards on doors with moralistic sentiments. Family reunions and marriages also offer cautionary examples: scenes of drunkenness, gluttony or ill-assorted newlyweds (for example, aging husbands with young brides) allowed painters to identify perils to family life. The Dutch also enjoyed depictions of holidays. The two most important were St. Nicholas Day (December 6), primarily a celebration for children, with stockings hung before the fire, and the Feast of the Three Kings (January 6), where merry-makers shared a cake in which a piece of gold was hidden.

3

3.
This scene with the husband smoking and the wife drinking on their terrace with their child looking on illustrates another aspect of Calvinist didacticism. This is the Dutch family as it should be. In this work of Peter Hooch, who is often compared to Vermeer, all is serene and harmonious.

1. *Family Scene,* (date unknown).
Jan Steen. Oil on canvas. 48.5 x 40 cm.
Rijksmuseum, Amsterdam.

2. *The Happy Family,* 1670.
Jan Steen. Oil on canvas. 110.5 x 41 cm.
Rijksmuseum, Amsterdam.

3. *A Courtyard in Delft,* ca. 1656-1658.
Pieter de Hooch. Oil on canvas. 78 x 65 cm.
Mauritshuis, The Hague.

4. *The Happy Family.*
School of Rembrandt. Oil on panel. 66.5 x 78 cm.
Rijksmuseum, Amsterdam.

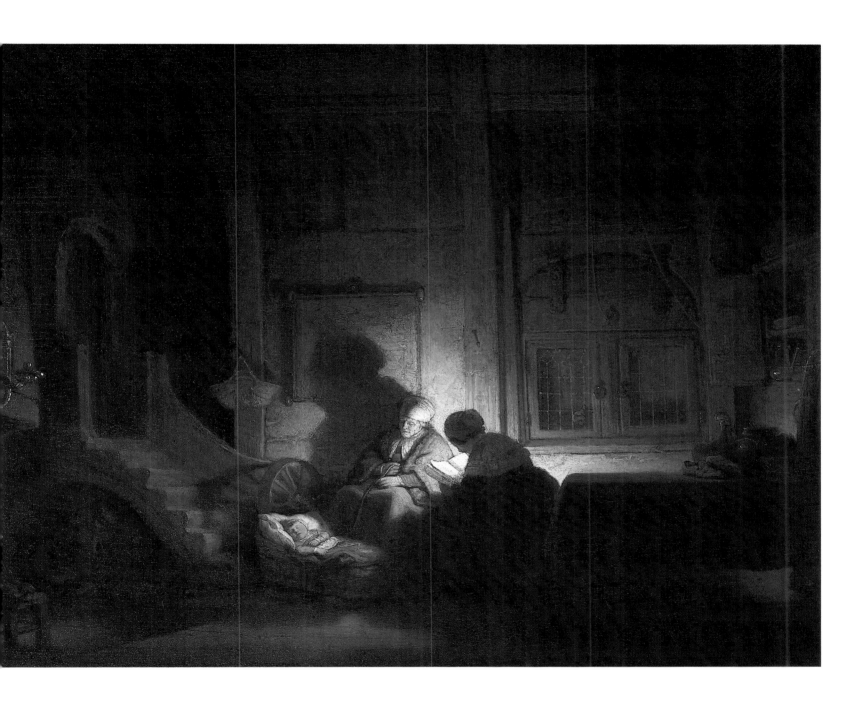

The Music Lesson

The depiction of musical performance has long provided painters with an allegory for romantic love. Titian in his *Venus and Lute-player* used the instrument's obvious sexual symbolism as a correlate to the expression of amorous intent. For the Dutch painters of the seventeenth century the music lesson became a favorite setting for representing love between the sexes, and often a surreptitious exchange of love letters is included in the compositions.

1

At the age of twenty, while still an apprentice, Rembrandt treated this subject, but without symbolic overtones. His *Concert* is a hybrid work. It includes many elements dear to the painter that are repeated and treated in isolation in later works. It shows his family playing music together as was the custom among the well to do of the time. In front of his mother, who listens attentively, Rembrandt presents his sister singing, his father on the viola, while he himself accompanies them on the harp. The richness and eccentricity of their dress suggest an already burgeoning interest in oriental costume.

The lute lying face down, the books spread across the floor, the precious goblet perched on the table beside the musicians, signal if not inclusion in then at least allusion to the genre of vanity painting. But we do not see that moralized theme of excess dominating the painting. Rather the young painter is already working on pictorial ideas that he would struggle with for his entire career.

1.
Steen didn't only paint tavern scenes. He also knew how to express the subtleties of the discourse between lovers, here conveyed through a musical instrument.

2

2.
Gerard Dou, who was one of Rembrandt's first students in the early days in Leyden, continued to work in the miniature style that characterized that period until the end of his life.

1. *Young Woman Playing a Clavier* (detail), 1659.
Jan Steen. Oil on wood. 42 x 33 cm.
National Gallery, London.

2. *Woman with a Clavier* (detail), 1665.
Gerard Dou. Oil on wood. 37.7 x 29.8 cm.
Dulwich Gallery, London.

3. *A Concert (or The Musicians or The Music Lovers)*, 1626.
Oil on panel. 63 x 48 cm.
Rijksmuseum, Amsterdam.

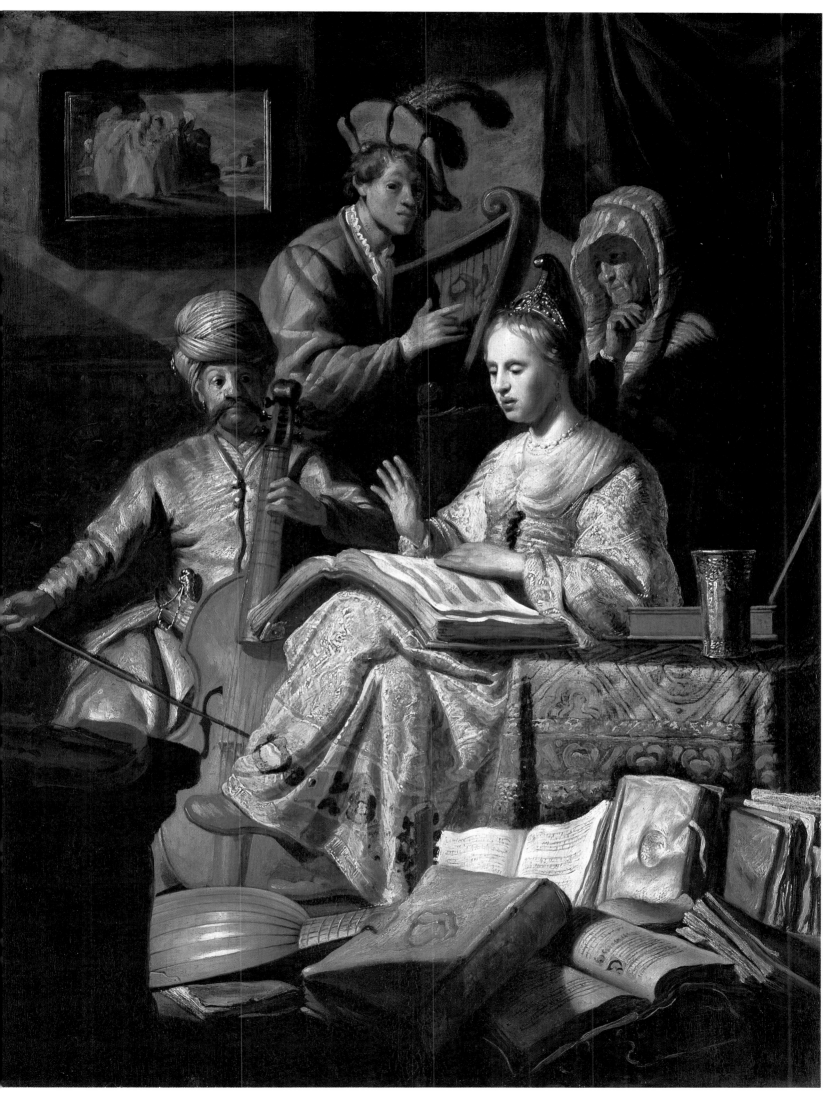

95

While Gerard Dou, Jan Steen, Dirk Hals, Terborch and Vermeer competed with each other in emotional refinement and the delicate renderings of the musical instruments they painted, Rembrandt took to the streets of Leyden preferring to take as his models the wandering musicians whom he met. Rembrandt was drawn to simple pleasures, which were also the subjects of popular songs, sometimes written by well-known poets such as Gerbraud Bredero and Jan Hermansz Krul. Theirs were songs of love, sometimes happy, often sad, and the enjoyment of food and good wine . . . in short of life.

1

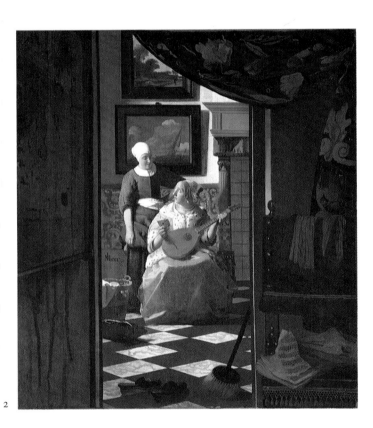

2

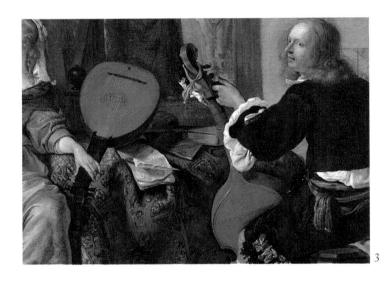

3

2.
One of the most highly esteemed genre works ever painted. The servant surprises her lady while she is playing the lute to deliver a love letter. The troubled expression on the lady's face is wonderfully rendered.

3.
It was common among affluent members of the Dutch bourgeoisie to hold musical concerts in the home.

1. *Merry Makers* (detail), 1627
Dirk Hals. Oil on wood.
Gemäldegalerie, Staatliche Museen, Preussicher Kulturbesitz, Berlin.

2. *The Love Letter*, 1666.
Johannes Vermeer. Oil on canvas. 44 x 38.5 cm.
Rijksmusuem, Amsterdam.

3. *A Concert*, 1659.
Gabriel Metsu. Oil on Canvas. 62.2 x 54.3 cm.
Metropolitan Museum of Art (H.G. Marquand), New York

4. *Strolling Musicians,* 1634.
Etching, first state. 13.8 x 11.5 cm.
Rembrandthuis, Amsterdam.

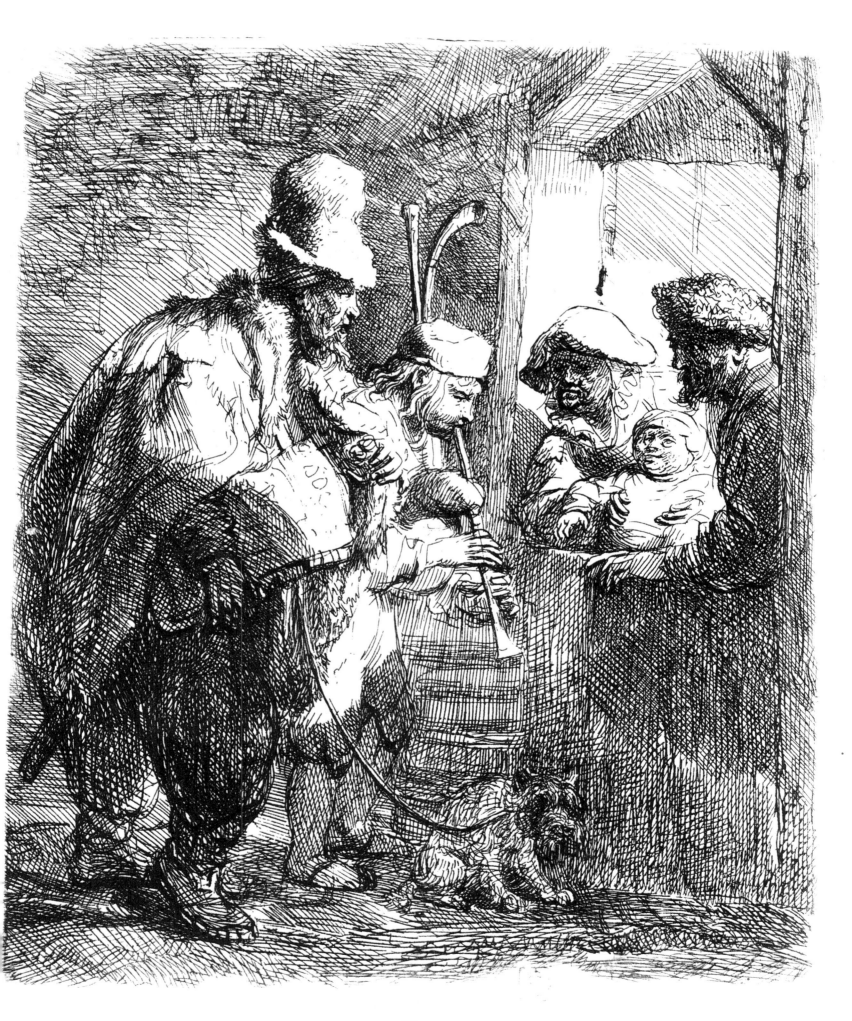

The Nightwatch

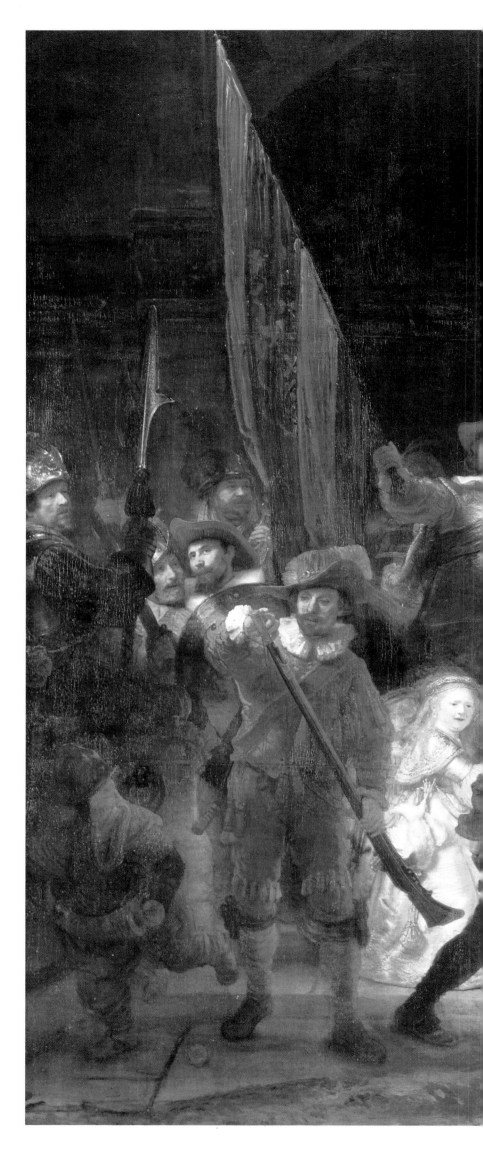

On the occasion of a visit of Mary Medici in 1638, the Corporation of the Citizen's Militia commissioned group portraits from six prominent painters of the time. The company of Captain Cock approached Rembrandt. Rembrandt's students Govaert Flinck and Jacob Adriensz Baker also received commissions along with two young painters then in vogue: Pickenoy and Joachim van Sandrart, Rembrandt's first biographer. The last commission went to Bartholomeus van der Helst, a well-known specialist in this genre and a one of Rembrandt's chief rivals.

All six portraits were meant to be shown in the festival hall of the civil guard. The dimensions of the room (3.40 m. in height) and the number of each company (from sixteen to thirty-two) dictated the dimensions of the finished works.

Each of the sixteen members of Cock's company put up about one hundred guilders for the painting, the precise amount depending on how prominently each figured in the painting.

Sixteen hundred guilders did not constitute a phenomenal sum, when one considers that the rarest tulip bulbs were fetching as much as forty-six hundred guilders. But the prestige of the commission conferred an undisputed celebrity on those chosen.

Rembrandt delivered the work at the beginning of 1642. Since the sixteenth century this genre had developed significantly. Franz Hals had already succeeded in giving naturalness to the models who before had been too stiffly posed. But Rembrandt once again overturned existing conventions, by choosing to represent the company at the moment that the captain calls for the watch

1. (and detail on following page)
The Nightwatch, 1642.
Oil on canvas. 359 x 438 cm.
Rijksmusuem, Amsterdam.

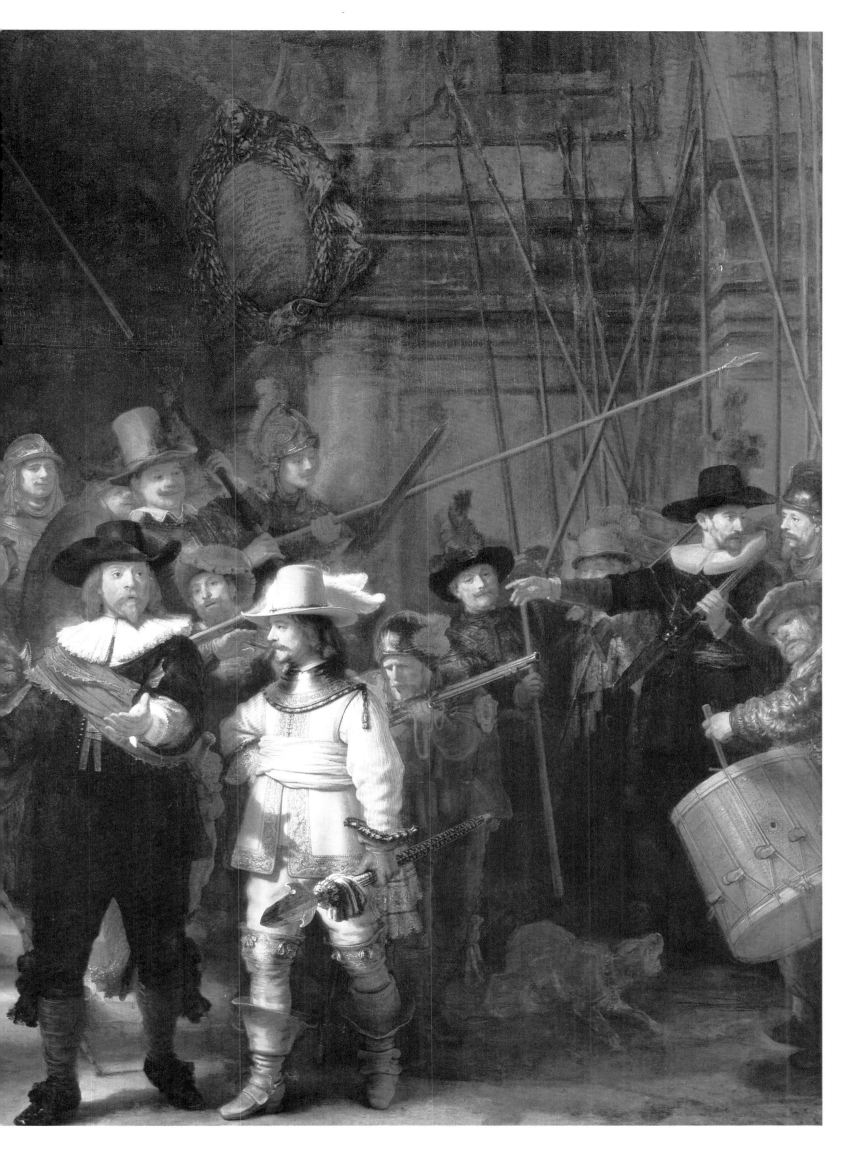

1. 2.
One Sunday in September of 1975 in the middle of the afternoon a mentally deranged man repeatedly slashed *The Nightwatch*. After painstaking restoration by M. Kuyper and M. Hesterman the work was finally returned to the public on July 24, 1976.

1

2

to begin. Every element in the picture contributes to the sense of movement. The captain and his lieutenant, Willem van Ruylenburgh, look out while advancing toward the viewer. (Paul Claudel remarked that the "two officers seem to be on the very edge of the frame.")

The confusion of weapons, with halberds, arquebusques and muskets crisscrossing, makes this a real action scene. The painter leaves no detail out.

And what should we make of the unidentified characters that the painter has taken the liberty of adding to the scene? Claudel writes of them: "Is it that they are hanging back from joining the procession? From the front of the canvas to the very back, Rembrandt depicts all the gradations and nuances of the movement which is about to get underway."

The Nightwatch is often considered to be the masterpiece of chiaroscuro. Zones of darkness and splashes of light guide the eye of the viewer, imposing a definite trajectory, and lead it to discover the vertical composition formed by the legs and arms and several horizontal axes: the powder horn held by a little boy, the little girl with a chicken tied to her belt, the dog barking at the drummer . . . It is probably the strange light that caused the work to be named, in the nineteenth century, *The Nightwatch*. The painting is actually set during the morning. The many coats of varnish laid on to protect the painting have had the effect of darkening it. The company sets forth early in the morning. The shadow of the captain's hand on the yellow outfit of his lieutenant, dressed to mitigate his shortness of stature, makes this clear.

The work received mixed reviews. Some saw it as an example of the artist's failing powers, others as the high point of his career. We do know that Captain Cock asked Rembrandt for a watercolor of the painting for his own collection. In 1715 the city of Amsterdam chose to exhibit *The Nightwatch* in the town hall. Unfortunately this honor resulted in a partial amputation of the painting, as it had to be reduced in width to get it into the building. This was not the last outrage perpetrated on this great work of art. In 1975 a mentally disordered man lacerated it with a knife in the Rijksmuseum in Amsterdam. The damage was severe and required several months of work by the art restorers, Hesterman and Kuyper, before it was finally returned to public view on July 24, 1976.

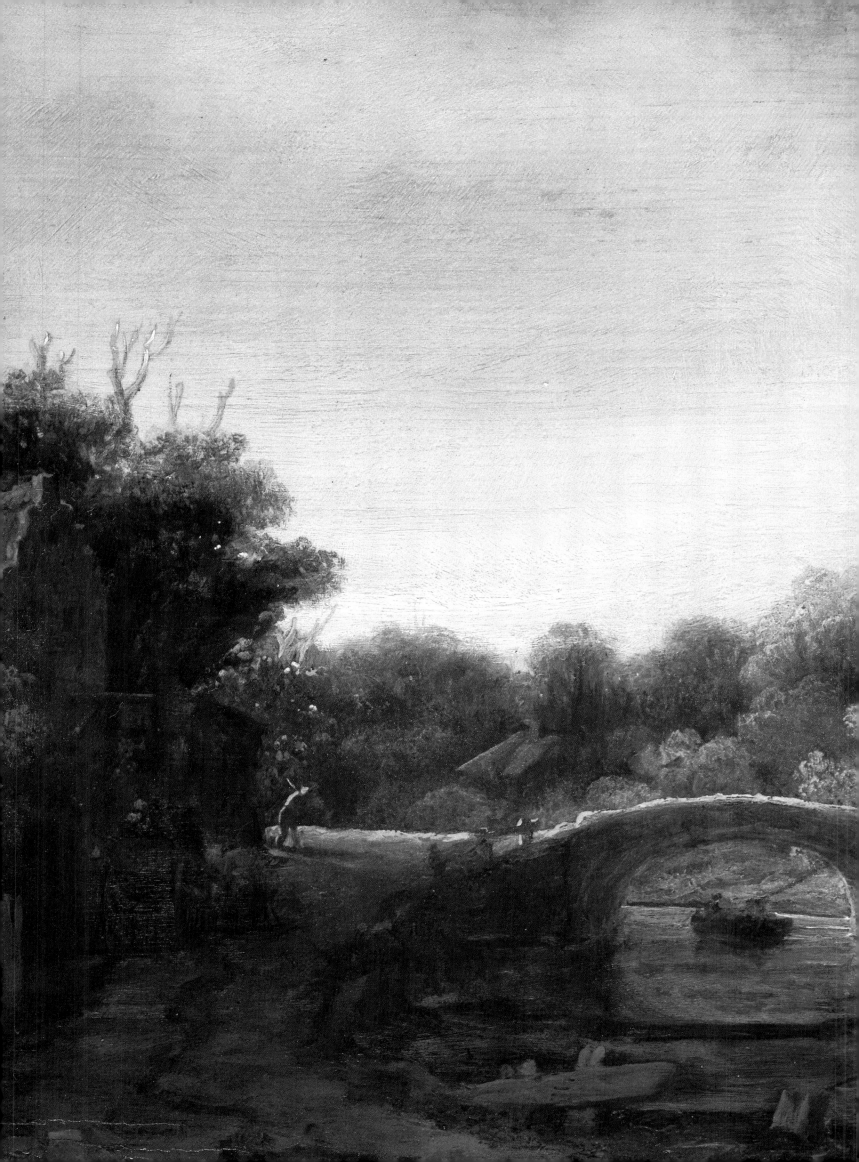

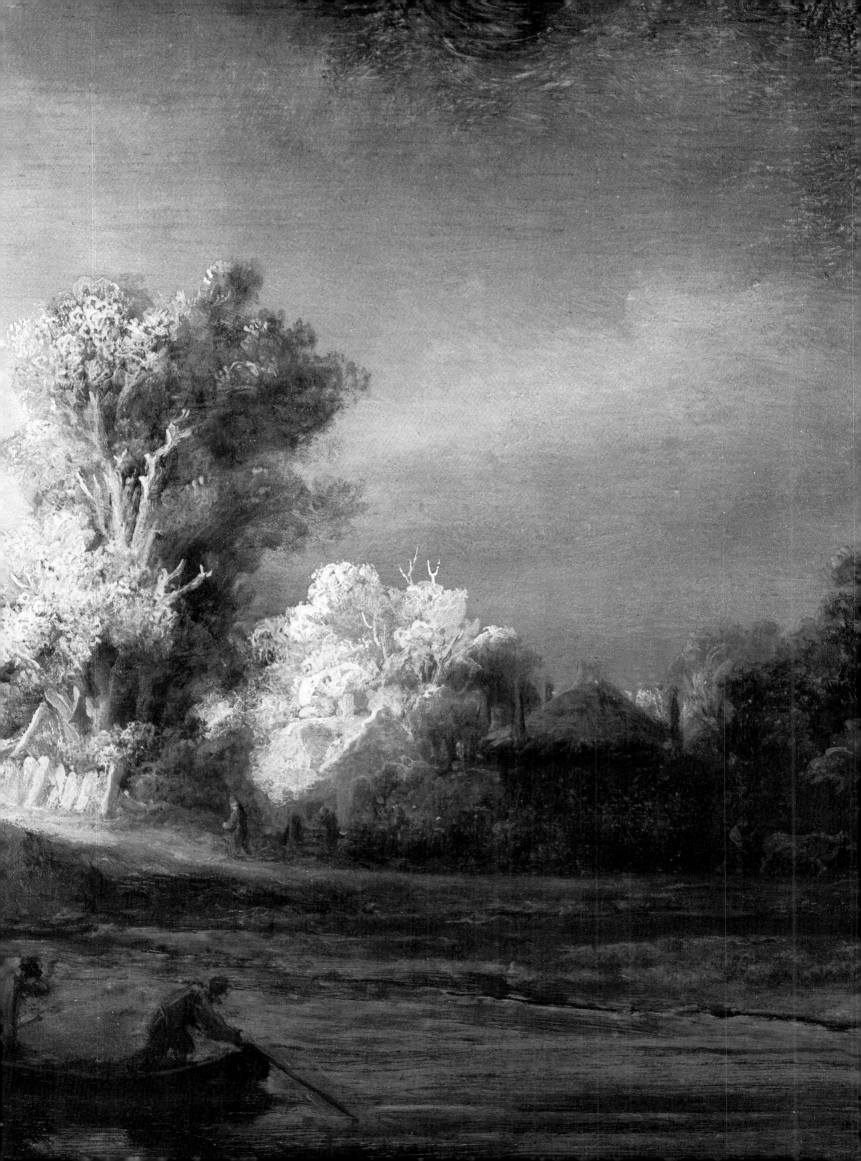

1

Rembrandt's Landscapes

2

Atﬆ a time when artists specialized in one genre and even one sub-genre, Rembrandt tackled all of them. Landscapes represent 10% of his total output; he worked on them starting in 1630 until the early 1650s. But they are unusual for their wide variation, since this genre, which was very much in vogue during the seventeenth century, was conceived of in very defined categories. Landscape painters all had their specialties: Jacob van Ruysdaël, Willem van de Velde and especially Van de Cappelle were known for their seascapes. Hendrick Avercamp, Esaias van de Velde and Van der Neer specialized in winter scenes. Forests, fields and cityscapes all constituted other sub-genres.

Rembrandt knew the works of these artists, even though it is probable judging from his private collection (containing practically nothing by his contemporaries) that he preferred earlier painters, such as his old teacher Pieter Lastman or Jan Porcellis and Jan Pyras. Among the best represented was an artist underestimated in his own time: Hercule Seghers. Rembrandt possessed eight works by this Dutch master. At a time when the realistic landscape painters of Haarlem such as Van Goyen, Milijn and Salomon Ruysdaël were achieving great renown, Seghers remained faithful to the Flemish origins of this style, characterized by the creation of a phantasmagoria of black waters, plunging gorges, gnarled trees and stormy skies.

Rembrandt's work as a landscape painter springs from two sources of inspiration. In his oils he works in a romantic visionary mode portraying storm swept landscapes, the heritage of Seghers, while in his etchings and drawings he follows the lead of the most

3

The landscapes of Titian, Rembrandt and Poussin are generally in complete harmony with the human figures in them. With Rembrandt the background and the figures are one. The whole painting captures and holds our interest. It is as if we were looking at a beautiful countryside, wherein every detail is delightful.

(Delacroix)

realistic of the Dutch painters. His work as an engraver, which was strictly delimited in time (1640-1653) allows an evaluation of his growing confidence in a genre that he had not yet entirely mastered. In certain works, sometimes completed within a matter of hours, the landscape is easily recognizable to any Amsterdamer who, like the artist, enjoyed rambling along the Amstel.

At other times he enjoyed combining different points of view or motifs that he would encounter by chance on his promenades. Farms, windmills, groups of trees and riverbanks are among his favorites. He rapidly became proficient in this new style of rendering, which was no longer just the work of a studio, but involved the close observation of exterior scenery. The character of the

I

1. 2.
Avercamp and van der Neer, known for their winter scenes, combined elements of genre painting (realistic and often humorous representations of people in everyday settings) with landscape. Typical of Dutch landscape painting is the very low horizon, resulting in the sky's occupying a large part of the canvas.

2

Dutch landscape that was hard to see because taken for granted, and the infinite variety of the skies, are captured with a very low horizon line so that the sky sometimes occupies two thirds of the picture. Rembrandt was not alone in recognizing this, but he was particularly successful in integrating people in his compositions, whether painted or engraved. The resulting harmony apparently no longer satisfied the artist and in 1653 he abandoned landscapes to concentrate on single figures.

1. *View of River in Winter*, 1650.
Van der Neer. Oil on canvas. 64 x 79 cm.
Rijksmusuem, Amsterdam.

2. *Winter Amusements.*
Averkamp. Oil on panel. 36 x 71.
Mauritshuis, The Hague.

3. *Winter Landscape*, 1646.
Oil on panel. 17 x 23 cm.
Staaliche Kunstsammlungen, Gemäldegalerie, Kassel.

3.
This landscape differs from most
of Rembrandt's other work of this
period. Here he works in miniature.
His other works were considerably
larger. The weight of the landscape
and his concentration on the effects
of light distinguish his winter scene
from those of Averkamp, van der
Neer and other genre painters.

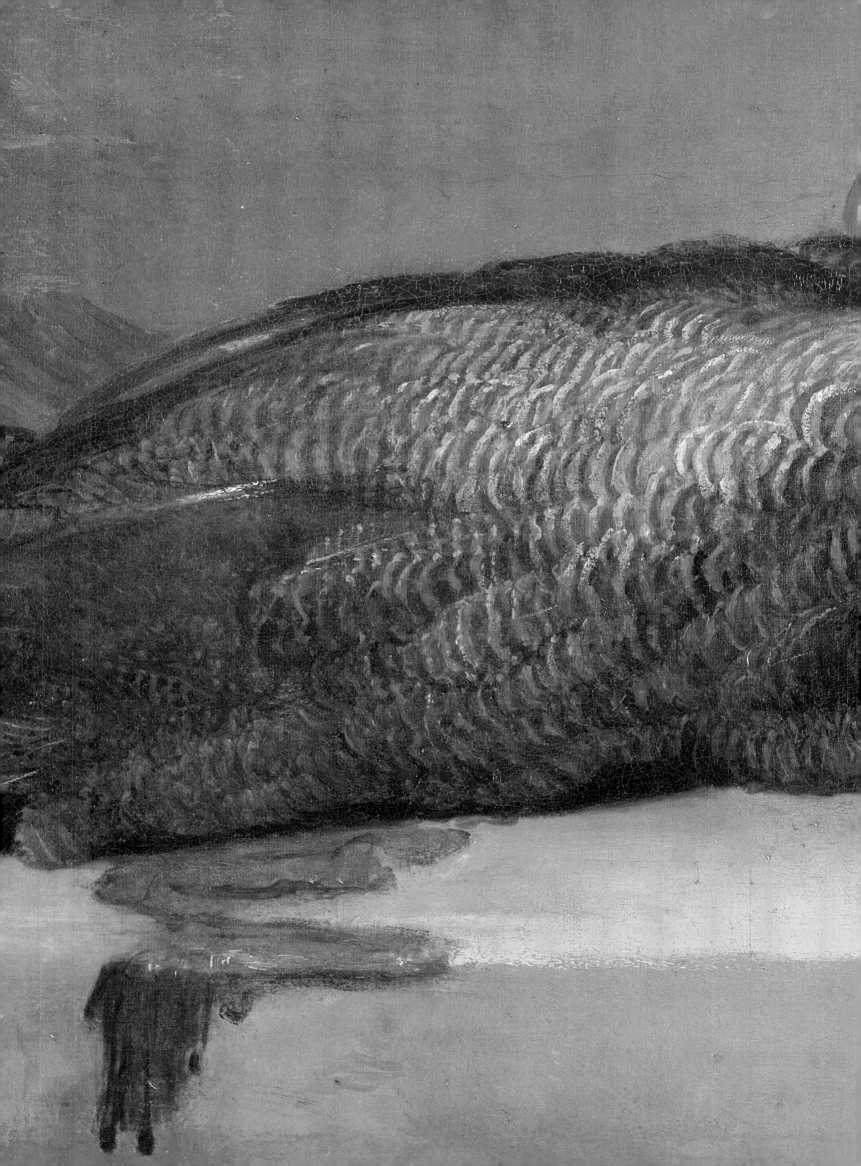

Still Lifes

Like landscapes, still life painting was a genre much admired in the seventeenth century Holland. It consisted primarily of *vanitas* pictures, in which human vices were symbolized by the objects depicted, floral painting, pictures of game and of tables spread with various dishes. All were represented in a highly realistic fashion.

The Calvinists appreciated *vanitas* painting. Here religious symbolism was rigidly codified to preach moral lessons. The masters of this genre included Jan van de Velde, Willem Claesz Heda, Jan Dandisz de Heem and Willem Kalf. Iconographic conventions allowed the viewer to understand that the lily alluded to the Virgin Mary, hazel-nuts to the Crucifixion and cherries to Paradise. Treatments of topics such as the vanity of books (meant to signify that there are proper bounds to human knowledge), were often required of fledgling art students in Leyden, where Rembrandt completed his apprenticeship.

Always interested in exploring new genres, Rembrandt took on the highly conventional one of the still life during a time when he had already gained considerable recognition. In 1639 he chose a subject that would become very fashionable a decade later, a still life of game. The hunt had remained up until that time a privilege of the nobility. However the upper middle class had the right to hunt on their own lands. It pleased them to have their trophies painted and hung up to decorate their houses. In *Still Life with Peacocks*, executed in 1639, Rembrandt once again breaks with conventions. He places a person in the composition allying it with genre painting. The figure is not a hunter but a young girl, which definitively alters the social context of the work. Yet again Rembrandt gives proof of his originality.

2

1. *Still Life with Old Books*, 1630.
(Contested Rembrandt sometimes attributed to Jan Lievens)
Oil on wood. 91 x 120 cm.
Rijksmusuem, Amsterdam.

2. *Still Life*, 1668.
Willem van Aelst. Oil on canvas. 58 x 64 cm.
Staatliche Kunsthalle, Karlsruhe.

3. (detail on preceding pages)
Still Life with Peacocks, 1637.
Oil on canvas. 145 x 135.5 cm.
Rijksmusuem, Amsterdam.

3. (and detail on preceding pages) Rembrandt began painting hunting scenes ten years before this genre came into fashion. However, his treatments were by no means conventional. He deprives the scene of indications of rank and status such as fancy weaponry or hunting equipment. Also he incorporates a human figure into the center of the work. The intense realism of the two dead peacocks suffice for this painting to succeed as a still life.

The Slaughtered Ox

In 1640, date of Rembrandt's first rendition of this subject, scenes from butchers' shops were not new. Painted by Aersten and Beuckelaer in the sixteenth century, numerous contemporary Dutch and Flemish artists, including Van Ostade, Téniers, Eeckout, Pieter de Hooch and van der Hecken, also tried their hands at it. Sides of pork or beef hung from hooks frequently with the addition of a human figure — often a child — served to highlight the idea of death. Thus this theme belonged as much to the genre of *vanitas* painting as to that of still life. Rembrandt, who included people in almost all of his paintings, even still lifes, did

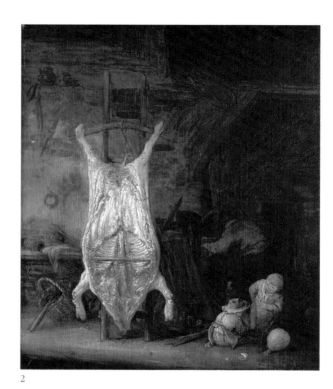

2

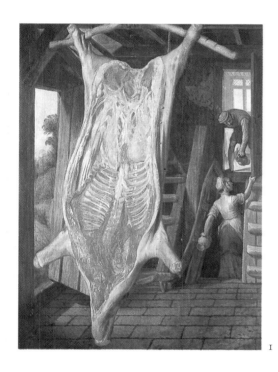

1

1 .2.
A number of painters had treated this scene before Rembrandt. Joachim Beuckelaer and Isaac van Ostade both handled it with vigor and talent.

not break with this habit in his depictions of hanging carcasses. But between his version of 1640 and that of 1655 the human figure has changed its role in the painting. In the earlier work, the butcher's wife cleans up the blood without seeming to notice the dangling carcass. In the later work she stays in the background within the doorway, which makes her appear monumental and as if projected forward toward the butchered beef that she contemplates. If during the seventeenth century this theme seemed edifying, by the beginning of the following century it would become "picturesque" and by the end of the eighteenth brutal and vulgar. In the following century Delacroix and Daumier painted it in homage to the master, as in our century it was reworked by Soutine, Fautrier and Francis Bacon.

1. *The Slaughtered Pig*, 1563.
Joachim Beuckelaer. Oil on wood. 114 x 83 cm.
Wallraf-Richartz Museum, Cologne.

2. *The Slaughtered Pig*, 1640.
Isaack van Ostade. Oil on wood.
Frans Hals Museum, Haarlem.

3. *The Slaughtered Ox*, 1655.
Oil on wood. 94 x 67 cm.
Louvre, Paris.

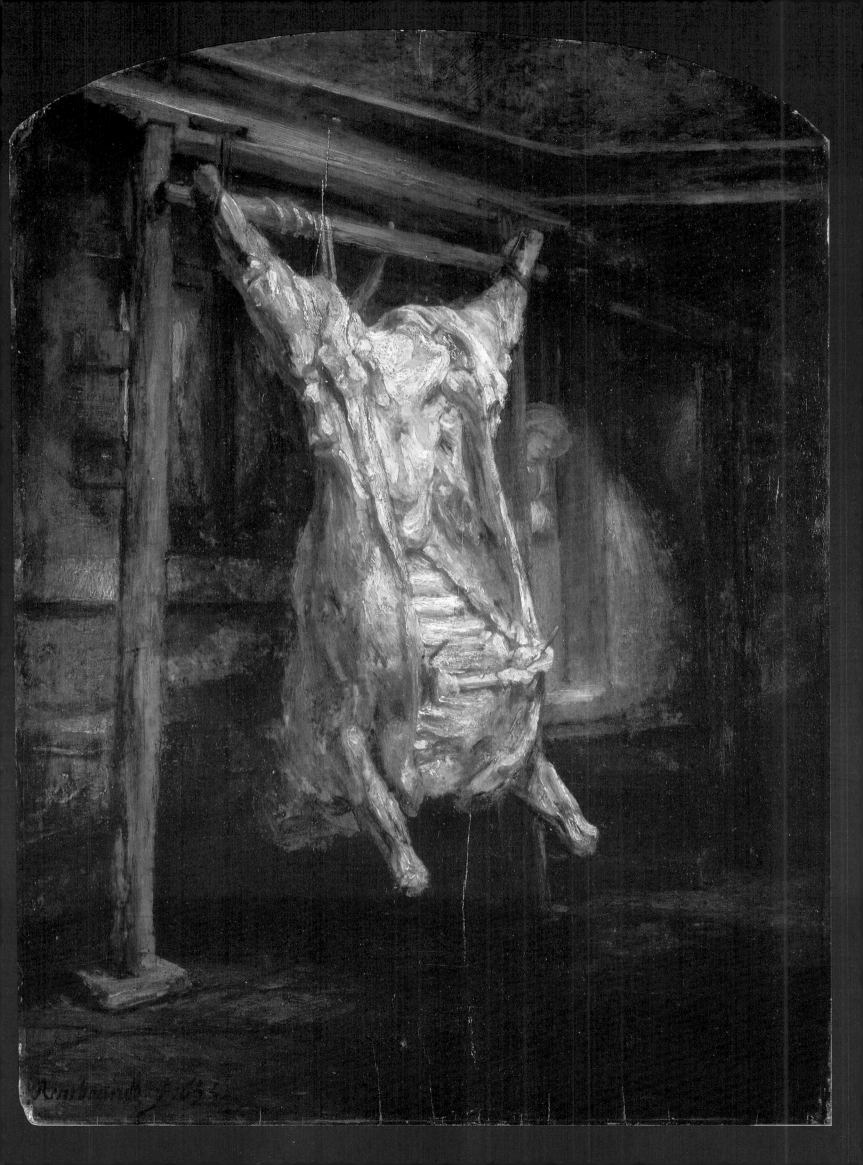

The Death of Saskia

After the birth of Titus in 1641, Saskia became ill; each day she grew weaker. She stayed in bed for long periods, but neither rest, nor the care of largely impotent doctors nor even the love with which Rembrandt surrounded her made any difference. On June 5, 1642, she made her last will and testament in which she left forty thousand guilders to Titus and her husband . . . as long as he did not remarry. She died a few days later on June 14, at the age of thirty, of consumption.

Rembrandt was at the high point of his glory. He had just finished the *Nightwatch*, and commissions were pouring in. It was not possible for him to care for Titus by himself, and all the women who had surrounded him, his mother Nelltjen, his sister-in-law Titia van Uylenburgh (in whose memory the couple had named their son Titus) and now his wife Saskia, had died within two years.

1. 3. 4.
Saskia was taken ill, and powerless to help her Rembrandt could only fix her image on paper. For the eight years that they were married Saskia was his favorite model. It is likely that the old woman's head is his mother's.

2.
This was a time of happiness for Rembrandt. He and Saskia were affianced but not yet married. She poses for him wearing a sumptuous dress.

1. 3. (detail)
Saskia in Bed, 1641-1642.
Preparatory study for an engraving. 15.1 x 13.6 cm.
Bibliothèque Nationale, Paris.

2. *Saskia van Uylenburgh, Portrait with Veil*, 1633.
Oil on wood. 65 x 48 cm.
Rijksmusuem, Amsterdam.

4. *Studies of Heads* (with Saskia in the middle), 1636.
Engraving, single state. 15.1 x 12.6 cm.
Rembrandthuis, Amsterdam.

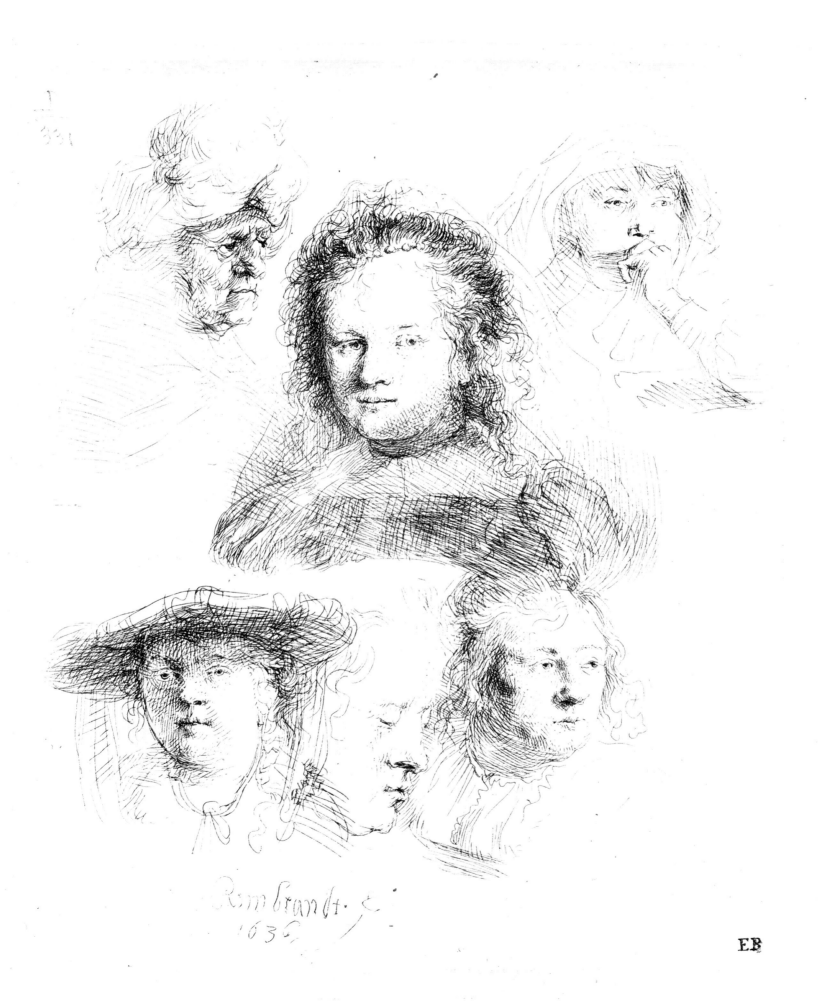

Geertje and Hendrickje

Soon after the death of Saskia, Rembrandt found it necessary to engage a nursemaid for Titus, who was just taking his first steps. For seven years, from 1642 to 1649, a rude peasant from the north, Geertje Dircks, served as a mother to the child and mistress to the painter. The two lovers dismissed the gossip about them. Say what you will Geertje provided ballast for Rembrandt and the emotional stability that he had lost. His style changed. He gave up oblique, virtuoso displays of light and dramatic attitudes.

There was a lot of talk about his relations with Geertje. It was an epoch in which extra-marital affairs were forbidden, and

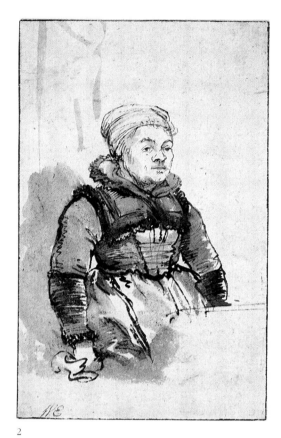

2

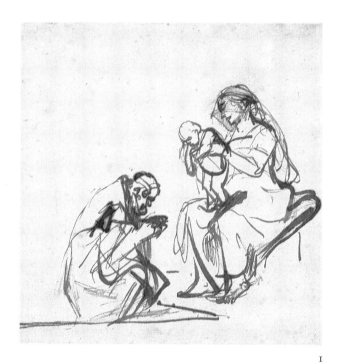

1

1.
Rembrandt used his family and those around him as models for his works on biblical subjects. Saskia and one of their children probably posed as Jesus and Mary.

2.
This drawing of Geertje Dircks shows her just when she was entering into Rembrandt's service. Recently widowed, he hired her as a nurse for Titus. She modeled for him many times during the seven years of their lives together. But only some drawings survive. This is the only one in which she appears full-face, It may be that Rembrandt destroyed some pictures of her after their painful separation.

adultery was punished by imprisonment. The ambiguity of his situation did not stop Rembrandt from drawing his inspiration from the Bible. He painted *The Holy Family with Angels* in 1645, *The Holy Family with the Curtain* in 1646 and a new version of *Christ at Emmaus* in 1648. But during the same decade he also painted a series of nudes: most notably, *Danaë* (1636-1643) and *Susanna and the Elders* (1647).

Geertje became sick in 1648 and designated Titus as her sole heir, leaving him the jewelry that his father had given her. However despite the affection that this bequest demonstrates, a notarized document dated June 28, 1649, states that the relationship between Rembrandt and Geertje was thereby dissolved. In consideration whereof Rembrandt agreed to pay his former mistress two hundred guilders within a year and an annuity of one hundred and sixty guilders for life.

1. *Adoration of the Magi*, ca. 1636.
Drawing.
Rijksmusuem, Amsterdam.

2. *Portrait of Geertje Dircks*, ca. 1642.
Drawing with pencil and watercolor. 13 x 7.7 cm.
British Museum, London.

3. *Hendrickje Stoffels with Velvet Beret*, ca. 1654.
Oil on canvas. 74 x 61 cm.
Louvre, Paris.

3.
In 1649, while Geertje was still living with Rembrandt in Sint Anthoniesdijk, he hired Hendrickje Stoffels. She soon became his mistress. She was twenty years younger than Rembrandt, but she took the place of Saskia. Hendrickje was brought before the ecclesiastical authorities because she and Rembrandt were living together outside the bonds of marriage.

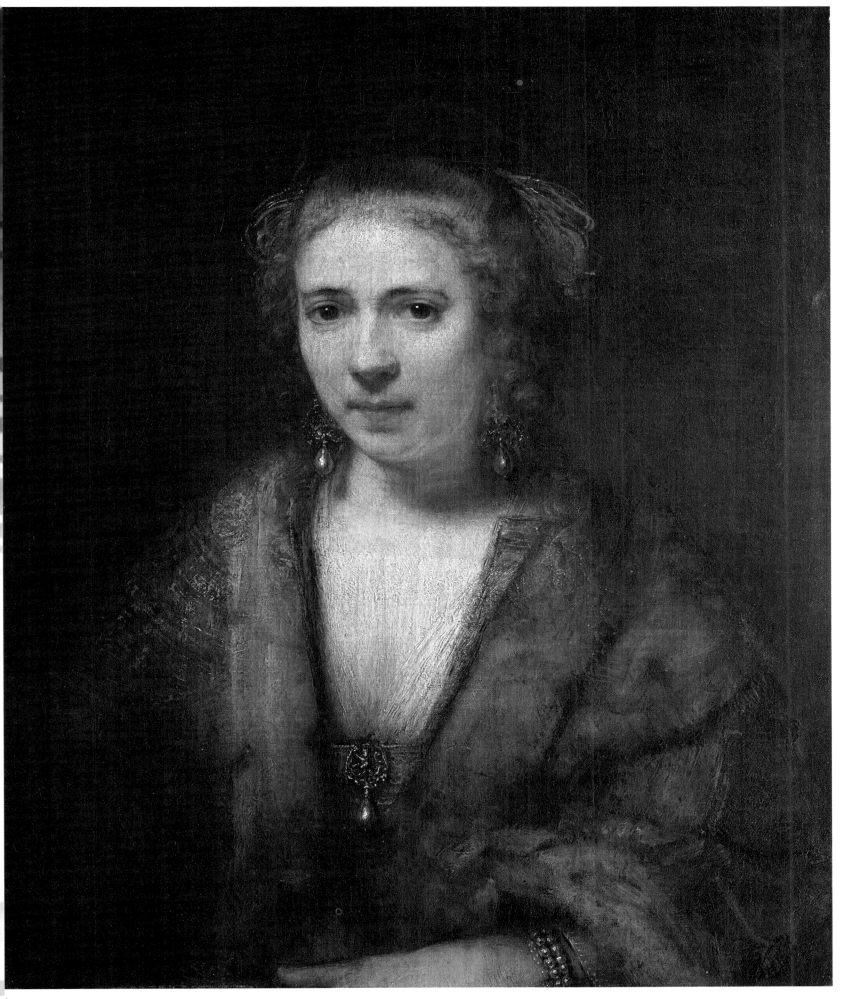

The document also mentions a ring, which is given outright to Geertje as long as she promises not to sell it. Geertje however, did not sign the document, which appears so favorable to her. The separation as a result had a certain air of drama. Soon she tried to sell the famous ring, which had originally belonged to Saskia. Rembrandt was furious and embarked on legal proceedings to accuse her of immorality. Geertje responded by accusing Rembrandt of breach of promise. Now the painter could not remarry without losing his inheritance from Saskia, a fact of which his angry lover was well aware. In any event Rembrandt succeeded, with the support of her own brother, in having Geertje imprisoned for twelve years in the asylum of Gouda. Her health failing, she was released in 1656 after having served five years of her sentence. She died a year and a half later without ever having touched the pension that Rembrandt had provided her.

In 1649, while Geertje was still living in his house, Rembrandt became the lover of the young and vivacious Hendrickje Stoffels. Her beauty and youth (she was twenty-three at the time) exacerbated Geertje's jealousy, over the period of months in which the two women lived with Rembrandt under the same roof. This embarrassing household arrangement probably accounts for the cruel way in which Rembrandt unburdened himself of his first mistress. She had become an embarrassment. Hendrickje did not hesitate to bear witness against her rival in the proceedings held against her in October of 1649. Once again calm had returned to the great house on Sint Anthoniesdijk. Rembrandt threw himself into painting with the same enthusiasm with which he painted the young Saskia. For the next fourteen years, until her death, Hendrickje was to be Rembrandt's companion. She accepted the fact that she would never be his legal wife and gave the painter one daughter, Cornelia. But what Hendrickje could accept, Calvinist society would not tolerate. "Living in sin" was proscribed by the official church, and the couple was summoned to appear before the ecclesiastical court. The lovers did not show up. The summons was renewed once again in 1654, but this time only Hendrickje was cited. She decided to go before the judges to tell them that she was not afraid of excommunication and that she would not renounce her relationship with painter. Her courageous choice inspired Rembrandt to paint her as Bathsheba, who was torn between her conjugal duty towards Uriah and her duty to submit to the desires of King David.

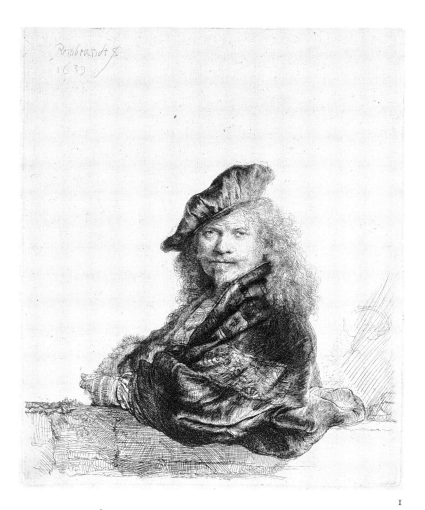

1.
In 1639 Rembrandt was rich and famous and still had Saskia at his side. He presents himself in a pose inspired by Titian's Ariosto. His etching manages to capture the full weight and texture, and even the sheen of the velvet, of his cloak.

1. *Rembrandt Leaning on a Stone Wall,* ca. 1639.
Etching. 20.5 x 16.4 cm.
Rijksmusuem, Amsterdam.

2. *A Woman Bathing* (Hendrickje Stoffels?), 1655.
Oil on panel. 62 x 47 cm.
National Gallery, London.

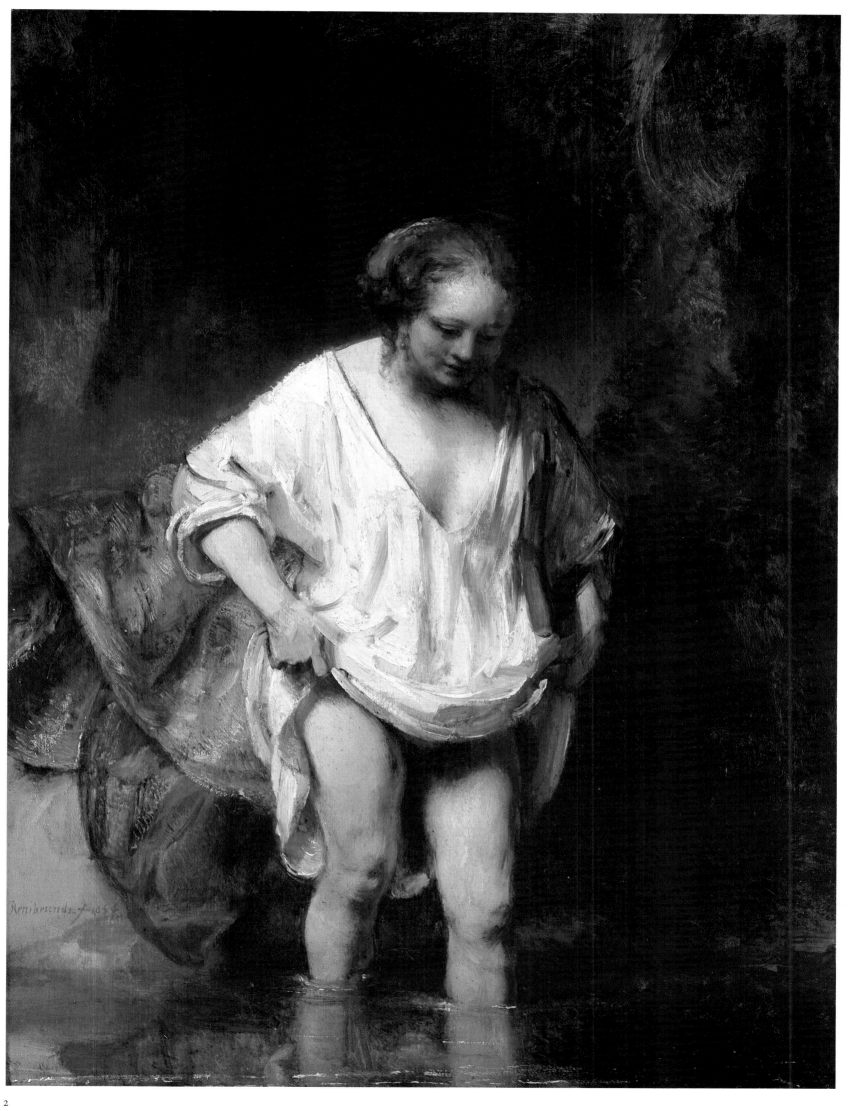

2

Pleasure Regained

1

1.
Contemporary critics, dismayed by Eve's ugliness in the etching *Adam and Eve* concluded that Rembrandt was insensible to the eroticism of the female nude. The sensuality of Antiope surprised by Jupiter, clearly proves them wrong.

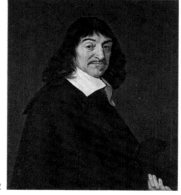

2

2.
Descartes moved to Holland in 1628. In 1649 he published *A Treatise on the Passions*. He died a year later. The work was proscribed by the church in 1663.

The women who shared Rembrandt's life always left their mark on his painting: Saskia, his young bride, Geertje, the nursemaid, and now Hendrickje, whose youth and physical beauty would reinvigorate the artist, now in his forties.

The human body appears relatively late as an important theme in the artist's work, and he did not begin to paint nudes until after the death of Saskia.

Certainly nude models often posed for his students in his studio at Bloemgracht, and Rembrandt sketched the bodies of both male and female nudes. There he acquired that profound knowledge of human anatomy that breathes through conventional paintings of scenes taken from classical mythology and the Bible (*Danae, Bathsheba, Jupiter and Antiope, Susanna and the Elders*).

Rembrandt, who had learned to approach his subjects not for what he wanted

3

1. *Jupiter and Antiope,* 1659.
Engraving, first state. 84 x 114 cm.
Rembrandthuis, Amsterdam.

2. *Portrait of Descartes* (after Frans Hals, old copy of a lost original), 1649?
Oil on canvas. 77 x 68 cm.
Louvre, Paris.

3. *Le lit à la française,* 1646 (title from seventeenth century).
Etching. 23 x 12.5 cm.
Bibliothèque Nationale, Paris.

4. *Danae,* 1636.
Oil on canvas. 185 x 203 cm.
Hermitage, St. Petersburg.

3.
Rembrandt accumulated an important collection of erotica. It included works of Raphael, Annibal Carrache and Durer. But this engraving clearly owes more to his relationship with Geertje, his son's nursemaid.

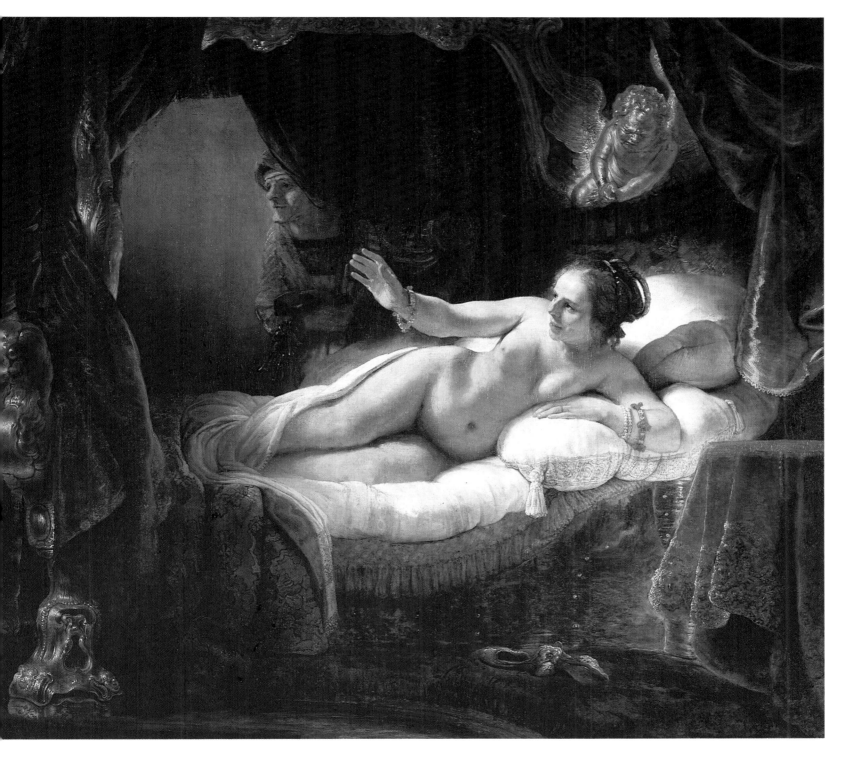

4.
King Acrisius learning from an oracle that his grandson was destined to kill him, had his only child Danae imprisoned to enforce her chastity (symbolized by the small Cupid in tears with his hands bound), but Zeus transformed himself into a shower of golden coins to escape her father's surveillance. Rembrandt inundates Danae's body and face in light. The prophecy was to come true.

them to be but for what they were, showed no repugnance in portraying women truthfully; plump and graceful girls, wrinkled and bent old women.

His contemporaries, who were products of the academic establishment, could not understand why he chose to paint old women whose bodies lacked charm and grace. The poet, Andres Pelz, was among this number. He observed: "When he wanted to paint a female nude, he chose for his model not a Greek Venus, but rather a washerwoman or a servant at a tavern: he called this mistaken enterprise, the imitation of nature . . . He chose not to follow any of the rules of moderation that specified which parts of the body were fit to be exposed . . . What a loss for art that such a skilled hand could not find a better use for its gifts. Who knows what he might have accomplished." The verdict of posterity has given Rembrandt his just dues. Elie Faure, the celebrated critic of twentieth century art, praises the way in which the painter knew how to represent a woman's

1

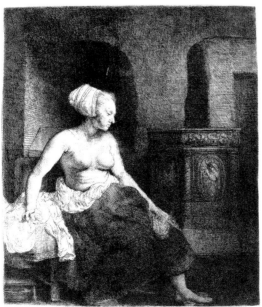

2

1. 2.
Rembrandt made numerous drawings and engravings of nudes in the years from 1650 - 1660. He was less interested in physical beauty than in portraying the body as an expression of the soul.

FOLLOWING PAGES:
Many models posed for the students in Rembrandt's studio in Bloemgracht. Sometimes, when taken by a pose of one of the models, he would execute a drawing along with his students.

1. *Woman Bathing*, 1658.
Engraving, drypoint, second state.
Rembrandthuis, Amsterdam.

2. *Female Nude before a Stove*, 1658.
Engraving, drypoint and burin, third state. 22.8 18.7 cm.
Rembrandthuis, Amsterdam.

3. *Bathsheba*, 1654?
Oil on canvas. 142 x 142 cm.
Louvre, Paris.

FOLLOWING PAGES:
Male Nude Seated on the Ground, 1646.
Engraving, second state. 9.7 x 16.8 cm.
Rembrandthuis, Amsterdam.

3.
The figure of Bathsheba had interested Rembrandt since the 1630s. In 1654 he returned to the subject. He pictures her just finishing bathing, torn between her loyalty to her husband Uriah and the desire of David whose summons to appear before him she has just received. The servant remains imperturbable, totally engrossed in her own concerns.

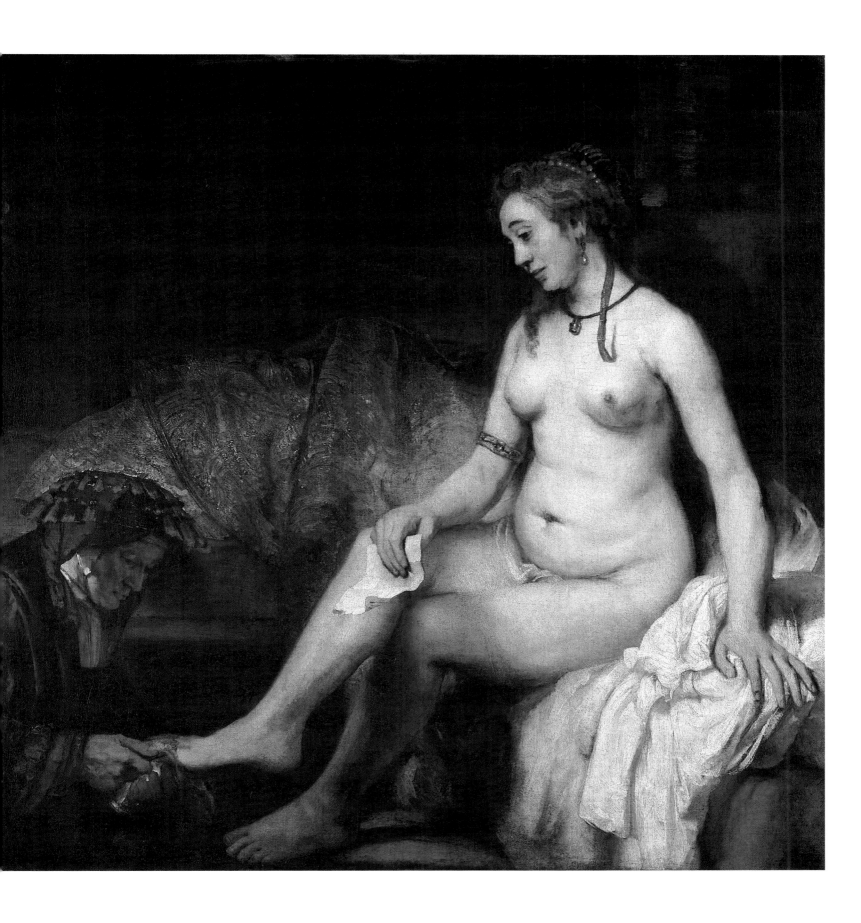

body at all stages of her life, whether young and desirable or old and filled with emotion. "He is there when she opens her legs to us with the same emotion as when she opens her arms to her baby. He is there at her moment of perfect ripeness. He is there when in her maturity, her belly is no longer flat, her breasts begin to hang down and her legs are heavy. He is there when she has become old and her wrinkled face is covered by her graying hair, and her bony hands are crossed at her belly as if to ask only that life bring her no more pain."

I

1. 2.
The moment when a beautiful woman is just about to leave her bath is one that has strongly appealed to painters. They have seen in it an opportunity to cast the nude female form into high relief. Just as with his rendering of Antiope, Rembrandt captures Susanna surprised by onlookers. Ingres's *Bather* abandons herself to a languorous sensuality that recalls Rembrandt's *Bathsheba*.

1. *The Bather*, 1808.
Ingres. Oil on canvas. 146 x 97 cm.
Louvre, Paris, RMN.

2. *Susanna and the Elders*, 1637?
Oil on canvas. 47.5 x 39 cm.
Mauritshuis, The Hague.

In Debt

Just as harmony was being restored at home, Rembrandt began to come under increasing pressure from his creditors. The painter was no longer rich. He disastrously mismanaged his affairs, and the overlong delays in fulfilling commissions began to alienate his patrons. This deepened his indebtedness to the dealers around him. He continued to expand his private collection, estimated at about ten thousand guilders in 1650, to which has to be added his own works, which were appraised at sixty-four hundred guilders in an inventory undertaken by his increasingly uneasy creditors. These assets only reassured them for a time. War with England plunged Holland into a recession during the 1650s. In February 1653, Rembrandt still owed Christoffels Thijssens 8,470 guilders on the mortgage for his house on Sint Anthoniesdijk. A new agreement was struck with his indulgent landlord in 1654 that required Rembrandt to pay five hundred guilders a year. But even though he had negotiated better terms, the painter had to borrow still more money. Several influential friends came to his aid: the burgomeister Cornelis Witsen and the merchant Isaac van Hertsbeesk each lent him four thousand guilders. Most generous of all was his friend Jan Six. Six was burgomeister for a time, but then retired to devote his entire energies to writing. (Rembrandt executed several engravings of landscapes in Six's country house along with an etching to illustrate the young writer's *Medea*.) Six was a humanist and an art lover. He owned several of Rembrandt's paintings including *Portrait of Saskia with a Red Hat* and *The Preaching of John the Baptist*. He bailed out the artist on one occasion with a loan of six thousand guilders in 1653 and one thousand more later on. But the noose continued to tighten. Commissions were coming less frequently, with some notable exceptions, such as *Aristotle Contemplating the Bust of Homer*, ordered by a Sicilian nobleman Antonio Ruffo who paid five hundred guilders for the work. In addition Rembrandt's relations with his clients were often strained; they reacted to what they perceived as his arrogance. A Jewish Portuguese merchant named Andrade hired Rembrandt to paint a portrait of his daughter and then asked for his payment of seventy-five guilders back, judging the likeness to be a poor one.

1

1.
From 1650 to 1660 England and Holland struggled for naval supremacy in the North Sea, The war plunged Holland into a deep recession.

Rembrandt's house in Breestraat, Sint Anthoniesdijk.

2.
In 1656 before selling of his property Rembrandt tried to save the grand house that was the root cause of his bankruptcy, by transferring legal ownership to his son Titus. He was forced to sell it nonetheless in 1658.

1. *Battle of the Sound*, 1658.
Willem van de Velde the Elder. Pencil and ink.
Historical Museum, Amsterdam.

3. *Poster Announcing the Sale of Rembrandt's Goods*, 1658.
Rembrandthuis, Amsterdam.

4. *Parable of the Merciless Creditor*, ca. 1655.
Drawing.
Louvre, Paris (Bonnet legacy), Paris, RMN.

4.
Rembrandt was able to contemplate his disastrous financial situation with clarity and humor. He never stopped painting, even when he ws forced to sell off practically everything he owned, and he was forced to surrender the rights to his own work.

E Lurateur over den Insol=venten Boedel van Reinbzant van Rijn / konstigh Schilder / sal / als by de E. E Heeren Commissarisen der Desolate Boedelen hier ter Stede daer toe geauthoriseert / by Executie verkopen de vordere Papier Kunst onder den selven Boedel als noch berustende / bestaende inde Konst van verscheyden der voornaemste so Italiaensche / Fransche / Duytsche ende Nederlandtsche Meesters / ende by den selven Rembzant van Rijn met een groote curieushayt te samen versamelt.

Gelijck dan mede een goede partye van Teeckeningen ende Schetsen vanden selven Rembzant van Rijn selven

De verkopinge sal wesen ten daeghe / ure ende Jaere als boven / ten huyse van Barent Jansz Schuurman / Waert in de Keysers Kroon / inde Kalver straet / daer de verkopinge voor desen is geweest.

Segget voort,

3

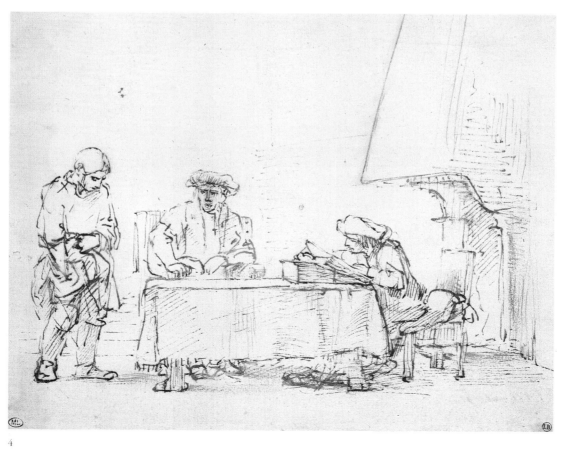

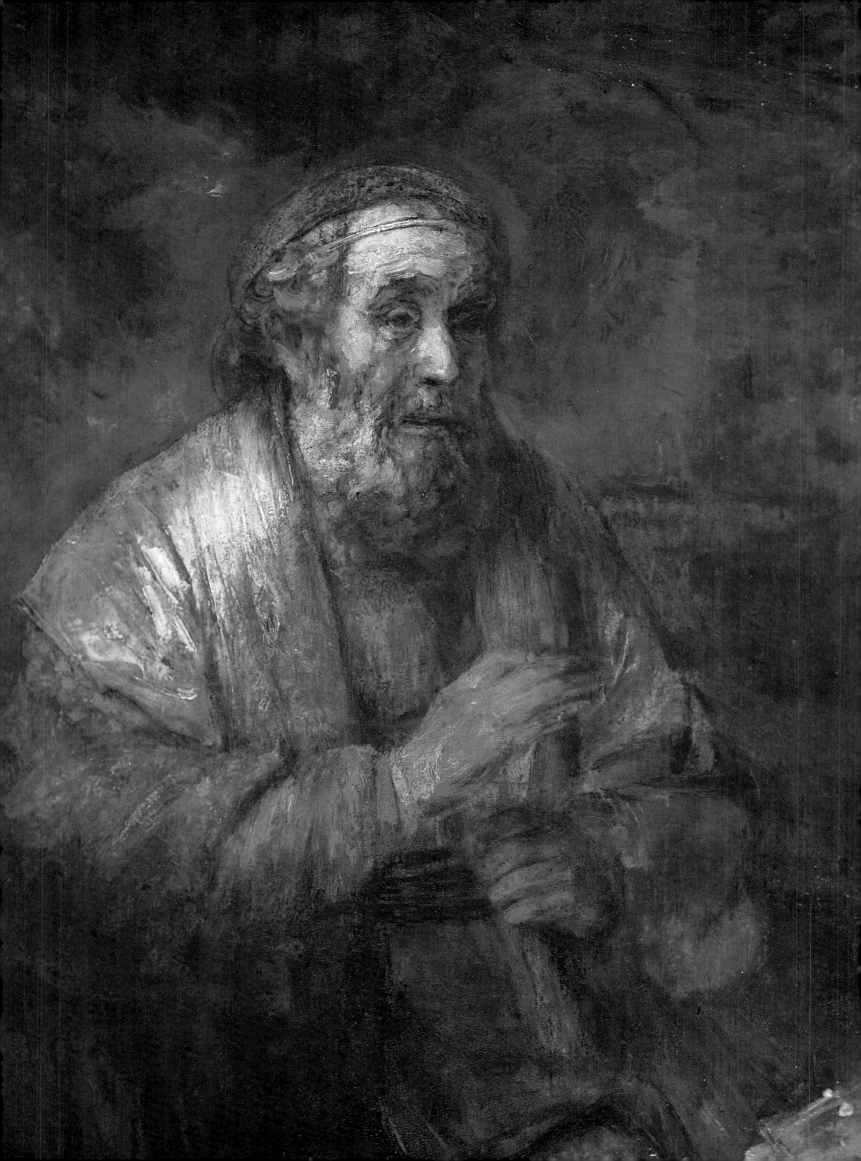

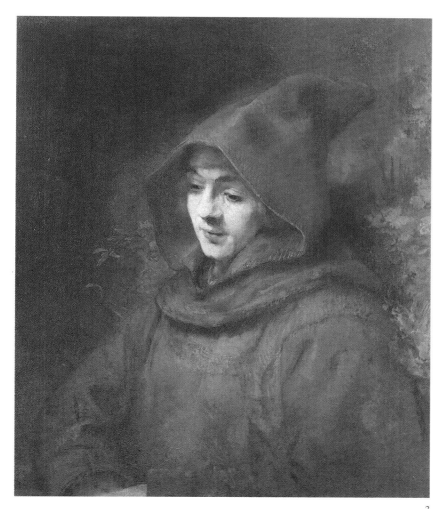

2

1.
This portrait was one of several commissioned by Antonio Ruffo, a Sicilian nobleman. The relationship bewteen the two men had its ups and downs. Rembrandt had to rework this painting after his patron pronounced it to be "unfinished."

2.
Titus dresses up as a monk to pose for a painting of St. Francis of Assisi.

1. *Homer Dictating to a Scribe* (fragment), 1663.
Oil on canvas. 108 x 82.4 cm.
Mauritshuis, The Hague.

2. *Titus in a Monk's Habit*, 1660.
Oil on canvas. 79.5 x 67.7 cm.
Rijksmusuem, Amsterdam.

Rembrandt refused and insisted that he be paid the balance still owed him. Finding himself in a corner Rembrandt resorted to some unusual strategies. He bought back his own prints from all corners of Europe to boost their price, but that only earned him the hostility of professional dealers. It was soon no longer a question of saving face. In July of 1656 Frans Janszoon Bruningh was appointed as official liquidator of the artist's property by the high court. Rembrandt succeeded in having the court declare his case to be a cessio bonorum (forfeiture of property) rather than bankruptcy for fraud. This contingency was usually reserved for losses at sea and commercial failures.

But even though this put a better face on things it didn't fool anyone. Even Jan Six would have nothing to do with him. On July 25 and 26 an inventory of all the painter's possessions was taken. From September onwards the veritable museum that Rembrandt had lovingly established for himself over the course of his life was dispersed on the auction block. Along with weaponry, seashells and oriental costumes were a series of busts of Roman emperors arranged in chronological order. Paintings by such masters as Raphael, Jacopo Basso and Giorgione and a remarkable collection of prints after the work of Michelangelo, Da Vinci, Titian, Raphael, Rubens and Holbein shared space with a picture of two dogs signed Titus van Rijn. The entirety, which was estimated at seventeen thousand guilders in 1650, was sold off for five thousand in 1658. Rembrandt also had to contend with the jealousy of the painters of the guild of Saint Luke, who under the pretext that the sale of his work would hurt the market, contrived that the auctions went unnoticed. All of his own etchings and those he had collected were sold on the street for six hundred guilders. Even after the sale of his house for 11,218 guilders Rembrandt was unable to satisfy all of his creditors. However, judicial proceedings moved at a slow pace, and the artist and his family did not have to vacate the premises until 1660 when they moved into a small house on the Rozengracht for an annual rent of 225 guilders.

On December 15, 1660, Rembrandt signed a document before a notary turning over all of his earnings to Titus and Hendrickje in exchange for which they promised to feed, house and care for him. Through this arrangement Rembrandt gave up the benefits of all his future production to his new creditors. In turn they preserved his honor and allowed him to continue his work.

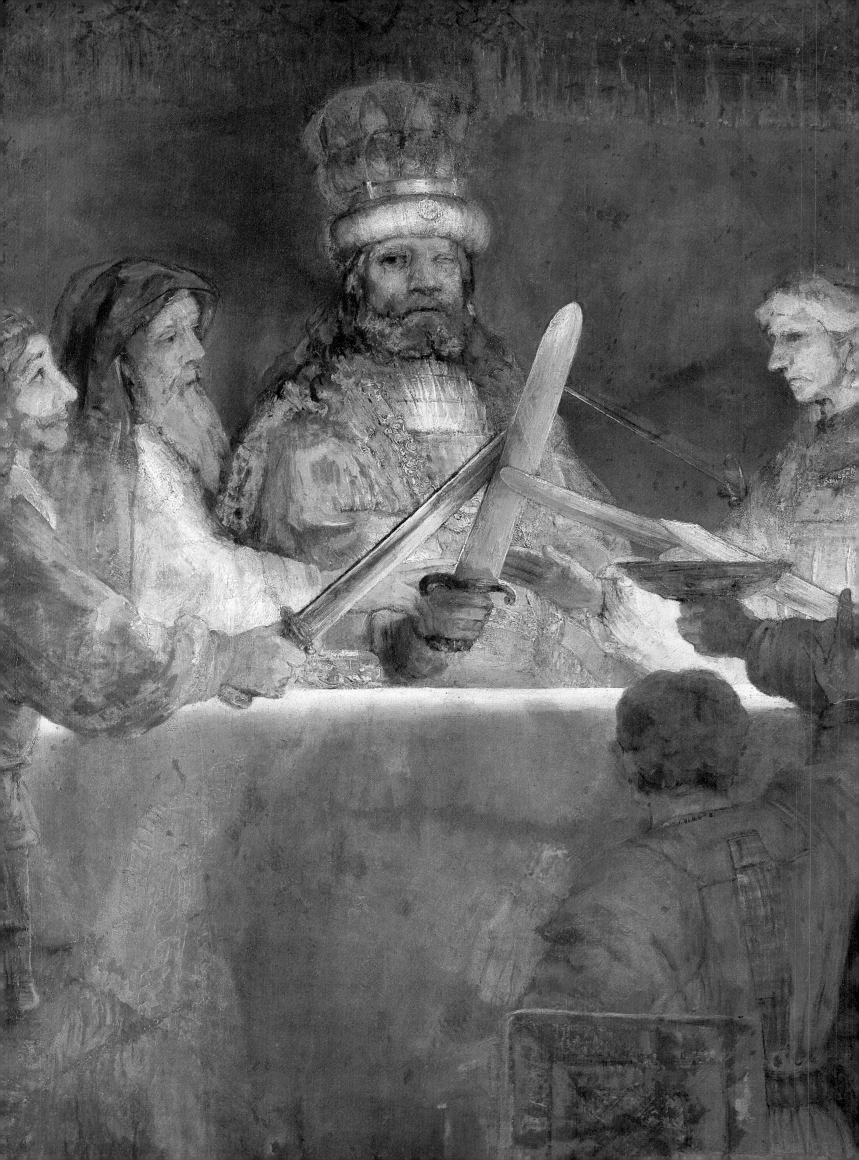

Claudius Civilis or *The Conspiracy of the Batavians*

In 1655 the city of Amsterdam called upon Govaert Flinck, a former student of Rembrandt, to decorate the newly built town hall. Govaert, however, died before he could undertake the work, and the city turned to his old master.

The theme of *The Conspiracy of the Batavians* was chosen to symbolize the independence of Holland. Tacitus makes reference to this episode. In 69 AD the Batavians, ancestors of the Dutch, entered upon a conspiracy to liberate their country from Roman domination. The rebellion against Rome, thus legitimized the Dutch revolt against Spanish rule.

Rembrandt set to work on a large fresco (25 sq.m.). Claudius (or Julius following some classical authorities) Civilis hosts the banquet. He is presented full-face. Claudius has but one eye, and the swords of his followers all converge toward his hollow eye socket. The table is incandescent, and the light illuminates the faces from below as if by footlights. The theatricality of the scene has made many think of Shakespeare. But in 1662 the painting was taken down after having been exhibited for only a few months. The town fathers probably thought that Claudius' infirmity detracted from the heroic message they wanted the painting to convey. The painting by Joris Ovens, which was destined to take its place, shows Claudius in profile. In order to resell the painting, Rembrandt had to cut it down to one quarter of its original size (the original composition survives only in a print).

About the same time Rembrandt accepted a commission for an equestrian portrait. Frederick Rihel was a rich merchant from Strasbourg who was part of the honor guard that escorted the young William III on his triumphal entry into Amsterdam in 1660. Equestrian portraits were quite rare among the Dutch. Rembrandt no doubt derived inspiration from Titian's portrait of Charles V, or Van Dyke's celebrated *Portrait of Charles I* of England. Although his does not entirely succeed in creating a sense of motion, this time the customer was satisfied. The following year Rembrandt sold the concession to his funeral vault in Ioudekerk and moved his wife Saskia's remains to a less costly site in Westerkerk.

I

1. 2.
Van Dyck was the official painter to the court of England. He was a master of equestrian potraiture, a genre not much practiced in Holland. Rembrandt did not attempt it until 1663.

PRECEDING PAGES.
Claudius Civilis or *The Conspiracy of the Batavians*, 1661-1662.
Oil on canvas. 196 x 309 cm.
Nationalmuseum, Stockholm.

1. *Portrait of a Charles I of England*, 1635-1640.
Van Dyck. Oil on canvas. 123 x 85 cm.
Prado, Madrid.

2. *Portrait of Frederick Rihel*, 1663.
Oil on canvas. 249.5 x 241 cm.
National Gallery, London.

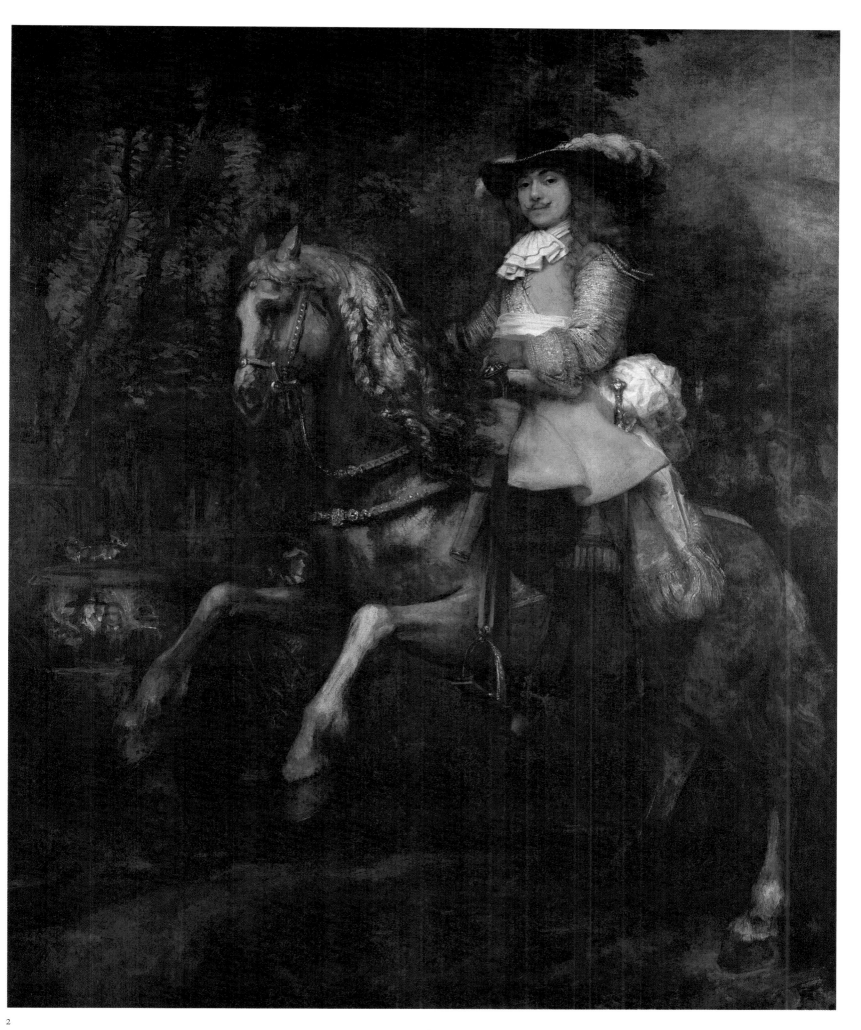

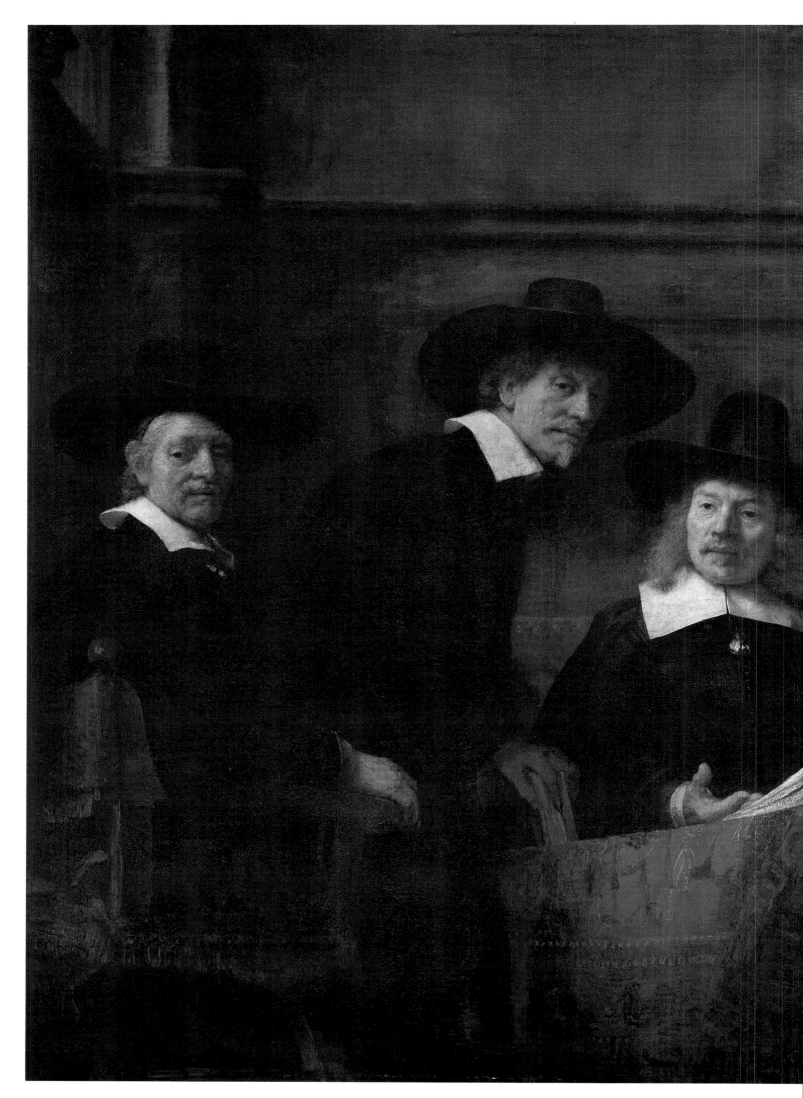

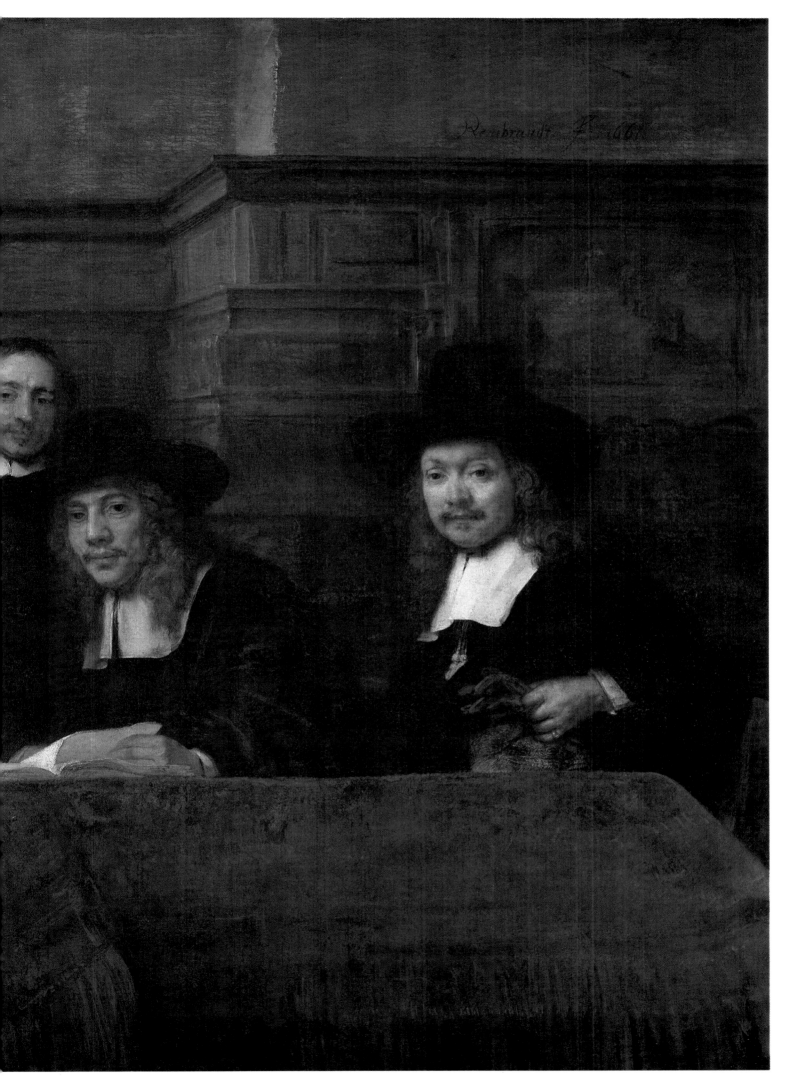

The Guilds

1

The painting of the Syndics is perfect, it is the most beautiful of all of Rembrandt's works... You see here Rembrandt is faithful to nature, although at the same time he remains noble, of the highest nobility, of an infinite sublimity... Rembrandt plumbs the mysteries and says things for which there are no words, in any language. It's right to call him a magician. Working in this way is not easy.

(Vincent van Gogh to his brother Théo, 1885)

1. 2. 3. 4.
Portraits of guild officers form a significant part of Dutch art of this period. They were in great demand. The leading figures of the community wanted to memorialize themselves in this way. The more important the corporation the more prestigious the commision. All of the great painters of the day tried their hands at it. But Rembrandt succeeded in breaking away from the rigidity of compostion and the monotonous arrangement of figures characteristic of the genre.

PRECEDING PAGES.
The Syndics of the Cloth Guild, 1662.
Oil on canvas. 191 x 279 cm.
Rijksmusuem, Amsterdam.

On August 7, 1661, an ailing Hendrickje made her will. Under its terms Rembrandt was to receive the usufruct of the property left to their daughter Cornelia. The legal papers refer to Hendrickje as the legitimate wife of the painter. Perhaps freed from the constraints of Saskia's will, which required that he remain celibate until Titus reached his majority, he finally married his longtime companion. It was at this point that the painter received a prestigious commission from the cloth guild of Amsterdam. This was to be his last group portrait. He had made a comeback. His talent was once again celebrated, and art critics like the poet Jeremiah de Decker, who once sat for Rembrandt, were enthusiastic. Nonetheless patrons were afraid that they would not recognize themselves in portraits done by the master. It is true that Rembrandt once again showed that he could transcend a somewhat conventional genre. Although the decor in the background

2

3

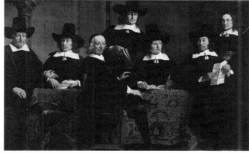

4

is what one would expect in this kind of painting, the disposition of the figures is surprising, as is the flamboyant red tapestry that covers the table around which they are arranged. Rembrandt seems to have interrupted them, as if he opened the door right in the middle of a discussion. The sense of disturbance is reflected in their gazes and lends vitality and realism to the tableau. This stands in sharp contrast to the *Guild of the Wine Merchants* by Rembrandt's pupil Ferdinand Bol, where the figures are stiff and haughty. There is also a marked difference from Johannes Vespronck's *Board of Governors of Saint Elizabeth's Hospital of Haarlem*. There the subjects are less stiff, but the light and composition cannot compare to the density of Rembrandt's. Jan Vos praised the painter in a poem, in which he recognizes him as the finest painter in Amsterdam, and, why not, the world. Rembrandt's good fortune was of short duration. In July 1663 Hendrickje died. She was buried next to Saskia in Westerkerk. Titus, now only twenty-two years old, was given sole charge of his father's affairs.

1. *Board of Governors of Saint Elizabeth Hospital of Haarlem,* 1641.
Johannes Vespronck. Oil on canvas.
Frans Hals Museum, Haarlem.

2. *The Syndics of the Arbalesters of Saint Sebastian in Amsterdam,* 1653.
Bartholomew van der Helst. Paper on wood. 50 x 67 cm.
Louvre, Paris, RMN.

3. *Regents of the Home for the Aged,* 1664.
Frans Hals. Oil on canvas. 170.5 x 249.5 cm.
Frans Hals Museum, Haarlem.

4. *Guild of the Wine Merchants.*
Ferdinand Bol. Oil on canvas. 193.5 x 305 cm.
Alte Pinakothek, Munich.

The Jewish Bride

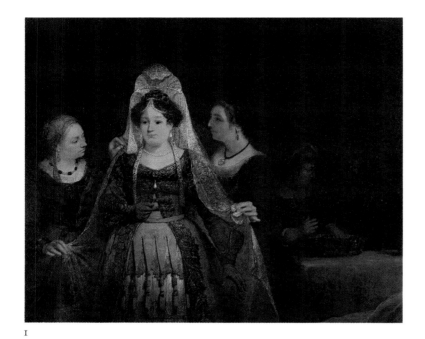

1

1. 2. 3.
Rembrandt lived in Breestrat the Jewish quarter of Amsterdam for more than twenty years. His Jewish neighbors served as models for the figures in his biblical painting. He was on friendly terms with many of them, including Doctor Ephraim Bueno whose portrait he painted.

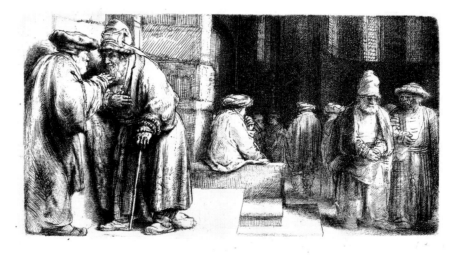

2

Wₑ do not know what was the inspiration for *The Jewish Bride*, one of Rembrandt's most beautiful paintings. Was it the marriage in 1668 of Titus and Magdalena van Loo, or was he returning to biblical themes, the marriage of Jacob and Rachel or Isaac and Rebecca for example? The painting radiates with an explosion of color, and an intense emotion underlies the husband's gesture. Rembrandt began the faces with a paintbrush and then modeled them with his fingers. The rest of the canvas is almost entirely handled with a palette knife accentuating its remarkable high relief. Houbraken joked that "one day Rembrandt completed a portrait that was so charged with color that one could pick it up by holding the nose of the painted subject." Rembrandt lived for only another four years. He died on October 4, 1669, one year after the death of his son Titus.

1. *The Jewish Bride*, 1684.
Aert de Gelder. Oil on canvas. 139 x 163 cm.
Alte Pinakothek, Munich.

2. *Jews in the Synagogue*, 1648.
Engraving, second state. 7.1 x 12.9 cm.
Rembrandthuis, Amsterdam.

3. *A Sibyl called Large Jewish Bride*, 1635.
Engraving, 5th state. 21.9 x 16.8 cm.
Rembrandthuis, Amsterdam.

FOLLOWING PAGES.
The Jewish Bride, 1665.
Oil on canvas. 121.5 x 166.5 cm.
Rijksmusuem, Amsterdam.

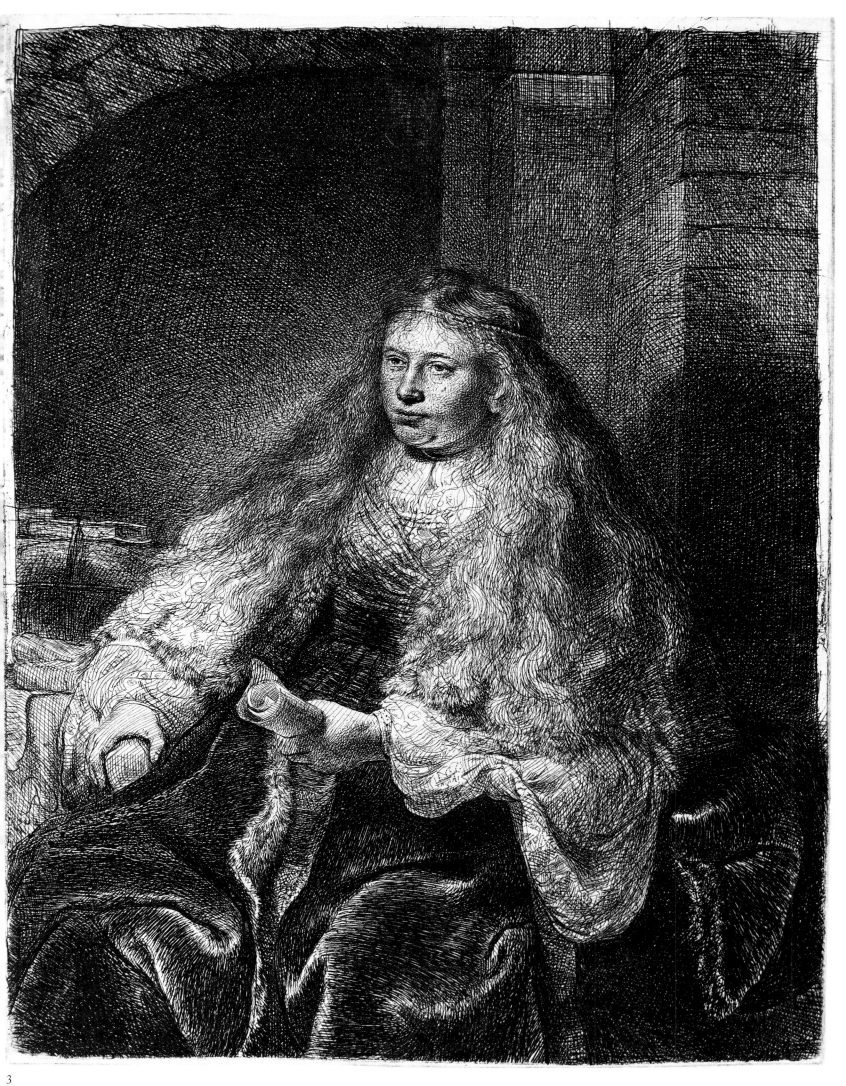

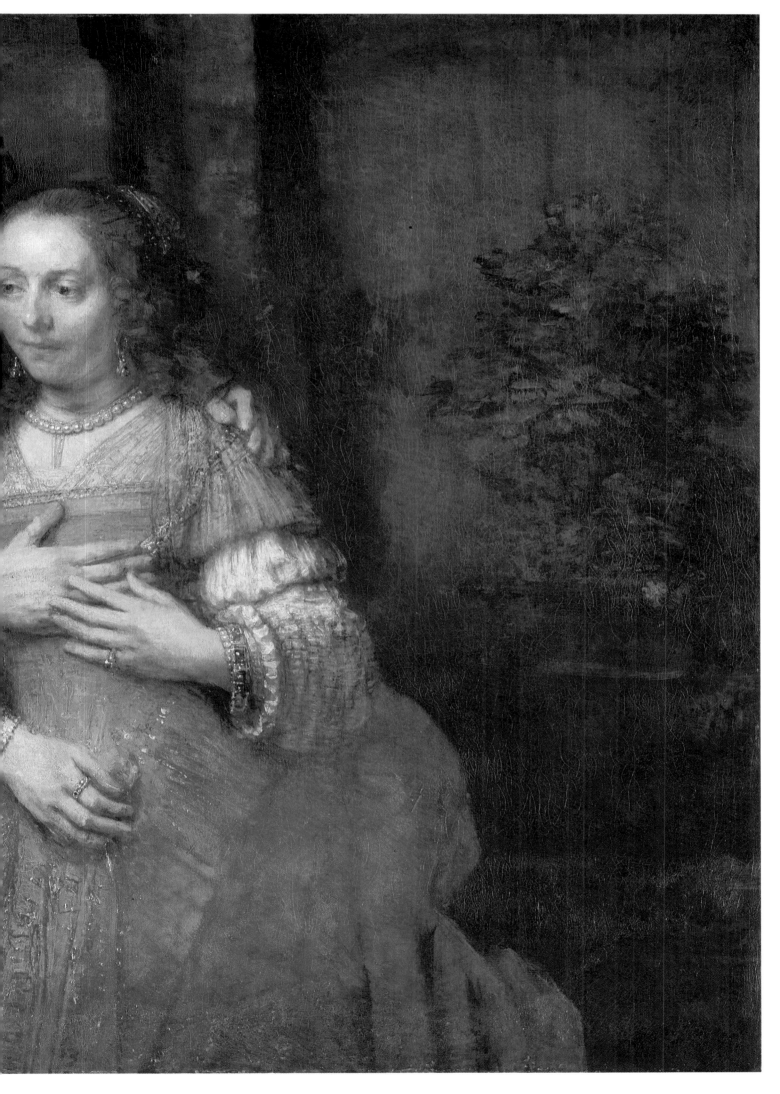

Contested or Rejected Works

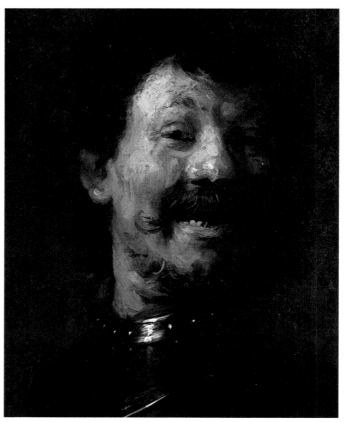

1

Given such a vast and complex body of work, it is no surprise that the authenticity of some of Rembrandt's works has been called into question from time to time. There are many problems. Many paintings issued from his studio; many others were done by painters eager to bask in his reflected glory by painting like him (this was common practice throughout the seventeenth century). The large number of counterfeit works makes the expert's job all the more difficult. We have already noted that Rembrandt's catalogue consisted of more than one thousand works at the beginning of the century. In the late sixties Horst Gerson reviewed the catalogue winnowing it down to around six hundred. For the last twenty years a team of eminent critics and historians have been working on the Rembrandt Research Project. Their stated task is to go over his entire body of work once again. Their conclusions, based upon the most rigorous analysis, are in the process of being published. Three volumes have already appeared, and the work is not projected to be completed until the beginning of the next century. But already some greatly admired works have either been deattributed or called into question. They include the famous *Man with the Golden Helmet, Two Black Men, The Laughing Soldier, Portrait of Elizabeth Baas* (Rijksmuseum, Amsterdam) *Rest on the Flight into Egypt* (Mauritshuis, The Hague) and *The Holy Family with Saint Anne* (Louvre, Paris). These findings have shocked the public, and the press has raised the alarm: to remove the *Man with the Golden Helmet* from Rembrandt's corpus, is to "attack the foundations of western culture," said one. It's hard to know what to think. If such a painting has already been rejected, what will be on the chopping block tomorrow.

In the words of Paul Claudel, a passionate admirer of Rembrandt's work: "Before a painting of Rembrandt we never have a sense of the permanent or definitive. Rather we are left with a precarious realization on the perimeters of our awareness. The curtain that has risen for just a moment is once again about to descend."

The greater the painting, the more profound the mystery. And Rembrandt remains a colossus, the painter of light and darkness, with all his profligacy and insolence. Rejected and abandoned by the same world that idolized him, he will never cease to be judged and to shoulder the judgment in the name of the truth to which he devoted his being.

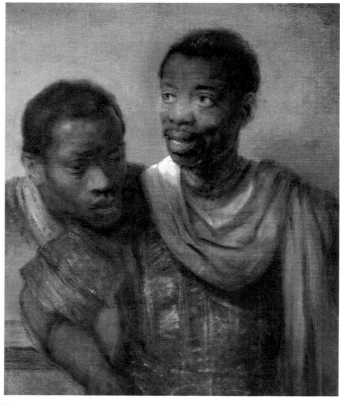

2

1. *Laughing Soldier,* 1629-1630.
(Rejected Rembrandt). Oil on copper. 15.4 x 12.2 cm.
Mauritshuis, The Hague.

2. *Two Black Men,* 1661.
(Rejected Rembrandt). Oil on canvas. 77.8 x 64.4 cm.
Mauritshuis, The Hague.

3. *Man with a Golden Helmet,* 1648.
(Rejected Rembrandt). Oil on canvas. 67 x 50 cm.
Gemäldegalerie, Berlin-Dalhem.

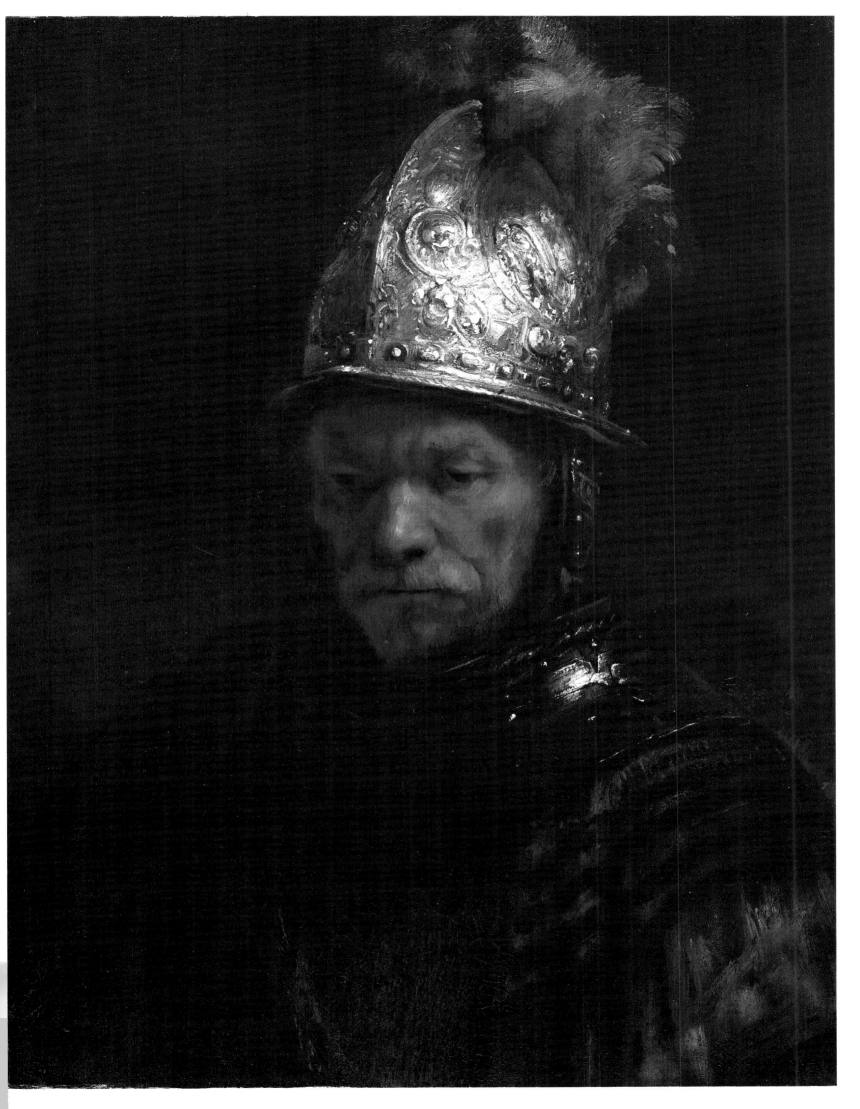

A Catalogue
of Other
Principal Works

1. *Portrait of a Man*, 1626.
Oil on panel. 48 x 37 cm.
Staatliche Kunstsammlungen,
Gemäldegalerie, Kassel.

2. *Portrait of an Old Man*, 1626.
Oil on panel. 24 x 20.5 cm.
Private collection.

3. *The Money-changer*, 1627.
Oil on panel. 32 x 34 cm.
Staatliche Museen, Berlin.

4. *Presentation in the Temple*, 1627.
Oil on panel. 55.5 x 44 cm.
Kunsthalle, Hamburg.

5. *St. Paul in Prison*, 1627.
Oil on panel. 72.8 x 60.3 cm.
Staatsgalerie, Stuttgart.

6. *Two Philosophers Conversing*, 1628.
Oil on panel. 72.5 x 60 cm.
National Gallery of Victoria,
Melbourne.

7. *Samson and Delilah,* 1628.
Oil on canvas. 59.5 x 49.5 cm.
Staatliche Museen, Berlin.

8. *Rembrandt's Mother*, 1629
Oil on panel. 58 x 45 cm.
The Royal Collection, Windsor.

9. *Self-Portrait*, 1629.
Oil on panel. 72.3 x 57.7 cm.
Walker Art Gallery, Liverpool.

10. *Self-Portrait*, 1629?
Oil on panel. 89 x 73.5 cm.
Isabella Stewart Gardner Museum,
Boston.

11. *Render Unto Caesar*, 1629.
Oil on panel. 41.5 x 32.5 cm.
National Gallery of Canada, Ottawa.

12. *Portrait of a Man with a Fur
Collar*, 1630.
Oil on panel. 47 x 39 cm.
Mauritshuis, The Hague.

13. *Officer with a Gold Chain*, 1630.
Oil on canvas. 36 x 26 cm.
Hermitage, St. Petersburg.

14. *St. Paul in Meditation*, 1630.
Oil on panel. 47 x 39 cm.
Germanisches Nationalmuseum,
Nuremburg.

15. *St. Anastasius*, 1631.
Oil on panel. 60 x 48 cm.
Nationalmuseum, Stockholm.

16. *Christ on the Cross*, 1631.
Oil on canvas. 100 x 73 cm.
The Church of Mas d'Agenais.

17. *Old Man with a Beret and Gold
Chain,* 1631.
Oil on panel. 60.5 x 51.5 cm.
City Museum, Birmingham.

18. *Andromeda in Chains*, 1631.
Oil on panel. 34.5 x 25 cm.
Mauritshuis, The Hague.

19. *The Raising of Lazarus*, 1631-
1632.
Engraving, third state. 36.7 x 25.7 cm.

20. *Joris de Caullery*, 1632.
Oil on canvas. 101 x 82.5 cm.
M.H. de Joung Memorial Museum,
San Francisco.

21. *Maurits Huygens*, 1632.
Oil on panel. 31.2 x 24.6 cm.
Kunsthalle, Hamburg.

22. *Self-Portrait*, 1632.
Oil on panel. 63 x 48 cm.
Art Gallery and Museum, Glasgow.

23. *The Noble Slav*, 1632.
Oil on canvas. 150 x 109 cm.
Metropolitian Museum of Art,
New York

24. *Young Girl with Earrings*, 1632.
Oil on panel. 69 x 53 cm.
Museum of Fine Arts, Boston.

25. *Young Woman with an
Embroidered Dress*, 1632.
Oil on panel. 50 x 60 cm.
Pinacoteca di Brera, Milan.

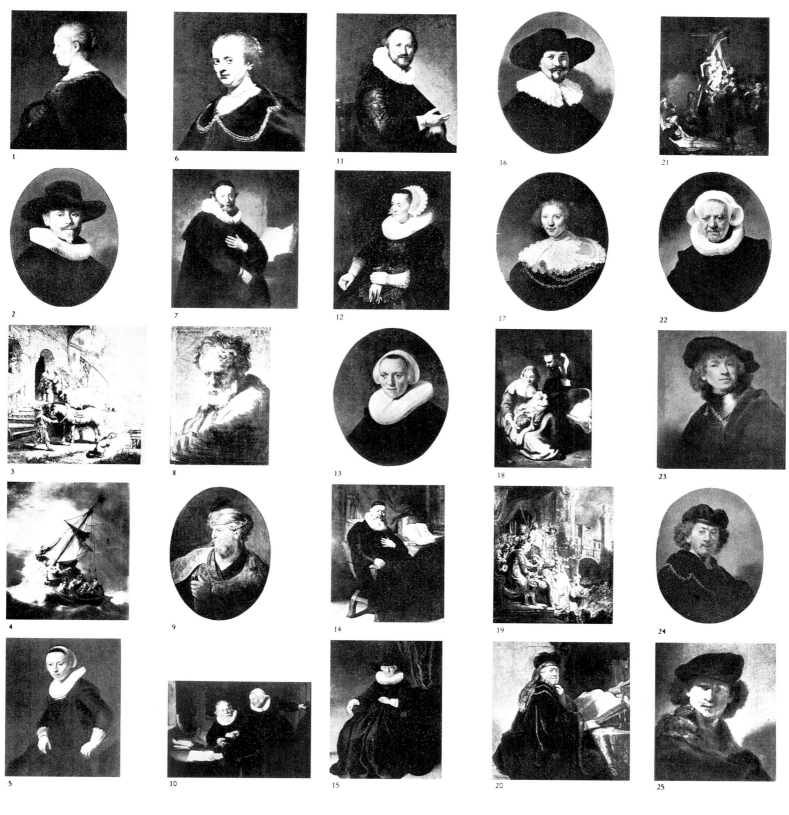

1. *Portrait of a Young Woman with a Fan*, 1632.
Oil on canvas. 72 x 54 cm.
Nationalmuseum, Stockholm.

2. *Aelbert Cuyper*, 1632.
Oil on panel. 60 x 47 cm.
Louvre, Paris.

3. *The Good Samaritan*, 1633.
Engraving, first state. 25.8 x 21.9 cm.

4. *Christ in the Storm on the Sea of Galilee*, 1633.
Oil on canvas. 159.5 x 127.5 cm.
Isabella Stewart Gardner Museum, Boston.

5. *Young Girl Seated*, 1633.
Oil on canvas. 92 x 70.6 cm.
Akademie der Bildendenkunste, Vienna.

6. *Woman with a Gold Chain*, 1633.
Oil on canvas. 62 x 55.5 cm.
Private Collection, South America.

7. *Jan Uyttenbogaert*, 1633.
Oil on canvas. 130 x 101 cm.
Private Collection, Mentmore.

8. *Portrait of an Old Man*, 1633.
Oil on panel. 9.5 6.5 cm.
Private Collection, New York.

9. *Portrait of a Man in Oriental Costume*, 1633.
Oil on panel. 85.8 x 63.8 cm.
Alte Pinakothek, Munich.

10. *The Shipbuilder and His Wife*, 1633.
Oil on canvas. 115 x 165 cm.
Royal Collection, Buckingham Palace.

11. *Seated Man*, 1633.
Oil on panel. 90 x 68.7 cm.
Kunsthistorisches Museum, Vienna.

12. *Seated Woman*, 1633.
Oil on panel. 90 x 67.5 cm.
Kunsthistorisches Museum, Vienna.

13. *Woman with a Large Collar*, 1634.
Oil on panel. 66 x 52.5 cm.
Private Collection, London.

14. *Portrait of John Elison*, 1634.
Oil on canvas. 173 x 124 cm.
Museum of Fine Arts, Boston.

15. *Portrait of Mary Elison*, 1634.
Oil on canvas. 174.5 x 124
Museum of Fine Arts, Boston.

16. *Bearded Man with a Large Hat*, 1634.
Oil on panel. 68 x 52 cm.
Museum of Fine Arts, Boston.

17. *Woman with a Gold Chain and an Embroidered Collar*, 1634?
Oil on panel. 68 x 52.5 cm.
Museum of Fine Arts, Boston.

18. *The Holy Family*, 1634.
Oil on canvas. 183.5 x 123 cm.
Alte Pinakothek, Munich.

19. *Ecce Homo*, 1634.
Oil on paper. 54.5 x 44.5 cm.
National Gallery, London.

20. *Philosopher in His Chamber*, 1634.
Oil on canvas. 141 x 135 cm.
Narodni Gallery, Prague.

21. *The Descent from the Cross*, 1634.
Oil on canvas. 158 x 117 cm.
Hermitage, St. Petersburg.

22. *Eighty-three Year Old Woman*, 1634.
Oil on panel. 68.5 x 54 cm.
National Gallery, London.

23. *Self-Portrait*, 1634.
Oil on panel. 67 x 54 cm.
Uffizi Gallery, Florence.

24. *Self-Portrait with Cap and Gold Chain*, 1633.
Oil on panel. 68 x 53 cm.
Louvre, Paris.

25. *Self-Portrait*, 1634.
Oil on panel. 57 x 46 cm.
Staatliche Museen, Berlin.

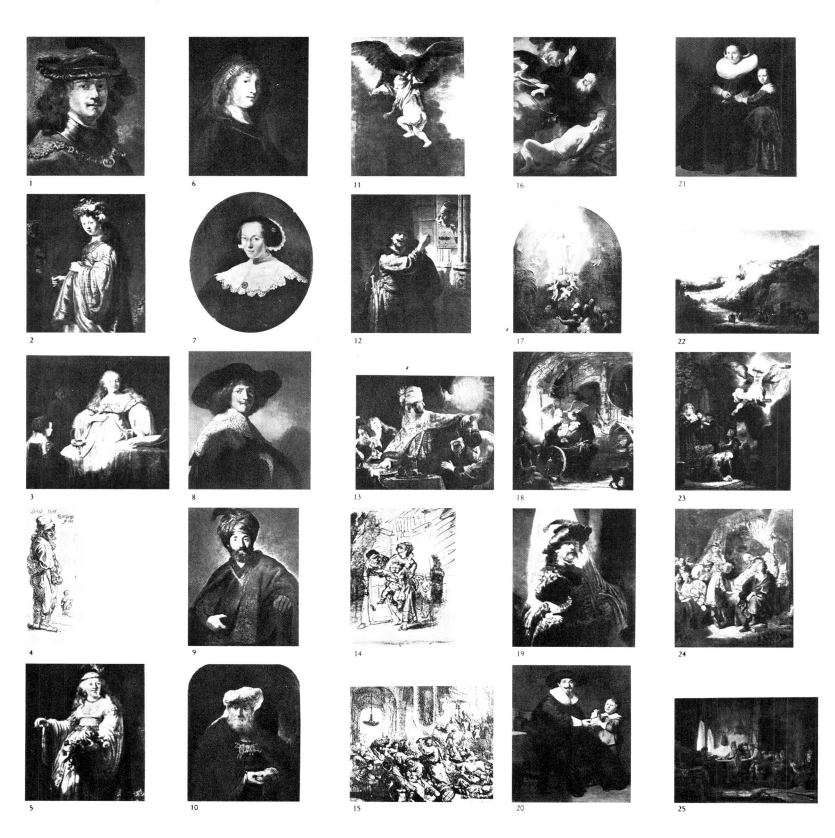

1. *Self-Portrait*, 1634.
Oil on panel. 55 x 46 cm.
Staatliche Museen, Berlin.

2. *Saskia as Flora*, 1634.
Oil on canvas. 125 x 101 cm.
Hermitage, St. Petersburg.

3. *Sophosnisbe Receiving the Poison Cup*, 1634.
Oil on panel. 142 x 153 cm.
Prado, Madrid.

4. *A Peasant*, 1634.
Engraving. 11.1 x 3.9 cm.

5. *Saskia as Flora*, 1635.
Oil on canvas. 123.5 x 97.5 cm.
National Gallery, London.

6. *Portrait of Saskia with a Veil*, 1635.
Oil on panel. 60.5 x 49 cm.
National Gallery, Washington DC.

7. *Portrait of a Woman*, 1635.
Oil on panel. 77 x 64 cm.
Museum of Art, Cleveland.

8. *Anthonis Coopal*, 1635.
Oil on panel. 83 x 67 cm.
Private Collection, Greenwich.

9. *Man in Oriental Costume*, 1635.
Oil on canvas. 98 x 74 cm.
National Gallery, Washington, DC.

10. *King Uzziah Stricken with Leprosy*, 1635.
Oil on panel. 101 x 77 cm.
Devonshire Collection, Chatsworth.

11. *The Abduction of Ganymedes*, 1635.
Oil on canvas. 171 x 130 cm.
Gemäldegalerie, Dresden.

12. *Samson Threatening his Father-in-law*, 1635.
Oil on canvas. 156 x 129 cm.
Staatliche Museen, Berlin.

13. *Belshazzar's Feast*, 1635.
Oil on canvas. 167.5 x 209 cm.
National Gallery, London.

14. *Woman with a Child*, 1635.
Pen and ink. 20.5 x 14.3 cm.
Kupferstichkabinett, Berlin.

15. *Christ Chasing the Money-changers from the Temple*, 1635.
Engraving, second state. 13.5 x 16.7 cm.

16. *The Sacrifice of Abraham*, 1635.
Oil on canvas. 193 x 133 cm.
Hermitage, St. Petersburg.

17. *The Ascension*, 1636.
Oil on canvas. 92.7 x 68.3 cm.
Alte Pinakothek, Munich.

18. *Tobias Restoring His Father's Sight*, 1636.
Oil on panel. 47.2 x 38.8 cm.
Staatsgalerie, Stuttgart.

19. *The Standard Bearer*, 1636.
Oil on canvas. 125 x 105 cm.
Rothschild Collection, Paris.

20. *Jan Pellicorn and His Son Casper*, 1636.
Oil on canvas. 155 x 123 cm.
Wallace Collection, London.

21. *Mrs. Pellicorn and Her Daughter*, 1636.
Oil on canvas. 155 x 123 cm.
Wallace Collection, London.

22. *Landscape*, 1636.
Oil on canvas. 85.5 x 108 cm.
Niedersächsisches Landesmuseum, Hanover.

23. *The Angel Raphael Leaving Tobias*, 1637.
Oil on panel. 66 x 52 cm.
Louvre, Paris.

24. *Joseph Recounting His Dreams*, 1637.
Oil on panel. 51 x 39 cm.
Rijksmusuem, Amsterdam.

25. *Workers at the Eleventh Hour*, 1637.
Oil on panel. 31 x 42 cm.
Hermitage, St. Petersburg.

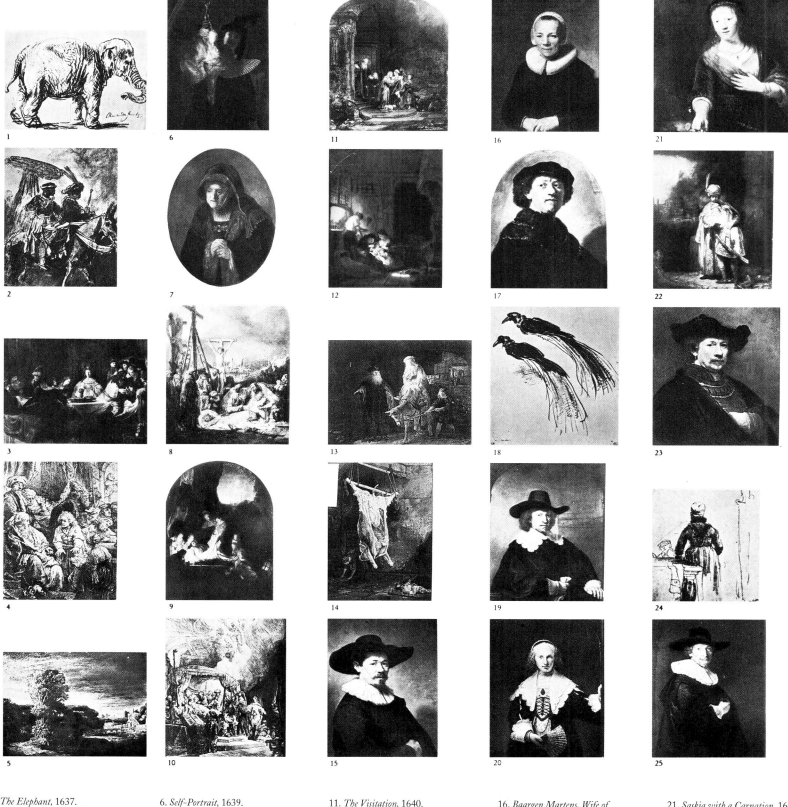

1. *The Elephant*, 1637.
Charcoal. 23 x 34 cm.
Albertina, Vienna.

2. *Black Drummers on Horseback*, 1637.
Ink, pastel and watercolor. 23 x 17 cm.
British Museum, London.

3. *The Marriage of Samson*, 1638.
Oil on canvas. 126 x 175 cm.
Gemäldegalerie, Dresden.

4. *Joseph Recounting His Dreams*, 1638.
Engraving, third state. 10.8 x 8.1 cm.

5. *Landscape with Ruins*, 1639.
Oil on panel. 30 x 46 cm.
Private Collection, Wassenaar.

6. *Self-Portrait*, 1639.
Oil on panel. 121 x 89 cm.
Gemäldegalerie, Dresden.

7. *Rembrandt's Mother*, 1639.
Oil on panel. 79.5 x 61.7 cm.
Kunsthistoriches Museum, Vienna.

8. *Lamentation over Christ*, 1639.
Paper on wood. 31.9 x 26.5 cm.
National Gallery, London.

9. *The Entombment*, 1639.
Oil on panel. 32 x 40.5 cm.
Hunterian Museum, Glasgow.

10. *The Death of the Virgin*, 1639.
Engraving, second state. 40.9 x 31.5 cm.

11. *The Visitation*, 1640.
Oil on panel. 57 x 48 cm.
Institute of Art, Detroit.

12. *The Holy Family*, 1640.
Oil on panel. 41 x 34 cm.
Louvre, Paris.

13. *The Departure of the Sunamite*, 1640.
Oil on panel. 39 x 53 cm.
Victoria and Albert Museum, London.

14. *The Slaughtered Ox*, 1640.
Oil on panel. 73.5 x 51.7 cm.
Art Gallery and Museum. Glasgow.

15. *Herman Doomer*, 1640.
Oil on panel. 74 x 53 cm.
Metropolitan Museum of Art, New York.

16. *Baargen Martens, Wife of Herman Doomer*, 1640.
Oil on panel. 76 x 56 cm.
Hermitage, St. Petersburg.

17. *Self-Portrait*, 1640.
Oil on panel. 65 x 51 cm.
Wallace Collection, London.

18. *Birds of Paradise*, 1640.
Watercolor. 18.1 x 15.4 cm.
Louvre, Paris.

19. *Nicolaes van Bambeeck*, 1641.
Oil on canvas. 105.5 x 84 cm.
Musées Royaux des Beaux-Arts, Brussels.

20. *Agatha Bas, Mrs. Bambeeck*, 1641.
Oil on canvas. 104.5 x 84 cm.
Royal Collection, Buckingham Palace.

21. *Saskia with a Carnation*, 1641.
Oil on panel. 98.5 x 82.5 cm
Gemäldegalerie, Dresden.

22. *The Reconciliation of David and Absalom*, 1642.
Oil on panel. 73 x 61.5 cm.
Hermitage, St. Petersburg.

23. *Self-Portrait*, 1643.
Oil on panel. 70.5 x 58 cm.
The Royal Collection, Windsor.

24. *Geertje Dircks*, 1642.
Pen and ink and watercolor. 22 x 15 cm.
Teylers Museum, Haarlem.

25. *Portrait of a Man*, 1643.
Oil on canvas. 104 x 76 cm.
Private Collection, Tisbury.

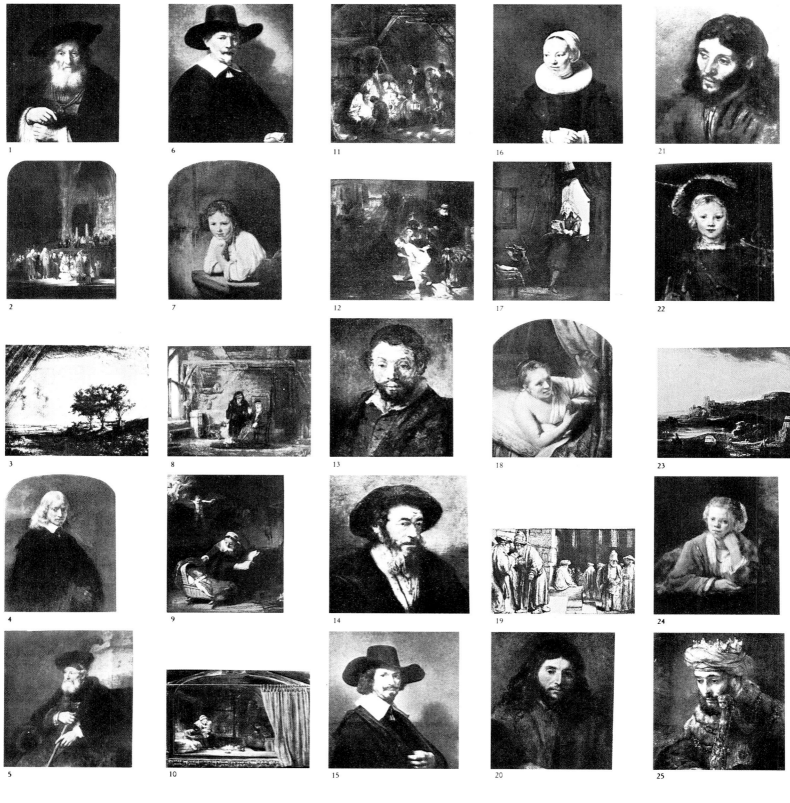

1. *Portrait of an Old Man*, 1643.
Oil on panel. 72.5 x 58.5 cm.
Private Collection, Woburn Abbey.

2. *Christ and the Woman Taken in Adultery*, 1643.
Oil on panel. 83.8 x 65.4 cm.
National Gallery, London.

3. *The Three Trees*, 1643.
Engraving. 21.1 x 28 cm.

4. *The Art Dealer, Clement de Jonghe* (?), 1644.
Oil on panel. 92.5 x 73.5 cm.
Private Collection, Buscot Park.

5. *Portrait of an Old Man*, 1645.
Oil on canvas. 128 x 112 cm.
Gulbenkian Foundation, Lisbon.

6. *Man with Glove*, 1645.
Oil on panel. 81 x 67 cm.
Metropolitan Museum of Art, New York.

7. *Young Girl Leaning on a Window-sill*, 1645.
Oil on canvas. 81.5 x 68 cm.
Dulwich College, London.

8. *Anna Accused by Tobit of the Theft of a Kid*, 1645.
Oil on panel. 29 x 27 cm.
Staatliche Museen, Berlin.

9. *Holy Family with Angels*, 1645.
Oil on canvas. 117 x 91 cm.
Hermitage, St. Petersburg.

10. *Holy Family*, 1646.
Oil on panel. 46.5 x 68.8 cm.
Gemäldegalerie, Kassel.

11. *Adoration of the Shepherds*, 1646.
Oil on canvas. 63 x 55 cm.
National Gallery, London.

12. *Susanna and the Elders*, 1647.
Oil on panel. 76 x 92.8 cm.
Staatliche Museen, Berlin.

13. *A Young Jew*, 1647.
Oil on panel. 24.5 x 20.5 cm.
Staatliche Museen, Berlin.

14. *Portrait of an Old Man*, 1647.
Oil on canvas. 25.1 x 22.5 cm.
Boymans Beuningen Museum, Rotterdam.

15. *Hendrick Maertens*, 1647.
Oil on wood. 74 x 67 cm.
Westminster Collection, London.

16. *Ariaentje Hollaer, Wife of Hendrick Maertens*, 1647.
Oil on panel. 74 x 67 cm.
Westminster Collection, London.

17. *Portrait of Jan Six*, 1647.
Engraving, third state. 24.5 x 19.1 cm.

18. *Hendrickje in Bed*, 1648.
Oil on canvas. 80 x 63.3 cm.
National Gallery of Scotland, Edinburgh.

19. *Jews in the Synagogue*, 1648.
Engraving, first state. 71 x 12.9 cm.

20. *Christ*, 1650.
Oil on panel. 25.5 x 21 cm.
Bredius Museum, The Hague.

21. *Christ*, 1650.
Oil on panel. 25 x 20 cm.
Staatliche Museen, Berlin.

22. *Portrait of a Child in Costume*, 1650.
Oil on canvas. 65 x 56 cm.
Norton Simon Foundation, Fullerton, California.

23. *The Ruin*, 1650.
Oil on panel. 67 x 85.5 cm. .
Gemäldegalerie, Kassel.

24. *Young Girl at a Window*, 1651.
Oil on canvas. 78 x 63 cm.
Nationalmuseum, Stockholm.

25. *King David*, 1651.
Oil on panel. 30 x 26 cm.
Private Collection, New York.

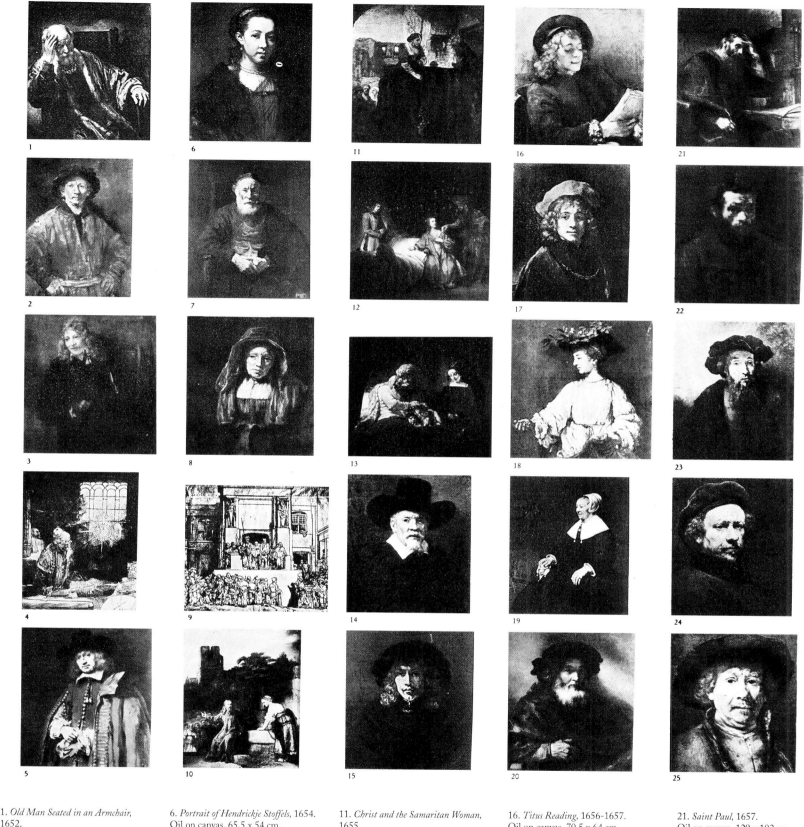

1. *Old Man Seated in an Armchair,* 1652.
Oil on canvas. 111 x 88 cm.
National Gallery, London.

2. *Self-Portrait,* 1652.
Oil on canvas. 112 x 81.5 cm.
Kunsthistorisches Museum, Vienna

3. *Nicolaes Bruyningh,* 1652.
Oil on canvas. 107.5 x 81.5
Gemäldegalerie, Kassel.

4. *Doctor Faustus,* 1652-1653.
Engraving, first state. 20.9 x 16.1 cm.

5. *Portrait of Jan Six,* 1654.
Oil on canvas. 112 x 102 cm.
Six Foundation, Amsterdam.

6. *Portrait of Hendrickje Stoffels,* 1654.
Oil on canvas. 65.5 x 54 cm.
Norton Simon Collection,
Los Angeles.

7. *Old Man Seated,* 1654.
Oil on canvas. 108 x 86 cm.
Hermitage, St. Petersburg.

8. *Portrait of an Old Woman,* 1654.
Oil on canvas. 74 x 63 cm.
Pushkin Museum, Moscow.

9. *Ecce Homo,* 1653.
Engraving, first state. 38.3 x 45.5 cm.

10. *Christ and the Samaritan Woman,*
1655.
Oil on panel. 62 x 49.5 cm.
Metropolitan Museum of Art,
New York.

11. *Christ and the Samaritan Woman,*
1655.
Oil on panel. 46.5 x 39 cm.
Staatliche Museen, Berlin

12. *Joseph Accused by Potiphar's Wife,*
1655.
Oil on canvas. 110 x 87 cm.
Staatliche Museen, Berlin

13. *Jacob Blessing the Sons of Joseph,*
1656.
Oil on canvas. 177.5 x 210.5 cm.
Gemäldegalerie, Kassel.

14. *Doctor Arnold Thoclinx,* 1656.
Oil on canvas. 76 x 63 cm.
Musée Jacquemard-André, Paris.

15. *Young Man with a Beret,* 1656.
Oil on canvas. 76 x 61 cm.
Payson Collection, New York.

16. *Titus Reading,* 1656-1657.
Oil on canvas. 70.5 x 64 cm.
Kunsthistorisches Museum, Vienna.

17. *Portrait of Titus,* 1657.
Oil on canvas. 71 x 58 cm.
Wallace Collection, London.

18. *Hendrickje as Flora,* 1657.
Oil on canvas. 100 x 92 cm.
Metropolitan Museum of Art,
New York.

19. *Portrait of Catrina Hooghsaet,*
1657.
Oil on canvas. 82 x 65 cm.
Penrhyn Castle, Wales.

20. *Portrait of an Old Man,* 1657.
Oil on canvas. 82 x 65 cm.
Private Collection, Kenosha.

21. *Saint Paul,* 1657.
Oil on canvas. 129 x 102 cm.
National Gallery, Washington DC.

22. *Portrait of a Bearded Man,* 1657.
Oil on canvas. 70.5 x 58 cm.
Staatliche Museen, Berlin.

23. *Portrait of a Rabbi,* 1657.
Oil on canvas. 78 x 66.7 cm.
National Gallery, London.

24. *Self-Portrait,* 1657.
Oil on canvas. 50 x 42.2 cm.
National Gallery of Scotland,
Edinburgh.

25. *Self-Portrait,* 1657.
Oil on panel. 49.2 x 41 cm.
Kunsthistorisches Museum, Vienna.

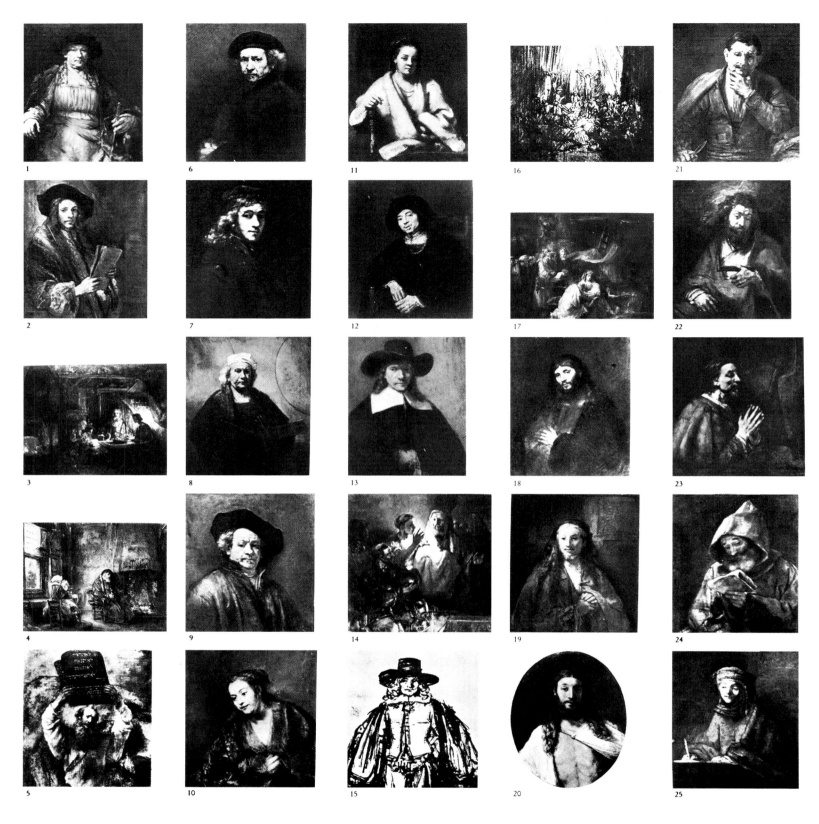

1. *Self-Portrait*, 1658.
Oil on canvas. 133 x 103 cm.
Frick Collection, New York.

2. *Man Holding a Book*, 1658.
Oil on canvas. 109 x 86 cm.
Metropolitan Museum of Art, NY.

3. *Philomen and Baucis*, 1658.
Oil on canvas. 54 x 68 cm.
National Gallery, Washington DC.

4. *Tobit and Anna Waiting*, 1659.
Oil on panel. 40 x 54 cm.
W. van der Vorm Foundation,
Rotterdam.

5. *Moses Breaking the Tablets*, 1659.
Oil on canvas. 167 x 135 cm.
Staatliche Museen, Berlin

6. *Self-Portrait*, 1659.
Oil on canvas. 84 x 66 cm.
National Gallery, Washington DC.

7. *Portrait of Titus*, ca. 1660-1662.
Oil on canvas. 72 x 56 cm.
Louvre, Paris.

8. *Self-Portrait*, 1660.
Oil on canvas. 114 x 94 cm.
Kenwood House, London.

9. *Self-Portrait*, 1660.
Oil on canvas. 77/.5 x 66 cm.
Metropolitan Museum of Art,
New York.

10. *Portrait of Hendrickje Stoffels*,
1660.
Oil on canvas. 76 x 67 cm.
Metropolitan Museum of Art,
New York.

11. *Hendrickje Stoffels*, 1660.
Oil on canvas. 101 x 83 cm.
National Gallery, London.

12. *Young Man Seated*, 1660.
Oil on canvas. 93 x 87 cm.
Eastman Collection,
University of Rochester.

13. *Portrait of a Man*, 1660.
Oil on canvas. 82.5 x 64.5 cm.
Metropolitan Museum of Art,
New York.

14. *The Denial of St. Peter*, 1660.
Oil on canvas. 154 x 169 cm.
Rijksmuseum, Amsterdam.

15. *Portrait of a Man*, 1660.
Ink and watercolor. 23.2 x 19.4 cm.
Six Foundation, Amsterdam.

16. *The Three Crosses*, 1660-1661.
Engraving, fourth state. 38.7 x 45 cm.

17. *The Circumcision*, 1661.
Oil on canvas. 56 x 75 cm.
National Gallery, Washington DC.

18. *Christ*, 1661.
Oil on canvas. 108 x 89 cm.
Hyde Collection, Glen Falls, N.Y.

19. *Christ*, 1661.
Oil on canvas. 94 x 81.5 cm.
Metropolitan Museum of Art,
New York.

20. *Christ Resurrected*, 1661.
Oil on canvas. 78.5 x 63 cm.
Alte Pinakothek, Munich.

21. *St. Bartholomew*, 1661.
Oil on canvas. 87.5 x 75 cm.
Getty Museum, Malibu.

22. *The Apostle Simon*, 1661.
Oil on canvas. 98 x 79 cm.
Kunsthaus, Zurich.

23. *St. James*, 1661.
Oil on canvas. 90 x 78 cm.
Metropolitan Museum of Art,
New York.

24. *Monk Reading*, 1661.
Oil on canvas. 82 x 66 cm.
Athenaeum, Helsinki.

25. *An Evangelist Writing*, 1661.
Oil on canvas. 105 x 82 cm.
Museum of Fine Arts, Boston.

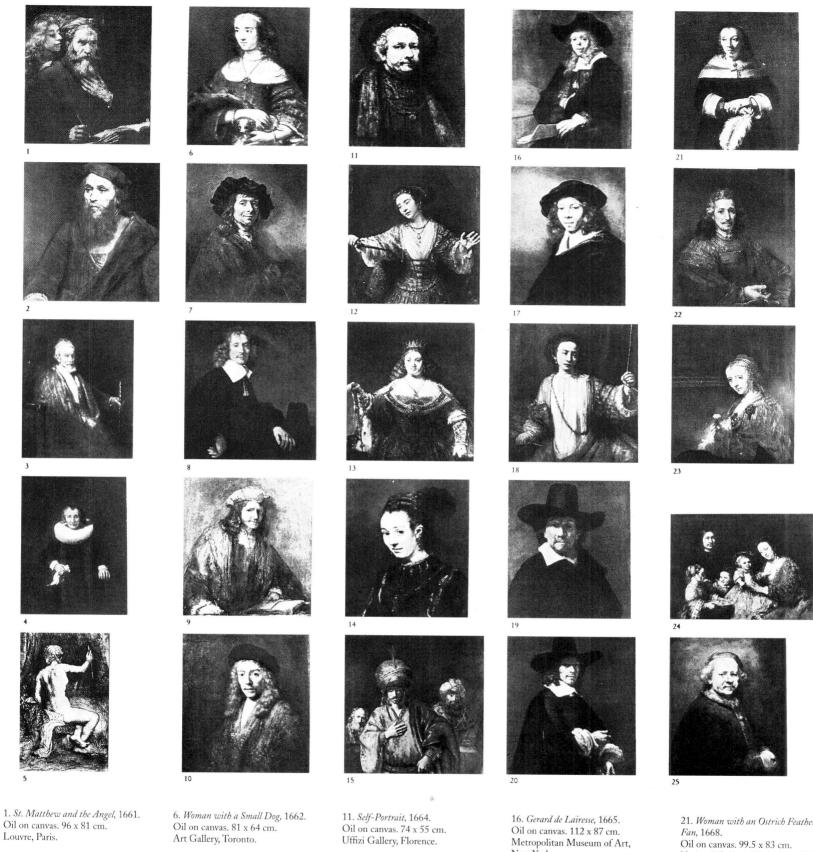

1. *St. Matthew and the Angel*, 1661.
Oil on canvas. 96 x 81 cm.
Louvre, Paris.

2. *Portrait of a Bearded Man*, 1661.
Oil on canvas. 71 x 61 cm.
Hermitage, St. Petersburg.

3. *Portrait of Jacob Trip*, 1661.
Oil on canvas. 130.5 x 97 cm.
National Gallery, London.

4. *Portrait of Margaretha de Geer, Wife of Jacob Trip*, 1661.
Oil on canvas. 130.5 x 97 cm.
National Gallery, London.

5. *Nude with Arrow*, 1661.
Engraving, first state. 20.3 x 12.3 cm.

6. *Woman with a Small Dog*, 1662.
Oil on canvas. 81 x 64 cm.
Art Gallery, Toronto.

7. *Portrait of a Young Man*, 1662.
Oil on canvas. 85 x 70 cm.
City Art Museum, St. Louis.

8. *Young Man Seated*, 1662.
Oil on canvas. 110 x 90 cm.
National Gallery, Washington DC.

9. *An Evangelist Writing*, 1663.
Oil on canvas. 102 x 80 cm.
Boymans-Van Beuningen Museum, Rotterdam.

10. *Portrait Presumed To Be Titus*, 1663.
Oil on canvas. 81 x 65 cm.
Dulwich College, London.

11. *Self-Portrait*, 1664.
Oil on canvas. 74 x 55 cm.
Uffizi Gallery, Florence.

12. *The Death of Lucretia*, 1664.
Oil on canvas. 116 x 99 cm.
National Gallery, Washington DC.

13. *Juno*, 1664-1665.
Oil on canvas. 127 x 107.3 cm.
Armand Hammer Foundation, Los Angeles.

14. *Portrait of a Young Woman*, 1665.
Oil on canvas. 56 x 47 cm.
Museum of Fine Arts, Boston.

15. *The Disgrace of Aman*, 1665.
Oil on canvas. 127 x 117 cm.
Hermitage, St. Petersburg.

16. *Gerard de Lairesse*, 1665.
Oil on canvas. 112 x 87 cm.
Metropolitan Museum of Art, New York.

17. *Portrait of a Young Man*, 1666.
Oil on canvas. 78 x 63 cm.
William Rockhill Nelson Gallery, Kansas City.

18. *Lucretia*, 1666.
Oil on canvas. 105 x 92.5 cm.
Minneapolis Museum of Arts, Minneapolis.

19. *Jeremias de Decker*, 1666.
Oil on canvas. 71 x 56 cm.
Hermitage, St. Petersburg.

20. *Man with Gloves*, 1668.
Oil on canvas. 99.5 x 82.5 cm.
National Gallery, Washington DC.

21. *Woman with an Ostrich Feather Fan*, 1668.
Oil on canvas. 99.5 x 83 cm.
National Gallery, Washington DC.

22. *Man with a Magnifying Glass*, 1668.
Oil on canvas. 90 x 73.5 cm.
Metropolitan Museum of Art, New York.

23. *Woman with a Carnation*, 1668.
Oil on canvas. 91 x 73 cm.
Metropolitan Museum of Art, New York.

24. *Family Portrait*, 1668-1669.
Oil on canvas. 126 x 167 cm.
Herzog Anton Ulrich-Museum, Brunswick.

25. *Self-Portrait*, 1669.
Oil on canvas. 86 x 70.5 cm.
National Gallery, London.

Select Bibliography

Rembrandt: sa vie et ses oeuvres, C. Vosmaer, The Hague, 1877.

Rembrandt: son vie, son oeuvre et son temps, E. Michel, Paris, 1893

Rembrandt, C. Neumann, Berlin, 1902.

The Portraits of Rembrandt's Father, A.M. Hind, *Burlington Magazine* no. 8, pp.426-431, 1905-1906.

Rembrandt und Cats, K. von Baudissen, Repertorium für Kunstwissenschaft no. 45, pp. 148-179, 1925.

Rembrandt, W. Weisbach, Berlin, 1926.

Jan Lievens, H. Schneider, Haarlem, 1932.

Rembrandt, A.M. Hind, Cambridge, 1932.

Rembrandt, J. Burckhardt, transcription of conference in Burckhardt Gesamtausgabe, vol. 14, pp. 178-197, Stuttgart, 1933.

Rembrandt, the Jews and the Bible, F. Landsberger, Philadelphia, 1946.

Cleaned Pictures, exhibiting the results of restoration by the National Gallery, London, 1947.

Rembrandt's Conception of Historical Portraiture, W.R. Valentine, Art Quarterly no. 11, pp. 117-35, 1948.

Rembrandt, H.E. van Gelder, Amsterdam, 1948.

Rembrandt: Life and Work, J. Rosenberg, Cambridge, 1948, 1964.

Verzamelde stüdien en essays, no. 2, Rembrandt, FF. Schmidt-Degener, Amsterdam, 1950.

Rembrandt et son temps, R. Avermaete, Paris, 1952.

Rembrandt Harmenz van Rijn, L. Münz, New York.

Hercules Seghers, E. Haverkamp, Bergemann, Rotterdam, 1954.

Rembrandt, A.B. de Vries, Baarn, 1956.

Rembrandt, G. Knuttel, Amsterdam, 1956.

Rembrandt, Otto Benesh, Geneva, 1957.

Constantin Huygens et Rembrandt, H.E. van Gelder, Oud Holland no. 74, pp. 174-79, 1959.

Rembrandt and Ancient History, O. Benesh, *Art Quarterly*, no. 22, pp. 309-32, 1959.

Seven Letters by Rembrandt, H. Gerson, The Hague, 1961.

Rembrandt and His World, C. White, London, 1964.

Rembrandt and the Italian Renaissance, K. Clark, New York, 1966.

Rembrandt and His Time, Robert Wallace, Time-Life, 1961.

Rembrandt, H. Gerson, Le Livre partout, Paris, 1968.

Rembrandt's Drawings and Etchings for the Bible, H.M. Rotermund, Pilgrim Press, Philadelphia, 1969.

Rembrandt, His Life, His Work, His Time, B. Haak, New York, 1969.

Rembrandt, Tout l'oeuvre peint, J. Foucart, Flammarion, les classiques de l'art, Paris, 1969.

Rembrandt, Anne-Maries Vels Heijn, Editions Knorr et Hirth GMBH, 1973, 1977, 1981.

La peinture flamande et hollondaise, Hewvig Guratzch, VNU Books, International, Amsterdam, 1979.

Rembrandt and the Bible, A. Hyatt Mayor, New York, 1979.

Rembrandt: Self-Portraits, C. Wright, London 1982.

Les peintures de Rembrandt au Louvre, J. Foucart, Editions de R.M.N., Paris, 1982.

A Corpus of Rembrandt Paintings, (Stichting Foundation, Rembrandt Research Project), J. Bruyn, B. Haak, S.H. Levie, P.J.J. van Thiel, E. van de Wetering, The Hague, Boston, London, 1982.

La Peinture hollandaise et flamande, Pierre Courthion, Nathan, Paris, 1983.

La Peinture de genre hollandaise au XVII siècle, C. Brown, De Bussy-Vila, Paris, 1984.

Rembrandt, His Life, His Paintings, G. Schwartz, Viking, New York, 1985.

Rembrandt Autoportrait, Pascal Bonafoux, Editions Skira, Geneva, 1985.

De Rembrandt à Vermeer, Ben Broos. Catalogue of exhibition at the Grand Palais entitled "Les Peintres Hollandais au Mauritshuis de la Haye." Edition de la Fondation Johan Maurits von Nassau, The Hague 1986.

Rembrandt, Anne-Marie vels Heijn, Scala, Amsterdam, 1989.

Rembrandt, le clair, l'obscur, P. Bonafoux, Gallimard, Paris, 1990.

Rembrandt biographie, P. Descargues, Jean-Claude Lattès, Paris, 1990.

Rembrandt, M. le Bot, Flammarion, Paris, 1990.

Rembrandt O. Benesh, Editions Skira, Geneva, 1990.

Photographic Credits

Index of Rembrandt's Works

Adam and Eve . 76
Adoration of the Magi, The . 116
Anatomy Lesson of Doctor Johan Deyman, The 52, 53
Anatomy Lesson of Professor Tulp, The 48-49, 50
Artist Drawing a Model . 42
Artist in His Studio, The . 41
Artist's Studio, The . 43
Balaam's Ass . 33
Balthazar Castiglione after Raphael . 66
Bathsheba . 123
Blind Homer Dictating to a Scribe . 130
Bust of a Man in Oriental Costume . 85
Christ at Emmaus . 82, 83
Christ Healing the Sick or The Hundred Guilder Print 75
Claudius Civilis or The Conspiracy of the Batavians 132-133
Concert or The Musicians or The Music Lovers 95
Crippled Beggar Known as Captain Eenbeen 34
Danae . 121
Descent from the Cross, The . 69
Entombment, The . 72
Female Nude before a Stove . 122
Hendrickje with a Velvet Beret . 117
Jeremiah Lamenting the Destruction of Jerusalem 81
Jewish Bride, The . 142-143
Jews in the Synagogue . 140
Judas Returning the Thirty Pieces of Silver (Preliminary Study) . . . 80
Jupiter and Antiope . 120
Landscape with Bridge . 102-103, 104
Last Supper after Leonardo da Vinci, The 66
Le lit à la francais . 120
Male Nude Sitting on the Ground 124-125
Man Urinating . 34
Nightwatch, The . 98-99
Old Man with Long Beard . 76
Old Woman Seated with Folded Hands 26
Parable of the Merciless Creditor . 129
Philosopher in Meditation . 44-45
Portrait of a Man with a Large Hat (Dirck Pesser?) 56
Portrait of Cornelis Claesz Anslo . 60
Portrait of Ephraim Bueno . 60
Portrait of Ephraim Bueno . 61
Portrait of Frederick Rihel . 135
Portrait of Geertje Dircks . 116
Portrait of Haesje van Cleyburgh . 57
Portrait of Maria Trip . 54
Portrait of Saskia Laughing . 55
Portrait of Saskia van Uylenburgh . 71

Preaching of John the Baptist, The . 78
Presentation in the Temple, The . 79
Prodigal Son, The . 89
Prophetess Anna, The . 59
Raising of Lazarus, The . 47
Rembrandt's Father Shortly before His Death 26
Rembrandt's Father Wearing a Gold Chain 26
Rembrandt's Mother in a Black Veil . 58
Rembrandt's Mother in a Nightcap . 58
Sacrifice of Abraham, The . 76
Saskia in Bed . 114
Saskia van Uylenburgh Wearing a Veil 114
Saskia Wearing a Straw Hat . 54
Self-Portrait . 31
Self-Portrait . 62
Self-Portrait . 65
Self-Portrait as the Apostle Paul . 64
Self-Portrait at the Age of 34 . 67
Self-Portrait Leaning on a Stone Wall 118
Self-Portrait or Rembrandt Laughing . 64
Self-Portrait with a Fancy Sword . 54
Self-Portrait with a Hat or Portrait of an Officer 63
Self-Portrait with Haggard Eyes . 63
Self-Portrait with High Collar . 63
Self-Portrait with Saskia . 70
Sibyl or Large Jewish Bride . 141
Simeon in the Temple . 77
Slaughtered Ox, The . 113
Still Life with Peacocks . 108-109, 111
Stoning of St. Stephen, The . 30
Strolling Musicians . 97
Studies of Heads . 115
Susanna and the Elders . 127
Syndics of the Cloth Guild, The . 136-137
Three Crosses, The . 74
Titus at His Desk . 90
Titus in a Monk's Habit . 131
Tobit and Anna with the Kid . 32
Wind Mill, The . 105
Winter Landscape . 107
Woman Bathing (Hendrickje), A . 118
Woman Urinating . 35
Woman with Babe in Arms . 91

Contested or Rejected Works, Works from Rembrandt's Studio

Artist Drawing a Model . 42
Artist's Studio, The . 42
David and Saul . 86-87
Happy Family, The . 93
Laughing Soldier . 144
Man with a Golden Helmet, The . 145
Samson and Delilah . 32
Self-Portrait (attributed to Lievens) . 62
Still Life with Old Books . 110
Two Black Men . 144